Tipping on a Tightrope

AFRICAN AMERICAN LITERATURE AND CULTURE

Expanding and Exploding the Boundaries

Carlyle V. Thompson
General Editor

Vol. 19

This book is part of the Peter Lang Education list.
Every volume is peer reviewed and meets
the highest quality standards for content and production.

PETER LANG
New York • Washington, D.C./Baltimore • Bern
Frankfurt • Berlin • Brussels • Vienna • Oxford

Aisha Damali Lockridge

Tipping on a Tightrope

Divas in African American Literature

PETER LANG
New York • Washington, D.C./Baltimore • Bern
Frankfurt • Berlin • Brussels • Vienna • Oxford

Library of Congress Cataloging-in-Publication Data
Lockridge, Aisha Damali.
Tipping on a tightrope: divas in African American literature /
Aisha Damali Lockridge.
p. cm. — (African American literature and culture: expanding
and exploding the boundaries; v. 19)
Includes bibliographical references and index.
1. American literature—African American authors—History and criticism.
2. African American women in literature. I. Title.
PS153.N5L64 810.9'896073—dc23 2011051541
ISBN 978-1-4331-0575-3 (hardcover)
ISBN 978-1-4539-0571-5 (e-book)
ISSN 1528-3887

Bibliographic information published by **Die Deutsche Nationalbibliothek**.
Die Deutsche Nationalbibliothek lists this publication in the "Deutsche
Nationalbibliografie"; detailed bibliographic data is available
on the Internet at http://dnb.d-nb.de/.

Author photo on back cover by Davinci Roshon

The paper in this book meets the guidelines for permanence and durability
of the Committee on Production Guidelines for Book Longevity
of the Council of Library Resources.

Printed in Germany

for Calion

CONTENTS

ACKNOWLEDGMENTS

I am grateful to have had the access and the ability to do what I most wanted in life: to read, to write, and to talk about literature. I have been fortunate to have had a number of wonderful teachers throughout my formal education including: Barbara Rowes, Kate Levin, and Tuzyline Allan. I can only hope to mirror their wealth of knowledge and enthusiasm in my own work. I thank the students who make me excited to go to class each day. Teaching and being taught by you, makes each day another opportunity for my life to change. I am also grateful to work at a place which attracts students like Sharette Allan, Jessica McGrady and Maggie Rich; their research assistance throughout this process was much appreciated. My gratitude for Dr. E. Anthony Hurley knows no bounds. He has been one of my most valued supporters without whose overwhelming generosity, this project would have fallen by the wayside long ago. Dr. Carlyle Thompson also thankfully believed in this project and urged me to push my ideas beyond comfort and my work is better for it. I thank my friends who make life at Allegheny College bearable and who gracefully allow me to crash parties and behave badly. I am also grateful for having the kind of family who never begrudges my absence and graciously makes a way for me to be there. I feel lucky to have a mother like Yvette George. She has been my toughest coach and greatest cheerleader and I continue to be buoyed by her deter-

mination and her love. Finally I thank Calion Barry Lockridge Jr. for keeping my feet warm, my soul happy, and for reading countless drafts.

Financial support for the research in this book was provided by the W. Burghardt Turner Fellowship, the Northeastern Consortium for Faculty Diversity, and Allegheny College.

I tip on alligators and little rattlesnakers
But I'm another flavor
Something like a Terminator
Ain't no equivocating
I fight for what I believe

. . .

You can rock or you can leave
Watch me tip without you
—JANELLE MONAE

INTRODUCTION:
DIVA DOES NOT MEAN
BITCH WITHOUT A CAUSE

There is a constant need for original and suggestive
tropes to capture an ever changing American scene.
—HOUSTON BAKER

There is nothing prosaic about a diva.
—WAYNE KOESTENBAUM

In the *Camera Obscura* issue titled "The Diva Strikes Back," the editor relates a story about a Patti LaBelle performance at Musikfest 2007. She is plagued by mosquitoes in the night air and demands the lights be turned off and then on again as she finishes her set "grandly spritzing herself with Off, just as if she were putting on Chanel No. 5" (Doty 2). This is just one of the many "Diva" stories we hear about today. These scenes are so prevalent and well-known in Western popular culture that Mars Candy Corporation previewed a commercial during the 2010 Super Bowl with a Diva theme. It featured Aretha Franklin as a body through which a young, petulant, white man could perform dissatisfaction. The male character is in a car with friends and is acting difficult and miserable, and is at this time personified by Aretha Franklin. His friends recognize that he is hungry and give him a candy bar. After eating he becomes calmer and is shown to be his white

male self again. When he is acting impossible he looks like Aretha Franklin and is called a Diva; when he is friendly and his hunger is satisfied, he is himself again—white and male.

The topic of this book is what Patti LaBelle exhibited in her 2007 Musikfest performance, and not the misunderstood bastardization of the Diva commodified by Aretha Franklin's performance of petulant white manhood. LaBelle's "tense good humor" (Doty 2) is often oversimplified as being that of a woman, and in this case a Black woman, behaving badly, but to see only this is to miss the beauty of the Diva. Patti LaBelle first asked the audience to look at her: "She had earlier encouraged the audience to appreciate how well she was looking these days" (2). She then demanded the lights be turned off to avoid being assailed by bugs: "They know what I look like!" (2). Finally, she ended the show amid bugs and sweat and bug spray with the lights on; in the end, she wanted to be seen. Furthermore, she wanted to determine when, how, and under what conditions she was seen. This scene brings to mind another: "I can do it all, why can't I have it all?" (Morrison 142). Sula Peace, the title character in Toni Morrison's 1973 novel, says this on her deathbed to a bewildered friend. Sula refuses to accept limitations, and LaBelle does not either. She occupies a single space imbued with multiple and competing desires, wanting to be both seen and not, protected and exposed. The audience's compassion for her predicament and praise for her voice and perseverance, in LaBelle's eyes, is paramount. Both the intersections these desires create and the links that exist between popular culture and African American women's literature are under observation here. Diva study is a careful examination of the flame that both illuminates and burns. This project traces the trajectory of the Diva figure, examines current popular culture references, develops literary examples, establishes an understanding of what a Black Diva is, and suggests a working literary model.

The term Diva has a long history that is not always apparent. It is used with such reckless abandon that, when asked if she thought she was a Diva, Diahann Carroll replied, "I don't know…'cause I don't know what diva means anymore" (Wendy Williams Experience). If Diahann Carroll does not know if she is a Diva, then something is woefully wrong. Kimberly Brown also usefully suggests "the term 'diva,' then, has been granted a great deal of cachet in contemporary popular parlance; it has come to encompass everything and nothing at all" (10). The Oxford English Dictionary (OED) lists the word as being of Italian and Latin origins and meaning "goddess, lady-love, 'fine lady'…female divinity" (Oxford English Dictionary). It goes on to attribute the first quote to an 1883 issue of Harper's Magazine, "The latest diva of the drama" (Curtis 468). The quote,

though, is misattributed. While it is indeed in *Harper's*, it was written by George William Curtis, not William Black, and is on page 468 and not page 465. These small errors may be of little consequence, but they do suggest a certain mystery and confusion about what a Diva is and where she comes from. Curtis writes in full:

> And what but good-nature can explain the enormous receipts of Mrs. Langtry's engagement....But the latest *diva* of the drama is not a great artist, and the secret of her success is the good-natured desire to see a famously beautiful woman. Such a box-office account could be possible only in a country of good humored people who make money easily and spend it generously. (468, emphasis Curtis)

His quip butts up against the definition the OED cites as the first reference in English language usage. This juxtaposition of definition and etymology reveal quite a bit about the Diva. The first attribution immediately brings forth a sense of petulance, not from the Diva, but from the observer. In his gaze, the Diva is defined by her lack of talent, her greed, and is said to be nothing more than a pretty face. His derogatory positioning runs counter to the etymology of the word, which identified the Diva as a goddess. Curtis's Diva is no Diva at all. Instead he employs the term to criticize—to judge who is and is not a Diva. Prior to his complaint he lists who he considers to be true Divas and writes "that all the other famous artists should receive great sums of money is not strange, for they were all prime donne and masters in their art" (486). Doing this then corrupts the idea of the Diva and puts mortals in the position of judging the supernatural, the critic judging the goddess. Naming someone to be or not to be a Diva becomes a measuring stick with which to beat another. In "Devouring the Diva," Melissa Bradshaw writes: "(The Diva) marks a cultural inability to imagine real and lasting female achievement" (72). Curtis's response to the beautiful, and in his opinion talentless, Mrs. Langtry falls in line with Bradshaw's argument. But the tension his criticism creates does not account for how the Diva may respond to her attackers. In the *Harper's* account, she is well paid despite what her detractors say. "It is good-natured evidence of the American good-nature which the philosopher observed, that a charming woman *can* travel in a country with great prestige and pecuniary success as something which she is not" (Curtis 469, emphasis mine). Here we see Diva. Curtis claims that the Diva is pretending to be something she is not. Instead, what we are observing is the Diva in action. Despite all, she is going about being a Diva, doing what she wants, being paid well for it, and surviving despite blistering commentary.

The Diva's perseverance, according to Wayne Koestenbaum in *The Queen's Throat*, is part of this figure's attraction and prominence in gay culture. "The particulars of the diva's conduct...chart a method of moving the body through the world, a style that gay people, particularly queens, have found essential. It is a camp style of resistance and self-protection, a way of identifying with other queer people across invisibility and disgrace" (85). Here, the Diva becomes a way to perform one's identity for a limited audience in a mixed and potentially hostile space. Her performance thus becomes one that embodies defiance and becomes her strength. The idea of the castrati is also part of the attraction. With the end of the castrati's era, women were engaged to perform their roles and the nostalgia their presence evoked explains in part why Divas were so heavily ridiculed in the *Harper's* article. In the castrati's absence, women became necessary to reach notes that testosterone interrupts.

> What was different was that in the early decades of the nineteenth century what had been the exception became the norm; the hero was now routinely written for a woman's voice. Visually the heroic character migrated from a castrato's body to a woman's body. The visual markers of the castrati—their physical characteristics—were remapped onto another type of body. (André 27- 8)

The Diva enters into a nostalgic place created by need and rife with scornful comparison, and yet she survives and thrives. It is the struggle for survival that remains firmly a part of Diva dynamics today.

The French film *Diva* by Jean-Jacques Beineix presents a Diva figure that embodies the performance indicative of this type of character. Her performance not only rests on her outstanding vocal abilities, but also extends to the control she exerts over the use of her voice. Wilhelmenia Wiggins Fernandez, an African American Diva, staunchly refuses to allow her voice to be recorded, frustrating her adoring fans. One such devoted fan makes a superior, but illegally produced, recording of one of her concerts, resulting in a police hunt for the fan and his tape across Europe. While *Diva* devotes very little screen time to the Diva herself, her voice remains the film's focus. Police officers, music executives, gangsters, and fans all try to possess her and yet she eludes them. In the end, the recording is destroyed. When asked why she refuses, she replies casually, "I sing because I like to sing. Not alone, I need an audience. A concert is an exceptional moment for the artist and the listener. A unique experience, music, it comes and goes; don't try to keep it" (*Diva*). Her refusal to record may appear overly self-indulgent, but reading beyond this, it becomes clear that her primary goal is to maintain her audience and to be the princi-

pal beneficiary of her music. She is unwilling to allow outside sources to make large profits, of which she would get little share. She may appear to affect the stance of a difficult Diva, but in actuality she is fighting to maintain control over her livelihood, fighting to ensure her continued existence. The Diva-worship that exists in this film finds its way to television, particularly in the VH1 show *Save the Music: Divas Live* and its derivatives.

The popular cable music channel, which is aimed at a 30-something viewing demographic, hosted an annual program entitled *Divas Live* from 1998 to 2004 and after a hiatus, returned in 2009. The program sought to engage the viewing audience in Diva-worship. While the performers represented a broad racial and ethnic spectrum aimed at having the widest appeal, the show dedicated only two programs to single performers during its run: Aretha Franklin and Diana Ross. These performers are undoubtedly two of the most famous Black female entertainers in recent music memory. Some of their fame is due to their singing ability, but, perhaps most notably, these stars are also admired for their ability to survive. Diana Ross's journey from poverty to the Central Park MainStage, and later to jail, is of great appeal to her fans. The marketing of these VH1 programs suggest yet another link between Blackness and Divaness. In the spotty history of the program, no show was ever dedicated to a white performer, despite participation by famous white entertainers like Cher. VH1 thus not only suggests that "real" Divas are indescribably Black, but it also reveals some of the earlier discussed confusion about who and what a Diva is. I want to avoid what Bradshaw says is "the inevitable dissolution of conversations about female celebrity into a game of 'Who's a Diva?'" (71). Therefore I will list the performers in the first year of the program and in the last aired performance[1] for your independent consideration: (1998) Celine Dion, Gloria Estefan, Aretha Franklin, Carole King, Mariah Carey, Shania Twain and (2010) Nicki Minaj, Sugarland, Grace Potter and the Nocturnals, Keri Hilson, Paramore, Ann and Nancy Wilson from Heart and MC Lyte. Simply put, the moniker without the goods means little. Therefore, I am suggesting that Diva is more than a title; it is a mode of expression.

The term still does not exist outside its troublesome history, so much so that Gloria Estefan expressed hesitancy in its application during the original *Divas Live* show. Her relationship to the term is complicated; there is simultaneous discomfort and desire expressed. During the program she said: "This 'Diva' thing is getting a little out of hand, I think. I mean if anything, I'm a divette" (VH1 *Divas Live*). Is the Diva getting out of hand, because the associated behavior is too over the top? Or is the term being too easily applied? Her suggestion that

she is a "divette," a diminutive Diva, implies the first reading but there are two conflicting desires in Estefan's comment: She wants to be identified with the long list of famous women who don the title, but also wishes to divest herself of the behavioral baggage that comes with the designation. The baggage she fears can be located in a look at Naomi Campbell and her run-ins with both her staff and the law.

Campbell has a well-documented relationship with anger and her refusal to manage it. Her legal troubles range from assault with cellular phones to attempting to refuse a subpoena from The Hague. In March 2010, Campbell again attacked her staff, this time slapping a driver on a ride through midtown Manhattan and fleeing the scene when he protested (Schmidt). Her behavior is often unexplained and the legal implications slight. She has never been incarcerated, has paid only minimal fines, and has completed just 200 hours of community service. Given her penchant for attacking people with inanimate objects,[2] these consequences or lack thereof almost seem to encourage her behavior. This kind of Diva behavior is also exhibited in Nella Larsen's *Quicksand* by the character Helga. "A sort of madness had swept over her…she suddenly savagely slapped Robert Anderson with all her might.…Then, without a moment of contrition or apology, Helga Crane had gone out of the room and upstairs" (Larsen 107–8). These two moments, one in popular culture and the other in a Harlem Renaissance novel, echo the view that the Black Diva exists simultaneously in both the popular and the literary imagination. They also reveal that unexplained motivations do not equate a lack of motivation. As the *Independent* reveals, "Campbell has held on to her supermodel status— and with it any requisite outrageous behavior—to this day. But then life has been rather more difficult for Campbell than for her Caucasian counterparts" (Frankel). While the story of her discovery is the stuff of fable, Campbell faced overt racism in the modeling business couched as buyer demand and preference. Annie Wilshaw, a model booker for Premier Model Management,[3] says emphatically that "the industry is racist. In Milan black girls never work. In Paris it's still the same. It's 2011 and that's quite disgusting, really" (qtd. in Pool, "'Fashion Is Probably a Bit Racist'"). Often her famous Caucasian model friends had to demand her hiring in high profile shows and magazines, "Christy Turlington told Dolce & Gabbana: 'If you don't use Naomi, you don't get us.'"[4] (Pool, "Naomi Campbell Fights Racism").

While Campbell recalls that story with pride, as a supermodel with a famous temper there have been a number of casualties. Model Tyra Banks considers herself to be one such casualty; the two have had a long-running feud

because Banks alleges that Campbell blocked her from runways and exclusive/lucrative photo shoots for advertising campaigns. ("The Tyra Banks Show").[5] Here it becomes evident that being a Diva is not a community-building exercise. As Campbell's runway career faded, stories of her violent temper became headline news. Instead of letting these instances hurt her career, she manages to turn them into further momentum, once showing up to court-ordered community service in a silver Dolce & Gabbana gown (Voguepedia). In August 2010 Campbell testified, under subpoena, that in the middle of the night she received "a few stones…they were small dirty-looking stones" (qtd. in Pearse). The case at The Hague was against former Liberian President Charles Taylor, and the dirty stones she dismissively recounts were uncut diamonds. According to her testimony, the night in question was just another day in the life of a supermodel. Frankly, girls like her prefer their diamonds cut and set.

Campbell amassed wealth throughout her career and used her Caucasian connections to gain access to lucrative modeling opportunities. She has a penchant for being engaged to rich and famous men she never marries, and she has remained childless. Yet 25 years after being discovered, she remains relevant. As Bethann Hardison, famous Black model advocate and a current *Vogue Italia* editor-at-large, says, "'You bring Naomi in, you get that sensationalism. It's very simple. The girl moves news'" (qtd. in Trebay). Most people, of course, do not put it all together because they are looking at the performance. A Diva wants you to do just that— pay attention to the performance, which here acts as a distraction—while she solidifies her position, a position which her race and gender usually dictate as unreachable. Naomi is hardly the first Diva, and a discussion of the famous castrati will provide further insight into this aspect of the Diva character.

Little reference remains to the OED's etymology of the word Diva, save the most caustic implications of it—bad behavior. Arguably the Diva's bad behavior is rooted both in fighting against the stinging criticism of Curtis in *Harper's* and in the legendary bad behavior of the castrati.

> The castrato Caffarelli…engaged in malicious behavior [*discolezze*] disturbing the composure of other singers, making lascivious gestures to one of the female performers, speaking from the stage with auditors who were in theater boxes, echoing phrases sung by others, finally refusing to join in ensembles with other singers. (Feldman 177)

While modern knowledge in endocrinology could account for some of the castrati's behavior, as they lost popularity and women took over roles originally reserved for them, protection for women came in the form of mimicry. Divas

had to seem to fit by performing the role of the castrati they were replacing. "Since women had already been performing male and female characters in the eighteenth century alongside the castrati, these female voices now became the sole representations of the multivalent relationship between voice and character that they had shared earlier with the castrati voices" (André 48). The Diva thus developed her behavior as a way to survive and thrive in the once castrati-dominated world of opera. Thought to be ridiculous, impossible to satisfy, and unrealistically demanding, it seems however, that this behavior for which the Diva has become so famous is premeditated and not at all as impulsive as it may seem. It functions as a method of control and self-protection and as a way to further her artistry and livelihood. The Diva creates a persona and must at all costs protect the creation—her survival depends upon it. As Oprah Winfrey said of Naomi Campbell, "You're projecting the image and the image is also who you are" (qtd. in Trebay). Would Naomi Campbell have been able to achieve and maintain worldwide fame without her notorious tantrums?

Each of the examples discussed suggests that, over time, Blackness came to be coupled with the idea of the Diva: "the diva is still essentially *niggerfied*" (Brown 11, emphasis hers). The Black community and its female constituents particularly claim it, and the popular definition allows them in. In order to succeed in the world as a Black woman, one must create a façade of sorts and then protect that façade at all costs. Like Janie Crawford at Joe Starks's funeral in Zora Neale Hurston's *Their Eyes Were Watching God* (1937), the Diva must present her face to the outside world while she does the internal work to survive. Living within this shell creates the distance and opportunity to create new figurations of Black womanhood. Dismissive of the social decorum that seeks to overtake her life, the Diva is able to create a life separate and different from cultural expectations. Black women writers recognize that they cannot afford to question the validity of their voices, but instead must do their own work to become full members of American society. The only hope for survival exists in creating a world free of confining ideologies that do not assist them in living productive lives. Doing this is no small feat and requires, at the very least, a bulletproof [6] exterior, which serves to protect the woman being nurtured inside. The Diva represents the glamorous, beautiful projection of the difficulty of being a Black woman in America. The Diva, after all, is just a character, an act of creating. "Focusing on the outward appearances of role, implies that roles...are superficial—a matter of style. Indeed life itself is role and theater, appearance and impersonation" (Babuscio 134). The Diva is created through the fiction of the real and the imagined.

Historically, Black women in America have had their gendered identity questioned, in large part because "the cult of true womanhood drew its ideological boundaries to exclude Black women from 'woman'" (Carby 39). The effects of this exclusion are felt even in the present era. bell hooks argues that she falls victim to American prejudice in part because of her Blackness, but far more so because of her gender (hooks, *Ain't I a Woman* 9). Literary Divas are therefore characters written outside the societal dictates of the cult of true womanhood as described by Barbara Welter in *Dimity Convictions* (1976) and reexamined by Hazel Carby in *Reconstructing Womanhood* (1987). This ideology stipulates that a woman be pure, pious, domestic, and submissive. The Diva is written as a rejection of both the cult of true womanhood and its afrocentric ideological outgrowths: Uplift, the Du Boisian call for Blacks to create beauty by "building themselves up in literature" (Du Bois, "Criteria for Negro Art" 757); New Negro Ideology, Alain Locke's call to shape a Black American identity that no longer considered race a problem that needed to be discussed and that above all else was "radical on race matters, conservative on others" (11); and Authentic Blackness, an ideology reimagined during the Black Arts Movement that suggested that Blackness could be defined and that authentic Black art must portray specific characteristics. Each of these ideological movements attempted to curb the creativity of women writers by dictating acceptable subject matter, which led their work to be less academically and commercially available. The Diva is an attempt to survive being both Black and a woman, with the understanding that survival depends on a careful performance of creation and protection. It is the performance of survival that defines the Diva.

The Diva figure grows out of and owes a great debt to Alice Walker's groundbreaking ideology of Womanism first articulated in *In Search of Our Mother's Gardens* (1974). In the foreword Walker defines Womanism as one who is defined by exhibiting "outrageous, audacious, courageous or *willful* behavior. Wanting to know more and in greater depth than is considered 'good' for one. Interested in grown up doings. Acting grown up. Being grown up….Responsible. In charge. *Serious*" (xi, emphasis Walker's). Walker's definition speaks to a state of being, a way of thinking. The Diva with that state of mind smashes open the world and takes what will help her to be the person she wants. The Diva is active and defined by her refusal to submit to protection, her desire to know more about herself and the world, her willingness to flout cultural expectations of Black womanhood, and her interest in her developing sexuality. The Diva moves beyond liminial spaces by acting on her world,

instead of letting it act on her. A Diva is not just a state of mind as implied by Walker's Womanism, but a character that goes on to provide alternative ways of being both Black and female, thus providing examples of other ways of living that are true to her desire to open up her world while choosing which parts to use and how she will engage larger Black communities. The Diva successfully negotiates the line between self and community, forcing the larger community to change in order to fit her needs and desires. In this way, she is a model member of society, mapping a road where a mountain existed. She is audacious and dares anyone to deny her any right she may claim.

The Diva does not take full shape within African American letters until well after the Harlem Renaissance, but there are inclinations towards Diva desire as early as the slave narrative. The slave narrative becomes the first place Black women gained access to a space in which they could write on their own behalf. In many instances, it became the only place Black women could defend themselves against the barrage of attacks on their moral character and to assert their humanity. True Diva desire, however, moves beyond this limited articulation. Harriet Jacobs, in *Incidents in the Life of a Slave Girl* (1861), desperately tries to confine her written narrative—but not her actual life, which included an interracial consensual sexual relationship and children born out of wedlock—to the morality of the period; she writes of the continuous sexual abuse by her owner in what would have been considered shocking detail. It is this decision to give such an unyielding account of her life that allows us to observe the beginnings of the Diva subject position. It is an autobiographical account that has many of the markings of sentimental fiction (Smith xxxi). Jacobs even creates another identity for herself, which she claims is necessary to protect her various benefactors. She writes her autobiography about a woman named Linda Brent, which suggests the distance required to survive; Linda Brent becomes the sheath in which Harriet Jacobs can exist.

Jacobs attempts to exercise control over her life with her text in a number of ways, but most significantly she demands the right to tell her story herself and the right to be paid for it. The text itself is, in part, written for financial ends; years of living in a tiny closet have made her arthritic and unable to do other work open to Black women at the time. Inherent within this is the suggestion that what she has to say is worth being heard and, what is more, worthy of pay. In addition to this, she controls her body by first initiating a relationship with a white man other than her master with the goal of gaining protection as a pregnant body. This proves to be a limited help, and when her master's desires continue to rage, she confines herself to a small garret for

seven years to prevent him access to her body. While this may seem to be a questionable choice, the attempt to make a life for herself as both a Black person and a woman outside societal expectations articulates her Diva desire.

Expected to stay on the plantation because of her children, according to communal expectations regarding mothering, Jacobs has no right to freedom without them. And yet leaving with them threatens her ability to be free at all. Black women during slavery are expected to become mothers but, as this and other examples reveal, Divas and mothers are a broken pair. Hiram Perez argues succinctly that "Divas hate their mothers" (113), but this may be a too easy generalization. Rather, the Diva figure is a complicated one that realizes the pitfalls of motherhood, that self-actualization and self-determination are not possible under the constraints of motherhood. Marianne Hirsch notes the contradistinction between the way Black mothers are often represented as being extremely maternal toward the white children in their care and the way they are represented in novels as being "ambivalent" mothers toward Black children (262). Unlike the mothers of the previous generation of Divas,[7] there is a lack of desire to insert themselves into the role of homemaker simply to elevate their status within local or global communities.[8]

The relationship between mothers and daughters, really between mothers and children, has always been tenuous in African American literature. In particular, a quick survey of the mothers in Morrison's texts reveal women who kill their sons and their daughters, and the children they do not kill, they neglect. So to avoid this pitfall altogether, Divas remain childless. "Bursting fully formed into glorious existence, [the Diva] does away with this messy and embarrassing business of the mother" (Perez 113). This often unnamed desire not to mother reveals itself in the robust Black women's writings of bustling 1920s Harlem.

Near the beginning of the Harlem Renaissance, Alain Locke defined the "New Negro" as "the younger generation…vibrant with a new psychology; the new spirit…awake in the masses, and under the very eye of the professional observers is transforming what has been a perennial problem into the progressive phases of contemporary Negro life" (3), and his ideology became the height of fashionable intellectualism among the Harlem literati. Locke called for a paradigmatic shift, a redefinition of Blackness that was to include American-ness. What ultimately came forth was a doctrine that in many ways shaped the types of art that were deemed acceptable and worthwhile to Black Americans. Despite the suggestion that Locke spoke of an entire generation, the *New Negro* seemed only to reflect male participation. He called for the concept of the old Negro

image to be eradicated. No longer "aunties and uncles" (5), Locke wanted Blacks to be seen as proud and intellectually viable members of the larger community, a group that was "radical on race matters, conservative on others" (11). It is this clause that arguably limited female acceptance within Locke's intellectual circles and initiated the reemergence of Diva desire, as female intellectual confinement provoked action. Some woman authors did not wish to write in so limited a manner, and thus to a large extent their texts came to be excluded from the legacy of the Black literary canon. The overwhelming use of male personal pronouns throughout Locke's essay suggests a construction of the "New Negro" as purely male. Thus, the "New Negro" had far-reaching consequences that curbed the creative development and intellectual acceptance of women during the Harlem Renaissance. Locke wanted very much to align himself with "the creation of Beauty" (Du Bois 782) in the same limited way Du Bois seemed to suggest in "The Criteria of Negro Art." Art was to be used as propaganda under "New Negro" ideology as well, despite the claim of being unconcerned with the opinions of white or Black purveyors. The suggestion that Blacks be "radical on race matters, conservative on all others" (Locke 17) speaks to censorship.

It is clear that, in spite of this, "the Harlem Renaissance was not a male phenomenon" (Wall, *Women of the Harlem Renaissance* 9); women, often in surreptitious ways, wrote across Dubois' singular instruction to "build themselves up in literature ("Criteria of Negro Art" 757). It is the need to write inside and outside the Uplift model that refines Diva desire. "The paradigm set forth in 'The New Negro' overstates the case for male writers, but it contradicts the experience of many women" (Wall 5). One must answer the question: "Does a place exist for women within Locke's New Negro world?" The answer seems a cautious "yes." There is a place for her, provided she understands the limited voice with which she will be allowed to speak, and that she find discursive ways to assert her existence into Locke's male world. The women selected for inclusion in *The New Negro* are few and of the forty-six short stories, poems, song, plays and essays only six entries are by women and of those six entries only one is a socio-political essay. Given this distribution it is difficult to imagine that Locke saw the New Negro as anything other than male. Elise McDouglad, the author of the sole essay from a woman's perspective, turns out to have a heavy task since hers is the only critical voice given space to represent the thoughts and feeling of an entire generation of women. She does admirably; her essay is the only attempt in the text to consider both race and gender simultaneously.

The title of McDouglad's essay, "The Double Task: The Struggle of Negro Women for Sex and Race Emancipation," was changed for publication in *The New Negro* to simply "The Task of Negro Womanhood," an immediate indication that suggests that gender and race were held to be mutually exclusive by editor Alain Locke. In the essay, McDouglad sets about the work of complicating the idea of Black womanhood. She argued that there is no universally representative Black woman: "one must not have in mind any *one* Negro woman, but rather a colorful pageant of individuals" (307, emphasis mine). She outlined what she saw as the four classes of women, carefully noting what they have done in the past and what each can potentially do in the future to improve the status of Black Americans. But if one accepts Henry Louis Gates's argument in *The Signifying Monkey* (1989), that double-voiced discourse is key to reading and understanding Black texts, then we have to look for the palimpsest in McDouglad's essay. She was writing an essay in a work that largely excluded women from its ideological framework, so what is the unvoiced text?

In an era that espoused racial uplift, which dictated the ways in which one should be Black, the model of the Philadelphia Negro was held in highest regard. Within this ideal, McDouglad questioned the notion of an ideal Black woman. She alluded to the constraints of the cult of true womanhood on Black women, suggesting that in the case of Black women "custom [was]…once more against her" (309). Despite being an ideology designed to define white women's existence, the cult of true womanhood came to be applicable to Black women through the insistence of uplift and its intellectual outgrowth, New Negro ideology. Anna Julia Cooper began addressing questions of "true womanhood" as far back as 1886. In "Womanhood: A Vital Element in the Regeneration and Progress of a Race," Cooper seemed to accept the inevitability of negative stereotypes about Black women. But in the same space, she attempted to write Black women into a protected category—the place of white women.

> The colored girls of the South:—that large, bright promising fatally beautiful class that stands shivering like a delicate plantlet,…so full of promise and possibilities, yet so sure of destruction.…Oh, save them, shield, train, develop, teach, inspire them.…There is material in them well worth your while, the hope in germ of a staunch, helpful, regenerating of womanhood on which, primarily, rests the foundation stones of our future as a race. (560)

Black women became subject to, and therefore worthy of, rescue, according to Cooper. While in some ways this was an astute maneuver, it also led the way

for the male writers of the Harlem Renaissance literati to confine Black women to the cult of true womanhood. It proved to be dangerous to insert oneself into a role, looking at it from the outside in. The pedestal Cooper suggested as a place of safety had its own very real set of dangers, and yet, the negative stereotypes she was trying to overcome were significant.

It is important to understand the weight of the cult and how Black women as a group came to suffer under something that, by definition, did not include them. True women were not Black because Black women could not meet each of the four tenets of true womanhood that Barbara Welter outlined in *Dimity Convictions* (1976). In addition, the tenets were unequally weighted, with piety and purity held in the highest regard; the structural inability to satisfy these two helped further distance Black women from the sphere of humanity (Carby 32) and from the gendered identity of woman. They could not be pious in the Western biblical sense because they were believed to lack a soul (Carby 26) and thus were not recognized as Christian. The persistence of purity is yet another matter.

The systematic rape of Black women excluded them from illusions of purity. Despite the inability to control or stop sexual abuses, the responsibility for sexuality purity, or lack thereof, rested on their own shoulders. In the post-Reconstruction era, Anna Julia Cooper called for the regeneration of Black women, not placing blame with them, but rather insisting that they vigorously reengineer their collective image so that they might be accepted as women. During the Harlem Renaissance, Black women continued to insist on the virtue of their character. McDouglad, again in "The Double Task," began to relay, without provocation, the existence of the Black community's strong ethical and moral codes for and amongst women: "contrary to popular belief, illegitimacy among Negroes is cause for shame and grief" (312). Cooper, McDouglad, and other women authors of the period attempted to combat sexual stereotypes about Black women. This, in many ways, has been a fruitless battle. Deborah White argues in *Ar'n't I a Woman?* that, even today, "the Black woman's position at the nexus of America's sex and race mythology has made it most difficult for her to escape the mythology" (28). One of the strongest social identities, that of womanhood, was denied Black women and, above all else, it is their perceived rampant sexuality that was used to exclude them.

Stereotypes about Black women's sexuality are widely believed to have issued from the access slavery gave white men to Black women (Carby, (1987); White, (1985); Collins (1991)). bell hooks argues that "American society allowed whites to sexualize their world by projecting onto Black bodies a

narrative of sexualization disassociated from whiteness" ("Selling Hot Pussy" 114). The sexual abuse and exploitation of Black slaves has not been well documented throughout African American history and exists primarily within the confines of Black women's narratives: for example, Jacobs (1861), Prince (1831), and Keckley (1868). These narratives obscure, to a large degree, the sexual abuses Black women withstood, as well as those they observed. Ever-conscious of their audience, the authors endeavored to counteract prevalent notions of unbridled Black sexuality with their cautious narratives. That the negative stereotypes about Black women's sexuality were based solely on the sexual deviance of white men had little to do with how Black women were perceived. Harriet Jacobs attempted to articulate this to a potentially unsympathetic audience when she wrote in *Incidents in the Life of a Slave Girl*. "The white sentimental novel was popular among the white women readers to whom her book was addressed....This technique would enable them to appreciate the ways in which slavery converted into liabilities the very qualities of virtue and beauty that women—or rather elite white women—were taught to cultivate" (Smith xxxi–xxxii). Ultimately, Smith argues definitively that this writing choice "deemphasized the complexity of her situation" (xxxii). It is easy to see how that liminal space works to suppress Diva desire. Trapped between the genres of slave narrative and sentimental fiction (xxxi), Jacobs is not quite able to tell the story she wants. Readers have to imagine the closed spaces and fill them with other historical documents in order to get a fuller picture of Jacobs's life. Modern Divas, however, assertively wrest their sexuality from the clutches of others.

Race men during the Harlem Renaissance embraced this limited definition of womanhood because it aligned them with popular, white male thinking. Black women thus became something of a conundrum. As non-women but clearly not men, Black women became socially unidentifiable, a claim "New Negro" philosophers were eager to escape. Locke was tired of Blacks being "argued about, condemned or defended, 'kept down,' or 'in his place,' or 'helped up,' worried with or worried over, harassed or patronized, a social bogey or a social burden" (1). So it seemed simpler to keep women out of their midst altogether. Black women as a group, being undefinable, were highly problematic for the propagandist mission at hand: Uplift. If whites were having trouble accepting Blacks in general, and Black women in particular, as human, then Harlem Renaissance male intellectuals were willing to continue on without them. Finding themselves intellectually abandoned, Black women, such as Zora Neale Hurston, were left to create an identity they could both

embrace and through which they could write and live meaningful lives. Unwilling to write only in terms of race, and wanting to discuss issues that were not nearly conservative enough, they created a type of literary character "viewed as outside (male) language" (Kaplan 120). While Kaplan does not suggest that this term be applied to the Diva figure, it seems fitting. The Diva flouts the mores of society and is content to do so. Knowing that she will never be truly accepted, she no longer attempts to be, and by this she attains a measure of self-actualization. These articulations of Diva desire harken back to the world of the castrati. These Black woman authors find a way to speak from liminal spaces. As Naomi André suggests of the castrati, the Diva can represent a "'third zone' [which] gives them latitude to exist in a liminal category" (49[9]). Lena Horne suggests during her heyday that "MGM didn't want Blackness in those days....So, I was made into a kind of neuter" (qtd. in Vogel 21), but as a Diva she takes on "aloofness as a strategic mode of Black performance" (Vogel 12). Horne, is not, in fact, neutered; instead, she navigates away from expectation and enters a new space, a "'space of possibility'...mediated between a synthesis of two familiar elements and something that is entirely new" (André 49). In that "third zone" she combines the seemingly known quantities of Blackness and womanhood and creates something new by performing the Black Diva.

Fiction writers, such as Nella Larsen and Zora Neale Hurston, dealt with unfeminine subjects like female sexuality and difficult heterosexual relationships, and experimented with the use of dialect, and so embraced this third zone. Essayist and fiction writer Marita Bonner best described an inescapable feeling of being trapped within the celebrated New Negro ideology, a doctrine that undermined her very existence: "so—being a woman—you can wait. You must sit quietly without a chip. Not sodden—and weighted as if your feet were cast in the iron of your soul" (Bonner, "On Being Young" 1209). As Alice Walker has said of the women in Jean Toomer's *Cane* (1923), women writers of the Harlem Renaissance, too, were like "exquisite butterflies trapped in an evil honey, toiling away their lives in an era, a century, that did not acknowledge them . . ." (Walker, *In Search* 231–32). One of the defining characteristics of the Harlem Renaissance was the clear intention of Blacks to join the American landscape as true citizens. Black men struggling to be accepted willingly conformed to the ideals of a white society and, thus Black women found themselves unable to articulate their own desires within the popular doctrines of New Negro ideology or the idea of the Talented Tenth. All of these ideas— New Negro ideology, the Talented Tenth, and the cult of true womanhood—

came to play a large role in determining what women writers, writing away from imposed ideologies, took for their subjects. Many stories featuring Divas focused on the limits surrounding the sexuality of Black women, in order to renegotiate the sexual politics set forth by those confining ideas. It is this aspect of the Diva that makes her seem dangerous to Black communities and to larger dominant culture. Is she obliterating stereotypes about Black female sexuality or reenforcing them? There is an anxiety about the Diva's erotic performance but women writing Divas actively write more complicated visions of Black women's sexuality; it may play an important part in a Black woman's life but, it is not the only thing that informs her life. Black female sexuality is not a binary construction; it is not only asexual or promiscuous. The Diva figure attempts to open the space between these two distant points as widely as she can.

Not only is the Diva written against popular ideologies concerning Blackness and Black womanhood, but also in response to specific stereotypes about Black women. The mammy, the jezebel, and the matriarch or superwoman have been written about extensively. The mammy is the asexual Black woman, the jezebel is the hypersexual Black woman, and the matriarch or superwoman is the emasculating Black woman. Patricia Hill Collins suggests that there has been a shift in the way we think about them but that largely they are the same. They may seem to have faded, but they are ever-present in racial memory. The mammy has become the modern mammy;[10] the jezebel becomes the "sexualized bitch."[11]

Unlike static stereotypes of Black womanhood, the Diva figure is a fluid identity. She is a character type that enables an author to critique the multivalent cultural expectations of Black womanhood while simultaneously providing an alternative way to be both Black and female. Thus, authors create works in which alternate ways of being can become emblematic of the variety of Black women's experiences in America. This unique, discursive construction generates the opportunity for Black female figures to exercise judgment and make choices rarely put to them outside of women's texts, thereby granting women the opportunity to express possible solutions that have not yet been voiced in society. The Diva performs her way into survival. Black women writers are forced to negotiate social boundaries, and those who are unwilling to submit to prevalent ideologies about race and gender write rejections of the stereotypical images of Black womanhood. Deploying the figure of the Diva is an attempt to unpack essentialized images of Black womanhood. In particular this space provides for more complex characters that evoke the potential of

Black women's lived experiences to change their present-day existence. Diva characters present Black women with an opportunity to gain control over the projected image of Black women in literature. The Diva is therefore defined by her refusal to submit to protection, her desire to know more about herself and the world, her willingness to flout cultural expectations of Black womanhood, and her interest in her developing sexuality. Her persistence dismisses easy generalizations and demands attention because ultimately, a Diva is never a bitch without a cause.

Diva Soprano Kathleen Battle grew up in Portsmouth, Ohio, and initially worked as a schoolteacher. She came a long way to become the world-renowned operatic Diva she is today. Her career is plagued with dastardly Diva tales, and backstage crews have been spotted wearing "I Survived the Battle" T-shirts during seasons she performed. She even famously threw her costar's dress out of a window leading up to a performance (Pringle). The Diva might not invite us in, but if you want to understand what motivates her behavior, you have to look more closely. Some have suggested that Battle is "frightened," "very screwed up," even "sick" (Walsh). But her Diva dramatics seem more directly tied to her desire to see and be seen, to control the gaze. "Battle Fatigue," the same article that cites Met insiders weighing in on Battle's antics also reveals that "she has risen to worldwide fame in secondary roles that do not ordinarily make stars" (Walsh). Given her voice, known, not for its strength, but rather for its silvery quality and her ability to turn herself into a star in secondary roles, it is short-sighted to see her Diva strategy as misguided delusions of grandeur reflecting insecurity rather than the intentional acts they were. After her legendary dismissal from the Met, her need for Diva theatrics became more clear; without them everyone is eager to dismiss her and her talent. Listening "more closely than usual on the nuances of her performance, Miss Battle had to prove that her artistry outweighed the famous tales of backstage imperviousness" (Kozinn). It seems that her outlandish Diva behavior was designed to protect her from scrutiny and its persistence allowed her to maintain an active and lucrative career with the Metropolitan Opera House for seventeen years, longer than many others. Clearly, being a Diva has its benefits. They tend to behave as they do not merely for attention, but for what the misdirection of attention allows: the ability to control their lives and livelihoods in ways that close scrutiny would not allow. If you want to know what the Diva is doing, you will have to look, closely.

Chapters

Chapter 1, "Helga Crane: Failed Transnational Diva," puts Helga Crane in the hands of a politically astute Nella Larsen. She examines the possibility of an open transnational space for Helga to express her intersecting identities. Helga is often read as perpetually dissatisfied with life, but this dissatisfaction serves as a Diva's critique of the paltry offerings made available to a Black woman during the Harlem Renaissance. Helga mistakenly believes that she has properly prepared to become a part of America and longs to access the space in which she lives the life she chooses. She searches in the South, the place of literary Black authenticity; Harlem, the New Negro world; and even Europe, the place of literary cosmopolitanism. In each place, she seems to reach a tipping point but is held back from the leap because she cannot be accepted as the Diva she longs to be. Ultimately, *Quicksand* (1928) serves as an indictment of the idea of a monolithic Black community and the United States.

"Searching for the Diva in *Their Eyes Were Watching God*," the second chapter, examines Zora Neale Hurston's *Their Eyes Were Watching God*, written in 1937 at what is arguably the tail end of the Harlem Renaissance.[12] Against the relief of *Quicksand*, its predecessor by ten years, Hurston's style appears very different. While there are no swanky people or fancy parties, Hurston does express some of the same Diva desire through her protagonist. She does not impose on her characters the New Negro–constructed world of her Harlem Renaissance contemporaries. Instead, by indirectly acknowledging the belief systems undergirding New Negro ideology, she immediately critiques them. Uplift and true womanhood are under searing review in this novel. In this woman-centered text Hurston employs Janie Crawford as a vehicle to critique the Black community in which she lives, and it is through this critique that Hurston provides an alternative way to live as a Black woman: unencumbered by possessions or hierarchal structures. We witness a character willing to search for the love she imagines she has the right to have, and we watch her become the woman who would sacrifice that love in order to live under her own direction.

After the almost stifling silence of Black women writing from the 1940s through the 1950s—save, most prominently, Ann Petry and Gwendolyn Brooks—and the overtly chauvinistic gestures of the 1960s, there is a resurgence of Black women writing during the 1970s and 1980s. A Black women's Renaissance comes into full blossom as a direct reaction to the confining ideologies inherent in Authentic Blackness reimagined as the Black aesthetic. Black women writing during this period can be characterized by the willingness

to construct an identity that puts gender as a primary focus, followed then by race and ethnicity. In chapter 3, "The Bottom's Unrepentant Diva," I examine the new figurations of Black womanhood that Toni Morrison puts forth in each of the women characters in *Sula*. The most clearly articulated Diva figure in the novel is its namesake, Sula. I locate her as a revision of Janie Crawford in part because Sula represents a more fully realized Diva character. Janie Crawford learns to cope with the condemnation of the community for the choices she makes; Sula never considers those constraints. Her family structure by its nature contributes to her Diva stance. Because she is from a community of women who operate outside communal expectations, Sula has more opportunities to express her Divaness. Ultimately, she rejects the burden of motherhood in an attempt to give birth to the self she wants to be.

The growing interest in telling Black women's stories reveals itself in a variety of ways, and thus "Revising Janie Crawford: Divas under the Male Gaze," the fourth chapter, examines Spike Lee's filmic interpretation of the Diva. This chapter explores the question: How are Divas positioned by male writers and artists? Spike Lee seems to have a fascination with Diva characters. His first feature film, *She's Gotta Have It* (1986), intentionally invokes the spirit of Hurston's own conceptions of womanhood: "Women forget all those things they want to remember, and remember everything they want to forget. The dream is the truth. Then they act and do things accordingly" (Hurston 1). Indeed, the movie starts with this as an epigraph. His first Black female protagonist, Nola Darling, is an attempt to revise Janie Crawford. In his career, he has directed several films that feature Black women characters who attempt to revise patriarchal hegemony in their lives, most notably his film *Girl 6* (1996), in which he attempts to approach the Diva once more and this time revises Nola Darling. The figurations of Black womanhood fall flat and despite his intentions, no Divas show up in his films.

"A Canvas of Her Own: The Diva in *Liliane: Resurrection of the Daughter*," the fifth chapter, discusses a Diva who emerges a generation removed from Du Bois' Talented Tenth ideology. In Ntozake Shange's *Liliane: Resurrection of the Daughter*, we encounter a class of children unwilling or unable to get from underneath the weight of Talented Tenth expectations. Of the cadre of privileged playmates, the protagonist, Liliane, is the only one to survive. She decides during her adolescence that none of the principles that are meant to define her life suit the life she wants to lead. She therefore "crafted a delicate social structure, penetrable only by her, and contrived for her desires and her protection" (Shange 92). This became the guiding principle of her life. Liliane

performs survival; she critiques the mores that attempt to color her world and, in the end, creates an alternative way to live away from those strictures and yet, firmly rooted within her community. "Liliane believed you picked up what gleams and stands out lovely from the hardness and hushing up. You pull these startling elements onto a canvas of your own, and that's your life" (92). Liliane constantly defines and redefines that which "gleams" and "stands out"; while she is not able to choose the upbringing and social standards from which she came, she resolves that despite this she is the only one who will determine how her life will unfold. Shange reveals Liliane Lincoln to be a fully articulated twentieth-century Diva.

The conclusion, "Divas beyond the Fin de Siècle," examines twenty-first-century visual iterations of the Diva through a lens of Afrofuturism. In looking at them, I suggest that the Diva can be another useful lens through which to study African American women's literature. Unlike familiar stereotypes the Diva is not dismissive or negative; it is an empowering idea with vast potential for application.

· 1 ·

HELGA CRANE

Failed Transnational Diva

In *The Souls of Black Folk*, W. E. B. Du Bois fails to capture the predicament of Black women when he describes the Black identity crisis in America as being embodied in double-consciousness: "one ever feels his two-ness—an American, a Negro; two souls, two thoughts, two unreconciled strivings; two warring ideals in one dark body, whose dogged strength alone keeps it from being torn asunder" (*Souls of Black Folk* 694). His eloquent description of Black life at the beginning of the twentieth century by omission excludes the specific concerns of women. Kimberly Brown usefully argues for a need to shift "from double-consciousness to the multiple consciousnesses of African American women, the psychological battle to come to terms with the inter-related pressures of sexism, racism, and oftentimes classism" (69). Women had to consider how gender reverberated within the limitations double-con-sciousness in order to overcome it.

Marita Bonner in "On Being Young, a Woman and Colored" speaks more accurately to Black women's experiences in the Harlem Renaissance when she writes: "so—being a woman—you can wait…when Time is ripe, swoop to your feet—at your full height—at a single gesture" (1247). The boundaries she outlines in her essay reveal the underbelly of Du Bois's poli-tics of Uplift, "a discrepancy between the idealism projected by the intelli-

gentsia and the circumstances African American women encountered" (Musser 77). As a result, her work captures the true zeitgeist of women's experiences in the Harlem Renaissance. Bonner is particularly relevant because Alain Locke, a leading voice of the era, was overwhelmingly misogynistic (Lewis 96), and therefore women's experiences tended to be devalued. Despite the fact that Bonner lived outside New York City, her work speaks to the realities of Black women who relocated from the hot field labor of the South to the cold industrial labor of the North. While Locke attempts to reanimate Du Bois' original Talented Tenth ideal, women artists like Bonner write Black women into the urban 1920s to 1930s American landscape in a way dissimilar to the other women writers of the time.[1] She does not become caught between the classic tropes of the tragic mulatta and the New Negro. Contemporary Nella Larsen improves upon the rejection of these tropes by examining Helga Crane's Diva desire in *Quicksand*.

Nella Larsen is described as gifted and opportunistic as the dedication of *Passing*[3] to Carl Van Vechten, an acquaintance she shamelessly courted, suggests (Lewis 231). Her solid place in a highly contested Black literary canon can be attributed in no small part to Hazel Carby's *Reconstructing Womanhood* (1987) and Cheryl Wall's *Women of the Harlem Renaissance* (1995), as these texts reclaim the Harlem Renaissance as a highly productive period for Black women writing. However her place is also due, in part, to Alice Walker's rediscovery of Zora Neale Hurston. Excitement for *Their Eyes Were Watching God* arguably led to a newfound interest in Hurston's contemporaries, and in Larsen we find one of the most interesting.

> The Amsterdam News described Larsen as "a modern woman, for she smokes, wears dresses short, does not believe in religion, churches. . . ." What is known with certainty is that Larsen wrote one of the three best novels of the Renaissance, produced a second in a matter of months, traveled abroad with a female friend, had an affair with an Englishman, and followed her philandering husband to Fisk, briefly; then vanished. (Lewis 231)

While she was certainly more accepted within the Harlem literati than Hurston was, their lives and work present an interesting parallel.

Quicksand, in many ways, tests the boundaries of the Harlem Renaissance world and sets about the "undoing [of] fixed distinctions" (Roffman 765). Larsen claims for her heroine, Helga Crane, a literary landscape where womanhood is prominently featured. While other popular women characters of this era are able to learn from their missteps, Helga cannot. Her inability (or unwill-

ingness) to survive suggests the failure of Black communities to support women, and can also be seen as an indictment of America's slave past. While not always successful, Helga Crane serves as a predecessor to the more radical Diva figure to come ten years later in the form of Janie in Hurston's *Their Eyes Were Watching God*. Larsen lays the groundwork upon which Janie can be written. Hazel Carby argues that "Helga [is] the first truly sexual black female protagonist in Afro-American fiction" (Carby174). This makes her a significant aspect of the emerging Diva figure. Helga's articulation of an independent feminine sexuality is integral in the delineation of the Diva's rise. In particular, Helga's behavior is arguably a series of rhetorical questions, as Manalansan suggests of "di ba"(vii).⁴ Helga constantly asks herself: Is it going to make me happy/fulfilled/a part of society? Through Helga's questioning, Larsen interrupts notions of true womanhood and Uplift, suggesting that Helga already possesses everything she needs to be happy. The novel thus works as a "what-if" text (Baker, *Working the Spirit* 36) because it poses a number of questions about Black women and the relevance of Uplift living. The answers come in the form of Helga's over-used, incapacitated body found at the end of *Quicksand*. Behind Uplift and true womanhood, the chrysalis of the old negro reveals that a "New Negress" is trapped within the desire to be both part of and different from the expectations that dominate Black urban, middle-class women's lives during the Harlem Renaissance. Helga is presented as locating for herself a world on a silver platter, money enough to live with a room of one's own, to paraphrase Virginia Woolf, and yet she is still completely dissatisfied with her life. Casual readers might assume Larsen is merely capitulating to commonly held 1920s ideologies surrounding women's proper positions within a white male–driven, hierarchal sociopolitical society, and yet, if examined closely, this novel reveals a politically astute Larsen whose message goes far beyond capitulations to proper decorum; the Diva figure is fleshed out in Larsen's characterization of Helga.

The Diva is defined by her refusal to submit to protection, her desire to know more about herself and the world she lives in, her willingness to flout cultural expectations of Black womanhood, and an expressed interest in her developing sexuality. Helga articulates each of these aspects of the Diva with varying degrees of success. Early in the novel, she rejects both familial relations and marriage as viable options for a fulfilling life. She allows herself to want more than what society has apportioned to her in terms of employment, friends, and social decorum. She also taps into her burgeoning sexuality with clearly disastrous results. Unlike a true Diva, however, she does not survive the environ-

ment in which she finds herself, nor does she thrive by forcing the world around her to change. However, the ways in which she fails reveal her to be one of the building blocks of the Divas we meet in the future.

Quicksand is a tale of more than just thwarted sexual desire. It is the story of a woman who does not know exactly what she wants but knows that she wants more than what is being offered to her. "Her migrations are the result of her desire to desire, her need to be recognized as an individual subject, rather than an over determined object" (DeFalco 21). What she has most immediate access to is very limited: "The South. Naxos. Negro education and suddenly she hated them all. Strange, too, for this was the thing which she had ardently desired to share in" (Larsen 3). Helga has come to recognize the poor offerings laid out before her and seeks out more; "she was a failure here,...therefore no need to stay longer...she thought to go now, tonight" (5). Her claim of failure is not due to her lack of success as a teacher or potential bride. The failure Helga discusses in this moment is indicative of her unwillingness to find satisfaction with the Naxos scene—a place she finds uninteresting to either live or work. She intuits that somewhere away from the communal constraints of Naxos there must be a place more accepting of her desires and her difference.

Helga, while well educated, hardly holds claim to real middle-class status; at the outset of the novel, she has neither money of her own nor any immediate family. While Helga may initially yearn for familial roots and worldly possessions, once she gains access to those things through James Vayle, she is no happier than she was prior to having them, realizing that in there absense "all pretense brushed aside, the dominant [feeling] she suspected, was relief" (8). This fails in the end due to her frustration with life at Naxos and her intuitive knowledge that life with James will be even more confining than life at the school. Helga fritters away her one chance of communally sanctioned stability, despite the realization that "to relinquish James Vayle would most certainly be social suicide . . ." (8). Like a true Diva she realizes that choosing James is a false choice.

It is not just Naxos, family, and a spouse she is giving up by leaving the school—she is also signaling her refusal to sell herself so short, literally. Vayle's purely sexual interest in her disgusts her: "acute nausea rose in her as she recalled the slight quivering of his lips sometimes when her hands had unexpectedly touched his: the throbbing vein in his forehead [when] she had allowed him frequent kisses....She must have been mad, she thought" (24–25). Expressed female sexuality had led her to become the orphaned and isolated woman she was. Helga's "revulsion is simultaneously a resistance to white

tropes of black women as licentious and a succumbing to white myths of black-ness that work to pathologize black sexual desire" (DeFalco 26). However, DeFalco's reading fails to acknowledge Helga as an individual, while simultane-ously claiming *Quicksand* as a novel of "subjectivity and representation" (22). It is more likely that Vayle is simply sexually unappealing because he longs for her in a sexually uncomplicated way and, though she cannot articulate it just yet, his promise of strong family connections is just not desirable enough for Helga to allow his singular interest to provide her with questionable comfort. Helga expresses open disdain for Vayle's demonstrated willingness to barter his good name for access to her body. He knows that "he was liked and approved of in Naxos and loathed the idea that the girl he was to marry couldn't manage to win liking and approval also" (Larsen 7). And yet, he is willing to marry her still because he craves the frequent kisses she allows him. Helga rebuffs him in the end because she decides that access to her body will not come so cheaply, thus rejecting what she is expected to value. She realizes that being a part of the South, and part of a family, is not worth the cost.

Helga's objection to the confines of family reveals Larsen's critique of it. While Larsen's work is praised by many, most notably by Du Bois,[5] her work does not at all support Harlem Renaissance notions of the Black middle-class family. Instead, "as a modern woman without the protection of family and money, she has questions about a society with fixed roles for men and women" (Davis 274). In *Quicksand*, family is not a monument to be worshipped, but rather an institution worthy of intense scrutiny. And while the absent presence of family serves as a defining characteristic of Helga's life, it is not treated pos-itively in the novel. The rhetoric of the Harlem Renaissance world notwith-standing, Larsen sets out to complicate the concept of the Black middle-class family by placing Helga near to one, but just outside of it, clearly suggesting that most of Helga's problems originate in the lack of, desire for, and rejection of fam-ily. Her actual family, like quicksand, envelops any real chance she has to be part of a "first family"; her relations thus keep her from accessing the Talented Tenth world she at times desires. As she sees it, her mother's lust destroyed any hope of satisfaction: "in forgetting all but love she had forgotten, or perhaps never known, that some things the world never forgives" (Larsen 23). Helga's inability to find her place in the world is in part a result of her mother losing her own place in respectable society. Larsen imbues Helga with a sixth sense—the ability to wield her sexuality—and yet she is unwilling to use it merely to improve her social position in either Black society or white. Larsen initially attempts to present Helga as fighting the trope of the tragic mulatta.

Helga Crane's biracial/multiethnic identity gives her the advantage of viewing society from a critical vantage point that allows her to question the Black values of the striving strata of literati (Carby171). Whether she likes it or not, by education, if not by family, Helga is assumed by others to be a member of the Talented Tenth. However, the role she is expected to perform does not appeal to her. Prevalent New Negro ideology puts her at risk by forcing her to conform to the confines of Locke's ideals and attempting to strip her of a freedom she is not willing to surrender. She is at first swayed by the image of the Uplift world: "Helga had taught in Naxos...at first with the keen joy and zest of those...who have dreamed dreams...but eventually this zest was blotted out [by] the trivial hypocrisies and careless cruelties [that] were a part of the Naxos policy of uplift" (5). While she rarely speaks of her growing dissatisfaction outside of an internal monologue, she expresses it with her clothing choices.[6] Her rebellion is evident, not just in her clothes, or by the tantrum she throws in Dr. Anderson's office on the day she resigns, but also in her refusal to marry James Vayle. She does not stand quietly by and just wish she'd written "A Plea for Color,"[7] "but sets in motion a counter response—to never stop moving and thinking" (Roffman 764). She does not allow herself, despite the potential ease it might grant her, to become James Vayle's wife. Greg Hampton suggests that Helga wants to "be about the business of bettering herself and consequently uplifting her race" (168). This seems unlikely, because Helga does not marry James, and thus does not become a literal incubator for racial ideals. That is, she does not want to make Uplift/Talented Tenth babies or go on to send them to schools like Naxos. With limited available options, she runs from the constriction that, through her physical being, both James and Naxos reflect back to her. She is certain that, should she stay on such unsure ground, she will most surely be consumed by the quicksand underfoot.

Cheryl Wall contends that "the tragedy of [Larsen's mulatto characters] is the impossibility of self-definition" ("Passing for What?" 98). This, however, does not acknowledge the limited space within which Helga has to operate. Helga attempts to create her own identity, but the liminal space wherein she must act has clearly defined and immovable borders. She is a biracial woman of no means, without family, with a past she is told to hide, operating in a community of Uplift that expects her to be satisfied with marriage and children for the greater good of an imagined Black community. Her definition of self is difficult to realize because of this confining space that limits her movement. Her Diva desire then is evident in her attempt rather than in her success.

Indicative of her inability to thrive outside societal expectations, Helga Crane attempts consumerism as a way to free herself from confining external spaces. Longing to feel what she imagines it feels like inside a loved and protected space, from the outside, she tries to materialistically outfit her way in. Her interest in fine things is the only reason for her interest in money, because "money as money was still not very important to Helga" (54). However, she is hopeful of its ability to change her life when her Uncle Peter sends her $5000: "Helga Crane's first feeling was one of unreality. This changed almost immediately into one of relief, of liberation. It was stronger than the mere security from present financial worry which the check promised" (54). Eventually her pervasive "elegant consumerism" fails to satisfy her emotional needs (Monda 30), and she realizes that family attachment can be as confining as jail. Her clothes protect her as much as her relatives do—not at all.

It is at this juncture, the problem of family and protection, that we first observe a disruption between Larsen's goals and the different ones espoused by Anna Julia Cooper. In 1886, Cooper pled for the protection of Black girls in the South: "the colored girls of the South:—that large, bright promising fatally beautiful class that stands shivering like a delicate plantlet,...save them, shield, train, develop, teach, inspire them" (560). While there is a need to protect Black people, in both the postbellum South and North, and particularly Black women,[8] the insistence on protection begins to outweigh all other needs. Protection becomes possessive and suggests that survival for Black women is tied to a crippling state of dependency. This dependency primarily means marriage—to anybody. Marita Bonner's work is often able to reveal the subtle realities that govern the lives of women living and working during the Harlem Renaissance. Overall her work suggests that the prospect of marriage for Black women is dismal; "Bonner's fiction presents very few successful marriages, very few hardworking husbands" (Musser 78). Larsen expands upon this, as in *Quicksand* marriage exists only as a perilous option for Helga, demonstrated by the novel's dismal conclusion. Each marriage proposal is paired in turn with: the confining ideology of the Uplift world, a permanent position as an exotic Other, and unchecked procreation. None of these proposals is a viable option because none had the potential to lead to a path of self-actualization. Larsen identifies the concept of family and the protection it espouses—particularly through the advocacy of marriage—as problematic in the construction of a Black woman's self- identity and to establishing purpose in her life. When Helga is presented with the prospect of marriage in a distant land, she realizes the trap her found family has set for her but like the Diva she is trying to become, Helga eventually rejects that false choice as well.

Helga's lack of familial constraint allows her a freedom that many women characters in this period are without. The distant family she does have is not Black and, therefore, should not necessarily subscribe to the values inherent in Uplift, making it more desirable to her. However, her Danish family has its own type of uplift: pure social climbing. When Helga travels to Copenhagen to live with her mother's sister and husband, Aunt Katrina and Uncle Poul, she is faced with familial expectation and obligation, perhaps for the first time in her life. Arguably, thus far her lack of family ties has freed her, if not to find herself, then certainly to begin the search. Unlike her former fiancé, James, she has no one to whom she must answer. The Black part of her interracial family ceased to exist years ago and the white American part shunned and ostracized her. It is only when she reconnects with her European family that she feels the tug of familial expectation. Again this reinforces the notion that familial love is an overbearing institution that hampers young unmarried women.

Aunt Katrina and Uncle Poul immediately doll Helga up and put her on the marriage market. At once, she attracts the attention of Axel Olsen, a wealthy, aristocratic artist. Her aunt and uncle are pleased with what their ministrations have wrought. They push for the marriage despite Axel's almost curious distaste for Helga: "Her origin a little repelled him, and that, prompted by some impulse of racial antagonism" (Larsen 86). She is a mere curiosity; something to be possessed, but certainly not a person to be considered or, perhaps more accurately, not someone to marry. "The women too were kind, feeling no jealousy. To them this girl…was not to be reckoned seriously in their scheme of things. True, she was attractive, unusual, in an exotic, almost savage way, but she was not one of them. She didn't count" (70). When Axel finally offers Helga what everyone thus far considers the brass ring, marriage, she flatly refuses him, to the dismay and surprise of not only Axel, but also her family. They want this match as much for themselves as for Helga; it would be an opportunity for upward mobility, as well as a sign of their good matchmaking skills. "They…hoped that she would bring down Olsen, and so secure the link between the merely fashionable set to which they belonged and the artistic one after which they hankered" (90). Helga's relatives play upon their niece's exotic looks to secure and raise their status, with little thought as to what a life among a people so disdainful of her difference, and with a suitor so repulsed by her race, would mean to Helga.

Helga may not willingly acknowledge her relatives' plan to enmesh her hopes with their desires; she does, however, realize that following their advice will squelch her growing sense of self. They claim that they seek what is best

for Helga, but they very much take into account their own position in light of their niece's arrival. She recognizes that while family and marriage could provide the financial stability that equates to personal safety, the emotional cost is just too high, as Helga herself acknowledges. By refusing Olsen's hand, she disappoints all those around her, clearly faltering according to expected gendered codes of conduct. She tries to explain herself to Axel when she refuses him: "'You see I couldn't marry a white man…you might come to be ashamed of me, to hate me, to hate all dark people. My mother did that'" (88). It is in this type of refusal, one built on knowledge of past experience, that we see the expression of Helga's Diva desire. Her willingness to reject that which will not allow her to live the life she imagines is indicative of self-actualization. It is both the rejection of family and the desire to move away from this confined space that defines the Diva. However, without family or marriage, Helga is more susceptible to the quicksand beneath her feet. She shifts away from expectation and attempts to flesh out her own desires. That she ultimately does not go on to survive is not a reflection on her, but rather on the larger community, which does not grant her the space to unhitch herself from the ideals of Uplift and true womanhood.

The Denmark Nella Larsen writes about does not exist. In the time period she writes of, there *are* other Blacks living there, but as servants. More significantly, the specific geographic community in which Larsen locates the Dahls is solidly middle class.[9] Situating Helga's relatives thusly suggests a vacuousness of white European society. Larsen reconstructs a Denmark that, in many ways, puts Helga in an all-white community that has goals and expectations like those in both Harlem and Naxos that are similar to those to which she quickly soured. The Dahls expend significant capital to outfit Helga in clothes that can help them ascend Danish society. They are less solidly footed than described, essentially aligning their aspirations for societal recognition with that of Harlem's Black elite. Anne Grey [10] and Helga, for that matter, spend significant portions of their income trying to convince not only themselves, but all those around them, that they have a right to a place within respected society. This is particularly true of Helga, as she does not have the appropriate Black family connections that could protect her from the callousness of the Black Harlem elite. If the supposedly more cultured and cosmopolitan white European citizens in her own family are still struggling to make it, does the idea of the Black urban sophisticate vanish? With this Black-white comparison, Larsen subtly reveals the similarities between European and Black elite cosmopolitan communities. This critique takes aim at Locke's essentialist elitism

that suggested: "there was nothing wrong with American society that interra-
cial elitism could not cure" (Lewis 115). Just as Locke was both master and pup-
pet, so too were the Dahls, as presented in *Quicksand*. To Helga, initially, they
seem free to do whatever they want, including take in a sister's possibly illegit-
imate American mulatta child, but it quickly becomes evident that they are
attempting to use her as much as she is using them. Here Larsen highlights the
inherent difficulties of accepting white generosity. It comes at a great cost, yet
members of the Harlem literati continually allowed themselves to be ensnared
by the fantasy of other people's money. "[Locke's] stratagem was to use Mason's
money to prove how alike well-bred, intelligent whites and well-bred, intelli-
gent Afro-Americans were" (Lewis 54). Helga's refusal to marry Olsen reveals
how quickly the mask of generosity drops. Uncle Poul thinks: "charming, yes.
But insufficiently civilized. Impulsive. Imprudent. Selfish" (Larsen 91). As
Larsen reveals in this moment, white patronage does little to change long-held
racist beliefs.

Exploring this unexpected dichotomy displays Larsen's ability to write out-
side common narrative arcs of Harlem Renaissance texts while maintaining a
level of respectability in her characters. Her novellas were well respected by the
likes of Du Bois, which made Larsen appear to be a model of feminine virtue.
By most accounts, including David Levering Lewis's in *When Harlem Was in
Vogue*, Larsen was an avid social climber whose greatest desire was to become
a Black society wife and host charity balls. She attained this goal, briefly, when
she married the well-appointed Elmer Imes, a Black physicist with solid
Talented Tenth background and connections. Her writing, which began largely
after that marriage, is peppered with scenes of the very fashionable doing the
appropriately charitable. But in Helga Crane there is so much more than her
author's aspirations. She is a character whose restlessness highlights not just the
vacuousness of the Talented Tenth elite but also functions as a reckoning of the
white society that bred their contempt. Nella Larsen is not merely critiquing
one tiny subset of Black culture but is, like Richard Wright, who years later
wrote *Native Son*, calling on America to look at what it has wrought. The sim-
ilarities she exposes between white and Black middle-class aspirations serve as
the very basis of Larsen's most revolutionary idea: *Quicksand* as an indictment
of America itself.

Quicksand is written not just as a woman's personal narrative, or as a state-
ment about the vacuousness of the Harlem Renaissance elite; it is also written,
ultimately, against assimilation, against manifest destiny, against America.
Helga is a woman with an immigrant past who has been thoroughly assimilated

into the ways of dominant American culture: she dresses the *right way*, she wants the *right things*, she is well educated, she moves in the best circles, and she even has European connections, and yet the best she can expect from life is to be the wife of a European socialite, trapped in the sphere of the exotic Other. Her other options seem even worse. Larsen sends Helga to the American South to become wife to a sexually motivated down-home Southern preacher, whose unending lust ties her to a trajectory of perpetual childbed, leading to her presumed death. With "this abrupt unliberating ending, Larsen refuses…to endorse the dream of transatlantic freedom" (Doyle 555). Again, it is the comparison and alignment of these two situations that reveals an indictment of the dominant white American culture that informs many of the Harlem Renaissance's middle-class pretensions. The options for Helga all look pretty grim, and yet the American dream stipulates that they should not. She has done what America asks of all its citizens: educated herself and assumed appropriate cultural tastes. She has assimilated, and yet, as a Black-identified woman of a multiethnic subject position, there is no place for Helga to go. At the end of the novel, when she attempts to plot her final getaway, we are reminded of Bonner's comment about Black women and their long wait. Helga asks herself:

> How, then, was she to escape from the oppression, the degradation, that her life had become? It was so difficult. It was terribly difficult. It was almost hopeless. So for a while—for the immediate present, she told her—she put aside the making of any plan for her going…It was so hard to think out a feasible way of retrieving all those agreeable, desired things…Later. (Larsen 135)

It seems here that Helga is giving up and, in doing so, Larsen is marking the failure of America—both Black and white—to support the lives of Black women. Laura Doyle, seemingly in tune with some of the larger questions Larsen may have had as a result of her work at the 135th Street Library in New York, suggests as much by stating: "Transnational movement no more than national membership gains [Helga her] desires or freedoms" (Doyle 555). Neither the North nor the South, nor even continental Europe, can map a way to freedom for Helga. Realizing that no help will come, she attempts to free herself of her prejudices and sheds herself of her sexual conservatism. She admires Audrey Henny's [11] bold behavior (60) and strikes off to find her own happiness, to devastating ends.

Helga is often read as a classic tragic mulatta figure but, as discussed earlier, it is not just her inability to fit into one race or another that leaves her outside communal discourse. Her life is increasingly dictated by her carnal desires;

it is yet another reason for her constant movement. Cheryl Wall suggests that Larsen merely writes her in the trope of the tragic mulatta because that is the only narrative strategy available to her, and that Helga is not tragic at all ("Passing for What?" 97). Hosteler, too, argues that "Helga's constant shifting from one place to the next emphasizes the narrowness of place defined by race in the United States of the 1920s" (38). These ideas ring true, but must be expanded upon. It is the combination of race and gender limitations that leads to Helga's final demise. We observe this when she tries to force Dr. Anderson to fit the unfulfilled place in her life. Helga is initially attracted to Dr. Anderson and yet is unable to plainly articulate this, but her constant discomfort in his presence reveals it. There is a range of emotions in a single instant, which hint at her reluctance to explore her sexual desires: "there dropped from her that vague feeling of yearning...which his presence evoked. She felt a sharp stinging sensation...she searched for a biting remark...[and] bade him an impatient good-night and ran quickly up the steps" (Larsen 51). Helga has these conflicting emotions because she knows that the only sanctioned place where her desires can be expressed is in marriage. Already she has rejected two suitors, James Vayle and Axel Olsen, because she finds the obviousness of their sexual desire for her distasteful. Now, back from Denmark, she has realized the effect she has on men, and dares to hope for a better match than what she has thus far been offered. Earlier in the story, she indicates that she will not make an acceptable mate for Dr. Anderson when she departs Naxos while offering damning statements about her questionable pedigree: "the joke is on you, Dr. Anderson. My father was a gambler who deserted my mother, a white immigrant....I don't belong here" (21). Gambling by others has left Helga without family and with few friends, so initially, despite her desire, she is unwilling to take a gamble on Anderson. She is aware of other obstacles—her engagement to James, another teacher at Naxos—but, more significantly, Larsen continues to expose the ways that family ties act as a point of consternation in this Black woman's life. A man in his position, an accepted member of the elite Talented Tenth, would surely have family connections who would not accept a woman like Helga into their midst. When she meets up with him again in Harlem, the sexual tension is still there, but she dismisses it again; Anne does not. So when Helga flees from Copenhagen to return to Harlem for Anne's wedding to Dr. Anderson, Anne quickly accepts her friend's offer to stay elsewhere; Helga "had been a little surprised and a great deal hurt that Anne had consented so readily to her going" (94). She may be in denial about her charms, but Anne is clearly not.

Interactions with Anderson add another texture to Helga's desires. The longing glances between the two become longer, despite his marriage, and eventually there is the kiss, which leads to an invitation for a private meeting. Anderson initiates it, saying, "I want very much to see you, Helga. Alone" (106). Helga misinterprets this rendezvous as her opportunity to indulge her sexual desires—desires that she has kept bottled. While waiting for Dr. Anderson, she allows herself to free her imagination and the desires that reside therein as she has never done before. "That night riotous and colorful dreams invaded Helga Crane's prim hotel bed. She woke up in the morning weary and a bit shocked at the uncontrolled fancies which had visited her....She lived over those brief seconds, thinking not so much of the man whose arms had held her as of the ecstasy which had flooded over her" (105). Her own sexual desires have been suppressed for so long that finally she will let nothing—not communal outrage at her impending actions, not familial obligations, not friendship, not even her lack of standing in life—keep her from fulfilling her desire. This, however, turns out to be pure wishful thinking on her part. She is shut down because while she is willing to throw caution to the wind, her hoped-for partner is not. Anderson has too long been a part of the Black elite world and he has too much to lose: "he was not the sort of man who would for any reason give up one particle of his own good opinion of himself" (108). She is left angry and sexually frustrated: "a sort of madness had swept over her...she suddenly savagely slapped Robert Anderson with all her might" (107–8). When Helga finally acknowledges and attempts to act on her sexual desires for him, "she is 'slapped' by his cool apology [because] he holds out to Helga...a false promise based on a false premise, for Anderson separates subjectivity from sexuality and responds to Helga according to the cultural stereotype of women as object of desire" (Hosteler 43). It is this resulting frustration that leads her to the final, disastrous choice of Reverend Pleasant Green. Scrambling to right herself, she shifts again in an attempt to escape the quicksand dragging her under. Her geographical movement becomes linked with an identity that is tied not just to her ethnicity, but to her sexuality as well.

Helga is tired of trying to fit in and in the end is looking for a place that will be accepting of her intersecting identities. Only once she is able to recreate Authentic Blackness to fit her own definition, including gender and sexuality, is she able to come to terms with who she is versus who others want her to be. In Copenhagen, Helga frees herself, if only temporarily, from the everyday stresses of Uplift living. At first, she is ashamed of the display her relatives make of her. "She was dubious, too, and not a little resentful...she had...no

mind to be bedecked in flaunting flashy things" (Larsen 69). They were creating a savage image to which others could cling. "Helga felt like a veritable savage…[and] this feeling was intensified by the many pedestrians who stopped to stare at the queer dark creature" (69).

However, there are some positive outcomes to being thus bedecked. As a result of her costumes, Helga becomes much more aware of her sexual power. J. Martin Favor argues conversely that what other critics claim is sexual repression is, rather, sexual restraint. He insists that Helga is aware of her sexual power, and simply knows that it is generally not in her best interest to use it (97). This reading is problematic. At a time not too distant, Helga is better positioned to have a relationship with Dr. Anderson, but she never explores that opportunity. Why does she not indulge in a relationship with Dr. Anderson when he is free, interested, and in Harlem, away from the dreaded Naxos? Hosteler suggests that she is "terrified of her strong sexual attraction to Robert Anderson" (40), but never discusses why it is she might feel that way. The fact that Helga does not take Anderson when he is there for the having more strongly suggests repression than anything else. Cheryl Wall argues that Helga is always aware of sexuality and, furthermore, that she "mistakenly assumes it is hers to wield" ("Passing for What?" 99). However, Helga rarely seems to be in touch with her sexuality. She is aware that there is a strange discomfort in her dealings with Anderson initially, but perhaps because she has never felt these sorts of feelings for anyone—especially not for James—she does not know how to interpret them. It seems that she is sexually illiterate, that she does not have the language necessary to express complex sexual or romantic emotions. She is only aware of the dangers of sex, of the undesirability of some sexual situations; ultimately she simply does not want to end up like her mother. When she is solicited for sex in Chicago (Larsen 34), she knows immediately what is being asked of her and, without thought, makes the decision not to fulfill those requests. Perhaps she keeps running away from Anderson because her only picture of sexuality is from the prostitutes who sell themselves on the street. Her mother's seeming indiscretion, her mother's murky marital relation to her Black father in a period of far-reaching anti-miscegenation laws, and his subsequent abandonment are so much a part of Helga's daily reality that she cannot permit herself to be used in the same way. For Helga, sex leads to situational suicide. To her, sexual relationships are dangerous: When the tryst ends, in her experience, the woman is left in a weaker position—pregnant and without support. Helga's true and often unrevealed lineage is precarious by its nature, and therefore she will not take similar risks herself. One of Helga's desires is to be

a part of an accepting sphere and there is an understanding that her sexual awareness will not fit into any of them. This is repression, not restraint. As a Diva she fights to overcome this but as the conclusion of *Quicksand* reveals, she is not successful.

Helga's new status as a Dane urges her to embrace her previously repressed sexuality in Naxos, Chicago and in Harlem. Hosteler acknowledges this dramatic change but fails to cite a reason for it. In Harlem, before Copenhagen, she refuses to wear certain dresses because they are too revealing. In Copenhagen, she is initially ashamed of the bright, form-fitting clothes she is forced to wear. Helga becomes aware of herself as a sexual being while in Copenhagen, and that which she is clearly ashamed of while there—as evidenced by her discussion of the portrait (Larsen 89)—becomes a delight upon her return to the United States. She comes to enjoy the ill-gotten attention in Copenhagen, which is brought about, in part, because she is Black in a largely white world. For the first time, she is also made to look her best, although against her will. There is no longer any concern for the sense of impropriety that a bright or low-cut dress might cause in America. Uplift living, however, does not support female sexuality in any form, except, as Favor points out, as a breeder of Uplift babies (101). But in Copenhagen, Helga is encouraged to find her way, to attract suitors by whatever means available—if those talents lie in her physical appearance, so be it. For the first time, Helga does not have to think of herself as just a raced being but, instead, as a woman possessing a desirable body. It is this untempered revelation that makes her not just seductive, but also able to consider the potential of seduction. Helga enjoys her newfound power as a sexual being. She has always kept this part of herself repressed because she is afraid that the sexual deviance in her blood, put there by her mother's painful indiscretions, will lead to her own sad fate if she is not careful.

Helga's willingness to express her new sexual awareness, however, marks her as unfit for the New Negro world. Thus, according to Favor, she is forced to join "religious folk world" (108). Wandering the streets of Harlem serves as a metaphoric microcosm that mirrors her intercontinental travels. As she travels, she finds out more about herself and, in despair after Anderson's rejection, she hits the streets, hoping she will be able to find fulfillment. The thunderous rainstorm reflects Helga's inner turmoil. Without hope, she both physically and metaphorically attempts to get inside out of the rain. Inside the church, she laughs at the women's religious exhortations as they participate in the religious revival, but it is here that she identifies another way to express her sexuality—in Christian fervor. She is so excited by this discovery that she marries

the preacher who she feels is responsible for revealing this to her, Reverand Pleasant Green. In this moment, she invalidates any real claim to authoring her own sense of a developing sexuality. "In the evangelical arms of the Reverend Pleasant Green she experiences the oblivion of sanctioned sexual pleasure" (Hostetler 39) and "even as Helga's marriage to Pleasant Green substitutes for sexual fulfillment, her pregnancy substitutes for self-knowledge" (Hostetler 44). Having sex with Green releases her pent-up sexual desires, but having children obscures her path to complete self-enlightenment.

Helga's initial pleasure with the South is tied directly to her ability to express sexual desire without trepidation that her mother's past will become her own present. However, she claims gratefulness because Green has provided her with the ability to be "mistress in one's own home, to have a garden, chickens and a pig; to have a husband—and to be 'right with God'" (Larsen 120). These were all things she had previously rejected. She had had other, better opportunities to be a wife: she had had proposals from Vayle and Olsen and, arguably, could have had one from Anderson, as well. Helga has never articulated a religious penchant, and religion does not figure into the text until the night of the storm. Her new spiritual awakening is thus tied directly to her ability to have sanctioned sex, to express her sexuality in a way that is not only, in the Christian sense, pleasing before God, but pleasing to herself; she imagines that she is free from the specter of her mother. She has not given in to any sexual affair previously, including Olsen's "admirably draped suggestion" (84), and for whatever sexual thoughts she had before, her marriage is a sign of repentance. Shame and fear have defined her interest in sex, but once she discovers an acceptable outlet, she is relieved to have escaped a desperate fate. By manipulating Green into marrying her, she proves to herself that she is not her mother and instead is a respectable and legally married woman. Her enthusiastic verbalizations of wifely pleasure serve to cloak her relief at finally having sex and imagining that she is finally safe. Above all else, it is nighttime for which Helga is most grateful: "night came at the end of every day. Emotional, palpitating, amorous, all that was living in her sprang like rank weeds at the tingling thought of night, with a vitality so strong that it devoured all shoots of reason" (122). Above all else, she enjoyed this aspect of her new role. Motherhood, however, is more than she bargained for. In the end, family still manages to confine Helga; her biology becomes the final and inescapable trap. She will soon find that she is not in the position of her abandoned, unwed mother. Her fate is far worse. Helga becomes a default tragic figure because she is sentenced to maternity.

Uplift clearly fails Helga Crane. Cheryl Wall argues that Helga "assume[s] false identities that ensure social survival but result in psychological suicide" ("Passing for What?" 98). Hosteler argues conversely that *Quicksand* marks the beginning of greater freedom for self-examination in the writing of black American women" (36). Helga, as a Harlem Renaissance proto-Diva, is attempting to define herself; she does not just reflect her surroundings (Hosteler 37) despite being unable to change them because in this instance "diva citizenship does not change the world" (Berlant 223). As *Quicksand* reveals, the construction of the Harlem Renaissance world is rigid, and one mulatta, tragic or otherwise, without family or fortune, is not going to change it. While it might seem that Helga commits "psychological suicide" (Wall, "Passing for What?" 89), we cannot measure her only by her failures, even though her search for self does not end in discovery but in "sure death" (Carby 173). In the end, it is the attempt to perform survival that defines her. Helga may assume "false identities" (Wall, "Passing for What?" 98), but there is no deceptive intention; she is not always aware that she is creating another self. She is simply searching for access to a sense of agency. While it is easy to read Helga's demise as punishment for constant dissatisfaction with life, and later for her sexual desires, it seems more likely that Larsen is subtly critiquing the mores of the world in which Helga lives. Her own complex and multivalent desires do not fail her, the world she lives in does.

In Copenhagen, Helga attempts self-actualization for the first time. She begins to discover who she is, and briefly is able to clearly identify how her ethnicity and race position her in the world. She ventures out for long, solitary walks; it is amongst foreigners that she begins to feel most comfortable with herself. On one such occasion, she is approached by an old Danish woman and questioned about her racial identity. Helga comfortably responds, "I am a Negro" (76). This moment recalls another, when Mrs. Hayes-Rore suggests that Helga keep her biracial identity a secret. Helga felt like a criminal then (42), yet in Copenhagen she openly acknowledges and embraces her Black heritage. She no longer sees her Black racial identity as being a fraud; she accepts what the world sees her as—a Black American woman—instead of the marked tragic mulatta she fears being. This growing comfort becomes enmeshed with her realization that familial obligation is undesirable, despite whatever advantage family potentially affords her. These dual realizations lead her to action: to reject Olsen. The leisure walks and the financial support that permit these realizations also come at a price she finds herself unwilling to pay. "Though she had resolved not to think that they felt that she had, as it were, 'let them down,'

Helga knew that they did" (90). Larsen suggests within this section of the novel that familial love is, at best, questionable and, at worst, completely oppressive and conniving. This well-founded distrust is echoed in the counterintuitive choices Helga makes in the remainder of the novel.

Rebounding from this most recent dismal familial experience, the others having been abandonment and ostracism, Helga makes her most questionable decisions in the entire text. She indulges her growing interest in Dr. Anderson, to the point where she fantasizes that they will have a torrid, passionate affair, despite the doctor's recent engagement and subsequent marriage to Anne, her closest—and only—friend. He ultimately rejects her and, reeling from this rejection, she marries a Southern preacher and nearly dies on an eternal childbed. This, Larsen insists, is the result of family interference. Before reconnecting with her family, Helga had made a life for herself. She even says that "some day she intended to marry one of those alluring brown or yellow men who danced attendance on her...any one of them could give to her the things which she had now come to desire, a home like Anne's , cars...clothes and furs...servants, and leisure" (45). She had a job lucrative enough to keep her in the fashion of her choosing, and she planned to marry some young professional in Harlem. True, the rhetoric of the Harlem Renaissance world in which she lived felt stagnant, and she might not have made a family for herself, but the idea of a self-made family gave her some new place to tread water. For a time "Harlem was enough" (45). In the end, she did not marry then because her Danish family seemed to promise more. This promise led her to have what Uplift living dictates as unrealistic expectations of the world. It proves to be a trap to stop thinking for herself and planning for her future, and her life changes for the worse. The Dahl's plan for her life was far worse than what she originally planned for herself—a nice husband, clever friends, and material possessions—certainly limited but definitely better than becoming a permanent exotic Other and wife to a disdainful Danish aristocrat . Copenhagen gave her hope of a non-useful sort and, in the wake of this failure, she makes choices that lead to her virtual death.

Helga Crane is written against the backdrop of Josephine Baker in Paris. Terri Francis argues that *Quicksand*, like a number of novels that come out of the Harlem Renaissance during Baker's heyday, is written as a critique of the exoticism expressed in Baker's explicit sexuality. This seems limited and fails to recognize the complexity of Helga's desires. If there is a parallel to be drawn between Baker and Helga Crane, it is the rhetorical question at the root of the text: Why can't she embody multiple spheres in spite of the liminal spaces in

which she must operate? Being a Diva means just this: refusing to choose because she knows she should not have to. Her desires make up much of who she is and thus should not be separated simply for mass consumption. It seems that Larsen is arguing through Helga for the breakdown of socially enforced sociopolitical dichotomies. She goes beyond "index[ing] the problematics of transatlantic black popular culture, formed in the cross-currents of European Primitivism and the Harlem Renaissance" (Francis 84). We imagine Helga as having a significant cosmopolitan viewpoint but realize, through her virtual death, that for Black women there is no "'post-cultural' space where the subjects and objects of description are at least potentially reversible, where the mobility required for observations and comparison is not monopolized by one side" (Robbins 181). During the Harlem Renaissance there is an inability to access a transnational space for Black women. Stuck within an American paradigm there are few spaces Helga can inhabit. *Quicksand* is not meant to be a story about a trite, easily dissatisfied woman, but rather a social commentary on the world around her. Ultimately, it is a feminist text that suggests that the only thing a Diva can have during the Harlem Renaissance is her desire for something more. Helga is struggling for agency, but there is little to be attained. Her education, European connections, popular friends, and new wealth all suggest to her that she should have access to an agency that lies ever beyond her reach.

· 2 ·

SEARCHING FOR THE DIVA IN
THEIR EYES WERE WATCHING GOD

Janie Crawford, *Their Eyes Were Watching God*, and Zora Neale Hurston have captured the imagination of generations of Black scholars before and after Alice Walker's rediscovery of them in 1975. As Hortense Spillers writes, "talking about Zora Neale Hurston is like approaching the Sphinx—so much riddle, so many faces, and all of it occurring on rather high holy ground" (94). Readers have reveled in stories and rumors of Hurston's audaciousness; unlike Nella Larsen, she worked hard to appear disinterested in the Harlem literati. Her disinterest was almost even true; she did not want just to be a part of that Harlem literary elite—she was much more interested in remaking it in her image. She did not wear those big hats and make sure she was always in the right place for nothing. Rather than recount the scintillating half-truths that make her a character of our own imaginings, let us make a "difficult generalization" (Robbins 174–5): Hurston was a complicated figure who wrote books in which readers want to cast themselves and their neighbors. This sense of personal ownership has led to some of the more problematic renderings of *Their Eyes Were Watching God.* Briefly, let us turn to *Oprah Winfrey Presents "Their Eyes Were Watching God,"* a made-for-television film, which debuted on March 6, 2005, on the ABC network.

Winfrey's adaptation infinitely reduces the complexity of the novel and its protagonist by presenting the audience with what amounts to an over-determined love story. In the film's highly dramatized introduction, Winfrey claims, "I fell in love with this story. It was one of the most beautiful, poignant love stories I ever read....The first time Janie and Tea Cake kiss reinvents the whole idea and notion of kissing. I would have to say, if you can get a kiss like that, you can die a happy woman"(*Oprah Winfrey Presents "Their Eyes Were Watching God"*). Her introduction is both unnecessary and misleading. While she does manage to fit in aspects of generally accepted textual understandings of the novel, accuracy plays second position to embellishment. The love story between Janie and Tea Cake is privileged, the kiss she speaks of—which most would have to scour the text to find—is overemphasized. The film that follows has alterations and omissions that are all in service of highlighting a great love between Janie and Tea Cake. While their relationship is certainly a significant narrative strand in the novel, *Their Eyes Were Watching God* is not just a story about Janie and Tea Cake. It is a story about Janie coming to love herself in spite of the men she chooses to love. Despite the broad desire to romance the text evidenced in Ms. Winfrey's production, this chapter will avoid such inclinations. Instead, Janie Crawford's narrative will be examined for the Diva desires that have inspired a number of revisions by men and women throughout the twentieth century.

Their Eyes Were Watching God is a testimony to the boundaries of the Harlem Renaissance world, as "Hurston…was not particularly encouraged by the politics of her age" (Spillers 94). Hurston claims for her heroine, Janie, a literary landscape where womanhood is prominently featured and valued. Janie learns from her experiences and identifies the failures of her community, thereby allowing herself to realize that her freedom feeling is just fine (Hurston 90). While not always successful, Janie Crawford is an early example of the Diva figure because of her refusal to submit to protection, her desire to know more about herself and the world she lives in, her willingness to flout cultural expectations of Black womanhood, and an expressed interest in her developing sexuality. Hurston's pivotal model lays the foundation upon which future Divas come into existence, and it begins in one of the most classically Southern Black places of community.

The porch in *Their Eyes Were Watching God* serves as a potent symbol of the unforgiving boundaries of the Harlem Renaissance world because it is a physical structure that psychologically binds all those sitting on it. On the porch, there are indicators that delineate the limits of freedom that become the

liminal space whereupon a Black woman's life is often determined. Janie Crawford learns a lot on the porch and when she shows signs of going past its limits, she reverts back to the boundaries that it represents; it is difficult to transcend the porch. It also serves as a metaphor for Alain Locke's "New Negro" ideology. Locke argues that Blacks should no longer imagine themselves as social pariahs, but his message is rife with a palimpsest of other meanings. Elite New Negro writers served as a group of purveyors—looking, deciding, and finally limiting the offerings of one another. The porch reveals just such a place as Janie walks into town, downtrodden from burying her lover and accused of his death.

> It was the time for sitting on porches beside the road. It was the time to hear things and talk. These sitters had been tongueless, earless, eyeless conveniences all day long. Mules and other brutes had occupied their skins. But now, the sun and the bossman were gone, so the skins felt powerful and human. They became lords of sounds and lesser things. They passed nations through their mouths. They sat in judgment. (Hurston 1)

The porch is a living, breathing organism that will fight to keep from being ignored; it operates as a Black American equivalent of the Greek chorus. In an attempt to free Black writers from perceived literary limitations of a European literary tradition, the porch chorus reinforced greater ones asking that those New Negroes write in a way that would uplift the race. This meant that more subjects became taboo than what even conservative presses were willing to print. Good art was determined to be propagandist in nature; only specifically sanitized images of Black life were to be portrayed.[1] Uplift of the race was paramount, and thus stories about women and relationships, among other things, had to be constructed in ways that obscured both meaning and female enlightenment. As we find Janie sitting on her porch at both the novel's beginning and end, we understand how difficult it is, despite the desire to do so, to write oneself off the porch. While Janie is incapable of collapsing the support beams, she is able to stretch those boundaries so they temporarily fit the life she wants to live. Hurston writes Janie as the embodiment of escape, but the narrow confines of New Negro ideology sometimes restrict even Janie's ebullient Diva desires.

As an opening salvo, Hurston attacks the value of family and cites it as a hindrance to Janie's potential development. Despite being a problematic feature here, the family is prominently featured in many Harlem Renaissance texts, with the nuclear family serving as a frequent narrative element. Hurston critiques this type of family structure, digging into the very concept of what good

family means. Janie is raised in a single-parent household by her grandmother who, through her own experience with white male rape, is able to understand her daughter Leafy's refusal to mother Janie, also a mulatta child of rape; here we are able to observe the intersection of miscegenation and sexual violence. In spite of this, Janie is materially well cared for, living in a proper house with more than enough to eat. She has playmates, a strong sense of herself, and a maternal figure who appears to care for her deeply. Is not this the essence of good family life? And yet, despite the many positive aspects of this familial construction, Hurston simultaneously marks family as ultimately confining and destructive to Black women's identity development. It is Nanny's maternal pressure that demands Janie's first poor marriage and provides questionable instruction on choosing future mates. Love is presented by Nanny to be a thick molasses, not a fluid commune—not at all like the equal partnership Janie imagines while lying under the pear tree. The first love Janie experiences, Nanny's maternal love, sentences her to a loveless marriage by establishing a connection between love and protection. Janie, as a result, takes a long time to undo the link between these two concepts. It is indicative of both the era in which the book is published and its pre–Harlem Renaissance setting that her grandmother, a financially secure woman without a spouse, tries to lasso such a traditional notion to Janie's body. Nanny here performs the role of an authoritative patriarchal figure by attempting to curb Janie's desires. She marries Janie off to the detached, older, and financially secure Logan Killicks; his name alone reveals that, with him, dreams will be killed.

Janie's grandmother, unable to imagine a world where Janie might be self-sufficient with or without a husband, is key to the desecration of Janie's dreams. Many years later, after two stifling marriages, Janie will forget whatever love Nanny attempted to express for her: "Nanny had taken the biggest thing God ever made, the horizon…and pinched it in to such a little bit of a thing that she could tie it about her granddaughter's neck tight enough to choke her. She hated the old woman who had twisted her so in the name of love" (89). Her grandmother defends her position arguing, "tain't Logan Killicks Ah wants you to have, baby, it's protection" (15). Nanny posits as well that "yo' Nanny wouldn't harm a hair uh yo head" (14), but Nanny does just that by forcing Janie into a dismal marriage where she literally is bound to become "de mule uh de world" (14). Janie's Diva desire, therefore, begins in the most likely of places—with the maternal figure. As Janie grows older she recognizes the danger of the mother figure and Hurston rather pointedly excludes motherhood from Janie's life. Motherhood and motherlove are thus condemned and are

therefore, no longer available as potentially useful aspects toward a journey of self-actualization.

Janie struggles not just against motherhood, but also against something larger than herself, despite her inability to name it; her unspoken nemesis is tied to historical constraints on Black women's sexuality as defined by the cult of true womanhood. Unable to articulate her desires, Janie experiences them sitting while beneath the pear tree, watching reproductive mating while seeming to pleasure herself. "She saw a dust-bearing bee sink into the sanctum of a bloom; the thousand sister-calyxes arch to meet the love embrace and the ecstatic shiver of the tree from root to tiniest branch creaming in every blossom and frothing with delight.... Then Janie felt a pain remorseless sweet that left her limp and languid" (11). While the sexual connotations of this scene are clear, by focusing in on the "dust-bearing bee sink[ing]" and the "thousand sister-calyxes arch[ing]," we see Hurston utilizing natural imagery to suggest equal partnership as an idealized vision of love and marriage—"so this is marriage!" (11). Janie does not just want to be married for its own sake, or to be trapped in a traditional marriage. Instead, she witnesses nature and recognizes that it is telling her something far different from Nanny's restrictive expectations. Unfortunately, Nanny is unable to envision or imagine the type of relationship that Janie desires, in part because she has not had the luxury of leisure—the ability to one day simply lie under the pear tree and see what is there to be seen. "She didn't have time tuh think whut tuh do after you got up on de stool uh do nothin'" (114). What is being witnessed here is rather ordinary—it is a generational gap that has enormous implications. Nanny did not have the experience of leisure time during which to consider that there might be something more to desire. She thinks of Leafy, her rape, the resulting birth of Janie, and the waywardness of her daughter, and thinks that protection is the only way to see Janie clear of her mother's fate. But Janie refuses this prescription by wanting more; she thus sees beyond the possibility of a spiritual or moral downfall. Her desires are bigger than the place in which she finds herself and throughout her life Janie has varying degrees of success in freeing herself to pursue them. Nanny will prove to be the first stumbling block over which Janie ultimately succeeds.

The carnal desires Janie expresses to a certain extent characterize and determine the trajectory of her life. For example, Janie marries, but indulges the flesh first with Tea Cake because she wants a relationship in which her own pleasure is satisfied, rather than live her life as a communally sanctioned wife to make and/or uplift the race. It is an interest and desire in sex that yet again

sets this late–Harlem Renaissance early Diva apart from her literary counter-parts. For example, Angelina Weld Grimké, in *Rachel* (1920), represents her woman protagonist as chaste and disinterested in sex, and Jessie Fauset, in *Plum Bun* (1929), shows her protagonist as interested in sex only for its potential to ameliorate her social status. In addition, Hurston leaves Janie childless, thereby rewriting the gendered narrative of Black women's biological destinies. Sexual desire here is divorced from reproduction and this rift allows for the opportu-nity to achieve longed-for self-actualization. By leaving her childless and yet unlikely infertile, Hurston makes the powerful suggestion that in order to per-form survival, a woman must be without children, or even an expressed desire for them. This assertion harkens back to the success stories of Black men's slave narratives. The early canon of African American literature, particularly slave narratives, makes evident that physical and emotional escape are considerably more difficult with children. In fact, 70 percent of runaway slaves, for whom runaway ads were created, were single men in their teens and twenties (Horton). An obvious pairing of Harriet Jacobs's *Incidents in the Life of a Slave Girl* and Frederick Douglass's *Narrative of the Life of Frederick Douglass, an American Slave* reveals just that. These texts make clear that the desire for and constraints around escape are different for Black women and Black men. Douglass's narrative ties his independent mind, desire for knowledge, and com-ing into manhood to his need for freedom; his family—wife and children—do not figure into his narrative and the audience could infer that he does not have one. When he decides to escape, he only considers his own personal safety. This is not an option for women slaves; the expectations of motherhood bind them to the welfare of their children and they are thus often unwilling to leave with-out them. Take, for example, Harriet Jacobs's method of escape: When finally she decides she must run, her escape is derailed by her reluctance to leave her children and she therefore encases herself in a garret for seven years. She leaves only when the threat to both her life and the lives of her children out-weighs making an attempt at escape. This type of tethering is broken in the Diva figure; first with magical infertility as in *Their Eyes Were Watching God*, later by stated desire in *Sula*, and finally by exercising medical choices in *Liliane: Resurrection of the Daughter*. Hurston's magical infertility undoes the trouble of Black women's biological destiny and thus removes the presence and value imbued in maternal instinct; the novel blatantly implies that survival for Black women must be devoid of maternal longings, as they obscure both escape and self-discovery. Instead Janie's journey, in large part, is marked by her car-nal passions and not the lives of potential children.

Unable to articulate her own desires, Janie uses the symbolic mating seen under the pear tree as the example by which she measures what she wants her life to look like and what she does not want her life to look like. One of her first disappointments in the evaporation of the "dust-bearing bee sink[ing] into the sanctum of [her] bloom" (11) occurs when Logan stops playing with her hair, easily read as an abrupt cessation of Janie and Logan's sexual relationship. Janie seeks advice from Nanny in the only way she knows how—through references to her pear tree dream: "Ah wants things sweet wid mah marriage lak when you sit under a pear tree and think" (24). Nanny's immediate negative response can be read as an unwillingness to acknowledge sexual desire, but more likely it is an attempt to refocus Janie on the more appropriate politics of marriage: financial stability and personal protection. So worried is Nanny that Janie will demand more than is possible from this union that she spends hours praying to God to redirect Janie's passions: "Lawd, you know mah heart. Ah done de best Ah could do. De rest is left to you" (11). Nanny's prayer here suggests Anna Julia Cooper's arguments for the protection of young Black girls (560). However, this prayer in the end is not answered. With what little experience she has—kissing Johnny Taylor at the gate, the portrait of love the pear tree represents for her, and a growing sense that protection is equal to suffocation—Janie demands the right to have a healthy sexual relationship with her spouse; this is what a Diva looks like when she is acting on behalf of her desires. "From Janie's perspective 'protection' signifies a prophylactic that prevents life—her own" (Weathers 203) and this is something she is unable to accept. To constantly elude the dangers of living life is to stay trapped, and thus Janie does what she can to get out from under the weight of this *over*-protection. She leaves Logan with little consideration for cultural codes of behavior; she married him for her grandmother's sake and, with her death, has no reason to keep such a soul-crushing promise. Unfortunately, her second marriage does not prove to be much better than her first; this is indicative of a cultural stranglehold on Black women's sexuality and how the weight of family opinion can be oppressive to a developing sense of self.

For all her sense of adventure, Janie's choice of Joe becomes a more complete embodiment of Nanny's desires for her granddaughter. She pushes Logan to anger when she questions his love and commitment, and when satisfied that he cannot offer anything more than life behind a mule, "a feeling of sudden newness and change came over her [and she] hurried out of the front gate and turned south" (Hurston 32). Joe, on the other hand, buys her things, marries her like he promises, provides for her materially, but does all this without any

real emotional connection to her. For him, Janie is the final piece in the dig-nified portrait of power and respectability he wants others to believe; she is the trophy doll/wife, nothing more. All he has to offer is a traditional marriage con-tract: her physical beauty in exchange for financial support and undefined and yet overbearing protection. Their relationship more perfectly represents what Nanny wanted Janie to have with Logan. "The memory of Nanny was still pow-erful and strong" (29) but, like the Diva she is becoming, Janie weighs her choices and while "[Joe] did not represent sun-up and pollen and blooming trees…he spoke for far horizon" (29). The horizon he suggests is better than the small known world she has thus far inhabited.

If sex with Logan was lacking, sex with Joe is nonexistent—there is not a single reference to a sexual relationship between the two in the novel. From the outset Janie is looking forward to being able to spend more time together and she complains that "it jus' looks lak it keeps us in some way we ain't nat-ural wid one 'nother" (Hurston 47). Throughout their truncated courtship, he spends his time wooing her by appealing to an imagined vanity, telling her that she should be counted among a man's valuables because of her delicate beauty: "A pretty doll-baby lak you is made to sit on de front porch and rock and fan yo'self and eat p'taters dat other folks plant just special for you" (29). Calling Janie a pretty doll reveals both his desire for a mute attractive toy and his future plan to keep her on a shelf distantly admired but rarely handled. The day after their marriage, Janie observes that "Joe didn't make many speeches with rhymes to her" (34), suggesting that even in the blossom of a new relationship there is little love to be had and no carnal passions of which to speak. Eatonville becomes the site of his demonstrated passion and he spends all his time and attention creating it in his own image. Janie is left to her own devices and it is in that time that she is able to reflect on what she truly wants. When Janie attempts, unsuccessfully, to wrest from him his true love, she is left with "a feel-ing of coldness…far away from things and lonely" (46). While Joe does not think of her in an amorous way, he does not want anyone else to do so either, and like putting cellophane on a package, Janie is made to cover her hair with unattractive rags while in the shop. She finally becomes solely an object, avail-able only as a tool to further Joe's career goals, and taunting the community; collectively the men appreciate the way her physical beauty acts as a mirror, reflecting on Joe's power: "he had seen the other men figuratively wallowing in [her hair] as she went about things in the store" (55). His anger at this—"he felt like rushing forth with the meat knife and chopping off the offending hand" (55)—is therefore suggestive of their infrequent bedroom trysts. Her hair

is a potent symbol of her health and vitality, and while the physical description of her often signifies the erotic body of a tragic mulatta, it seems instead that Hurston is juxtaposing that image against Janie's own positive self-image. This suggests that it is not her biracial background that makes her a tragic figure but rather her poor marriages and bad choices. Joe is not the pear tree vision of love and despite early indications of this, Janie persists.

Fearing the potential loss of his trophy, Joe creates a world in which Janie is denied an active part, couching his love for her on a self-serving pedestal. Ultimately he is afraid that Janie will get from somewhere else what he is not making available at home, cutting her off from their marriage bed and from any other to which she might potentially be able to gain access. Joe positions her as the pinnacle of respectability, saying that "he didn't mean for nobody else's wife to rank with her. She must look on herself as the bell-cow, the other women were the gang" (41). His ambition cut off any potential for her to create a women's friend group with whom she could vent her frustrations; by design, "she couldn't get but so close to most of them in spirit" (46). Therefore Janie's only outlet becomes the liminal space in which she learns to have another part of herself, a place between Joe's expectation and her own contentment: "she mostly lived between her hat and her heels, with her emotional disturbances like shade patterns in the woods- come and gone with the sun" (76). Joe works to silence her because "he wanted her submission and he'd keep on fighting until he felt he had it" (71). The two engage in a long and sometimes silent war, which begins the day Joe stifles her speech at the street lighting and continues when he makes the deliberate and callous decision to undermine her publicly in the store just one time too many.

Janie has never wanted to be on the pedestal Nanny arranges for her, or that Joe insists she stand on and, finally, she publicly makes her own thoughts known to the entire Eatonville community that is sitting on the store's porch. When Joe reprimands an innocent mistake, saying, "A woman stay round uh store till she get old as Methusalem....Don't stand dere rollin' yo' eyes at me wid yo' rump hangin' nearly to yo' knees!" (78) in their first and only public battle, Janie attacks Joe's manhood, "cast[ing] down his empty armor before men" (79). Her submissiveness has, apparently, come to an end.

> Naw, Ah ain't no young gal no mo' but den Ah ain't no old woman neither. Ah reckon Ah looks mah age too. But Ah'm uh woman every inch of me, and Ah know it. Dat's uh whole lot mor'en you kin say. You big-bellies round here and put out a lot of brag, but 'tain't nothin' to it but yo' big voice. Humph! Talkin' bout me lookin' old! When you pull down yo' britches, you look lak de change uh life. (79)

The verbal dexterity of this direct attack on Joe's masculinity marks her growing reluctance to continue suppressing her desires, but signifies more than this; this attack also serves as explanation for her childlessness. In an age of few reliable birth control practices, "Janie's...marriages somewhat miraculously produce no children" (Hite 269). The common colloquialism of the *change of life* often refers to the onset of menopause and while there are few observable external physical changes, the implication of Janie making this comment about Joes is significant. What does it mean for a man to *look* like the change of life? It seems Janie is being more than just critical of her husband's lack of sexual vigor—after all, he is an old man compared to her. She is revealing that, like a woman's reproductive organs after menopause, Joe is impotent. His impotence and her willingness to out him because of it reveal Hurston's careful negotiation of motherhood for her most celebrated character. Motherhood obscured too many possibilities for Hurston to include it in the text and, in a moment least expected, she gives the careful observer the ability to suspend disbelief. Motherhood obscures self-actualization and, as a later Diva will suggest, it is far more important to make yourself and be free of the ties that bind. Janie attempts to do just that—to be free.

As a Diva, Janie begins to realize that, with her mouth, she can make herself just as she has made Joe. "She recognizes that Joe is only 'something in my mouth,' a kind of puppet dependent on her own willingness to create him. She seems to realize that by living a lie she participates in her own oppression; through her own 'mouth' she contributes to the construction of her oppressor" (Levecq 95). This discovery immediately changes the direction of her life because she no longer has to live a double life, to have two selves: one self trapped in the mirror while the other works in the store. By vocalizing her displeasure she buys herself the space and opportunity to be something other than what Nanny hopes for or Joe insists upon. Rather, she acknowledges her own complicity in her oppression, which is the first step in realigning her life to resemble the portrait of nature as she saw it under the pear tree. When Levecq argues "that in spite of her occasional epiphanies, Janie has made no clear plans for herself, [and] is therefore hardly a revolutionary figure" (95), it is evident that she has failed to recognize the subtleties of the scene in the store. That scene reveals that Janie has maintained an active mind, never becoming the complacent, thoughtless housewife Joe longed to create; instead, she has been "inwardly constructing new narratives—new knowledge—as her perceptions change" (McMillan 86). In rejecting Joe, she simultaneously rejects larger cultural expectations; the act itself is revolutionary and sets her apart from every

woman in Eatonville and beyond. Her candor also ruptures Joe's control, not just over her but also over the much-abused residents of Eatonville. His reaction is severe—moving out of the bedroom, giving her the silent treatment, eating without her—but is ultimately necessary for Janie to utilize the space she needs to become the person she wants. As she reflects, she uses nostalgia "as a tool of self and cultural critique, as a means of recalling important features of the past and as a way to impact the future" (McKnight 85). It takes her some time to conclude that the dream of the pear tree is not fulfilled by Joe, because she is not operating outside of time. Speaking her truth means she must strike down everything she has been taught to value, both by those who claim to love her and the communities in which she has lived; this is no small feat. Reflecting on her life, Janie considers the meaning of her past choices on her present situation and future hopes. She had reluctantly married Logan because of Nanny, and left Logan for what seemed like a closer realization of mutual love and respect with Joe. However, she soon finds that following blindly and quickly is not getting her any closer to her pear tree dream. Contrary to Levecq's mottled suggestion, the act of creating the space to think without prejudice and determine the course of her life is revolutionary, and "in Hurston's hands looking is indeed a performative act" (Clarke 611). Janie is performing her survival until she has the actual opportunity to live it. This challenge is brought to an end by her public performance.

It is in the time just before and right after Joe's death that Janie's Diva desires reassert themselves. From the day Joe "took the bloom off things" (Hurston 43) to just before his death, Janie has offered little by way of comment. After the incident in the store, she re-remembers what it feels like to be free as she was under the pear tree—to be free to think, say, and do as she wishes regardless of outcome. Janie does not apologize for her remembered way of seeing, and as Joe lies dying, she shares her mind: "you wasn't' satisfied wid me de way Ah was. Naw! Mah own mind had tuh be squeezed and crowded out tuh make room for yours in me" (86). She is not just interested in knowing herself, she also wants to speak her enlightenment to even the most resistant: "You done lived wid me for twenty years and you don't half know me atall" (86). This conversation serves as a reprimand for Joe but also for herself. Despite all, she had remained for years in an unhappy and stifling marriage, not realizing until almost too late that not only would she never be the kind of woman he and others wished to create, but also that she did not want to be that kind of woman. Unburdening herself from the social mores and expectations, she finds a way not to lose herself in others' wants. "Years ago, she had told her girl self to wait

for her in the looking glass. It had been a long time since she had remembered" (87) and she was trying to articulate an identity that more accurately defined the woman she was now. "She'd lie awake in bed asking lonesomeness some questions" (89). Confronting Joe in the store is a radical act that marks the beginning of Janie's alternative way of living; it is her announcement of the end of "true woman" expectations and ushers in a new period in her life—she has become a Diva on stage performing for an audience. "*Their Eyes Were Watching God*, then, represents a troubled search for a '*third way*,' a method for breaking out from the accommodating and replicating pattern" (Simmons 181, emphasis mine). As an early Diva, she shucks off the pressures of an expectant husband and community, tries to live her new life without compromise, and in the end demands more than just simple survival. Looking into the mirror without her head rag it becomes clear that it was initially a symbol of oppression, but as a Diva she is able to find power where it should not be. She turns her head rag into a cloak and behind it she grows stronger, out of the sight and influence of others. When an opportunity presents itself, Janie steps out in Diva fashion and handily remakes herself in the burnt-out ruins of Joe's manhood. After his symbolic castration, a slash-and-burn strategy she employs to salvage her dream, she is able to seed herself in the charred earth of his demise. Janie is able to see the waiting, hopeful, girl-self she left in the mirror long ago, and instead of ignoring her, she contemplates her mistakes and reconsiders the trajectory of her life.

Janie's new self-love is not appreciated—not by Joe, as his declining health and death reveal, nor by the town. The town that once pitied her—"de way he rears and pitches in de store sometimes when she make uh mistake is sort of ungodly" (Hurston 50)—now shows open disdain for her: "this one and that one came into her house with covered plates of broth and other sick-room dishes without taking the least notice of her as Joe's wife" (83). Though at times they seem to despise Joe and all he manages to acquire, and even sympathize with Janie for the constant abuse she suffers at his hands, the appeal of Janie being cast aside is too great. The "bell-cow" has lost her rank. They now see a place for themselves beside the great Joe: "'Mr. Starks needs *somebody* tuh sorta look out for him at the house'" (83, emphasis Hurston). They traipse through her house without civil acknowledgement. It is, in part, this disrespect that will allow Janie to fly in the face of convention when she does come across a younger, sweeter man. Their inability to empathize and the distance Joe artificially inserts between Janie and the town means that after his death she feels allegiance to only herself. What they do not notice is her complete dis-

interest in being the leader of a pack. She has worked hard to be independent of Joe, and the town, as his appendage, soon suffers a similar fate. She is a Diva and has learned to make herself with her own mouth. She enjoys her new freedom by laughing away all would-be suitors, allowing Hezekiah to manage the store, and deciding that "she liked being lonesome for a change" (89). So exuberant is she in this new space that she shares her newfound joy with a disapproving Pheoby.

> "Tain't dat Ah worries over Joe's death, Pheoby. Ah jus' loves dis freedom."
>
> "Sh-sh-sh! Don't let nobody hear you say dat, Janie. Folks will say you ain't sorry he's gone."
>
> "Let 'em say whut deh wants tuh, Pheoby. To my thinkin' mourning oughtn't tuh last no longer'n grief." (93)

Pheoby, ever mindful of cultural expectations of Black womanhood, quickly reprimands her friend, and while Janie may choose to stay silent, her momentary silence here does not equal assent.

Janie's freedom comes at a high cost, and though her present economic situation perhaps contributes to her freedom, her mental freedom is not a result of money. Discounting Janie's contributions to her own economic independence, Houston Baker in *Blues, Ideology, and Afro-American Literature* suggests that it is ultimately Joe's hard work that allows Janie to have her freedom (58). His reading, based entirely on economics, disapproves of what he calls more "romantic readings" (60), suggesting that literary critics—read: women literary critics—are unwilling to see *Their Eyes Were Watching God* for what it is. He begrudgingly allows that Janie helped build the store as a sidebar to Joe's entrepreneurial spirit, but erroneously suggests that Janie sells the store to finance her relationship with Tea Cake. Despite Baker's reading, neither Janie's bourgeois status nor Joe's money, which is her money too, is responsible for her freedom. Instead, her desire for independence has been growing alongside the store, "between her hat and her heels" (Hurston 76), but is overlooked both by Joe in his burning desire for domination and by the town in its disdainful worship of his process. Her status as a wealthy widow is not the driving force behind her willingness to explore love and sex outside strong social mores, or her willingness to leave the big white house and careful perch she was forced to endure during her marriage. The Starks' money has been one of the greatest barriers between Janie and her immediate community, and after Joe's death the interest in her economic status, as well as communal expectations, force her

to suffer through insulting offers of protection and financial management assis-
tance, all wrapped up in a discourse of Plexiglas love.

In the end, she leaves Eatonville because she is looking for a certain kind
of life, a specific kind of shared relationship, and "the few who saw her leave
bore plenty witness…she had no business to do it. It was hard to love a woman
that always made you feel so wishful" (Hurston 116). Janie does not aim to make
others feel wishful; she does not want to be looked at so closely, and instead she
wants the opportunity to reverse the gaze and do some of the looking herself.
Janie wants to see, and as an early Diva figure she is not interested in living up
to the standards of those who would lift her up as an example of virtuous
Black middle-class womanhood. If having money is part of the problem, she eas-
ily relinquishes it because she is looking for a life without the middle-class
expectations that come along with it. She even agrees to live on only the money
Tea Cake can earn. "Ah no need no assistance tuh help me feed mah woman.
From now on, you goin tuh eat whatever mah money can buy and wear de same.
When Ah ain't got nothin' you don't git nothin" (128). To this Janie easily
replies, "Dat's all right wid me" (128). While she does fret when Tea Cake steals
her money for gambling, her consternation has nothing to do with the actual
money; her concerns reflect a lack of confidence in herself. She is afraid she will
be sentenced to return to Eatonville like Annie Tyler,[2] with her tail between
her legs. Janie comes to realize that part of her oppression is tied to econom-
ics and social status. Joe "classed her off and Janie soon began to feel the
impact of awe and envy against her sensibilities. The wife of the mayor was not
just another woman…she slept with authority and so she was part of it in the
town mind" (46). Janie is forced to confront this in the immediate aftermath
of Joe's death. "She had hosts of admirers…and all that they said and did was
refracted by her inattention and shot off towards the rim-bones of nothing"
(92–93). According to Mary Helen Washington, Janie, like the other women
in the town, is left outside the power structure of the community ("I Love the
Way Janie Crawford Left Her Husbands" 193); her widowed status does not help
this situation. She is only able to attain some degree of freedom because she real-
izes that money is half of the problem. It becomes clear that middle-class
expectations and the money that comes along with them are the stumbling
blocks keeping her from love and freedom, and not the other way around.

Freed from Nanny's middle-class desires and her own internalization of
them, Janie easily encourages Tea Cake to pursue her. She relishes the intrigue
of someone like Tea Cake, in part because he lacks the material success of his
predecessors and is more reminiscent of the sweet kiss she got from Johnny

Taylor at her grandmother's gate after her pear tree realization. Tea Cake also speaks to a difference she cannot quite verbalize; he "wanted her to play...thought it natural for her to play" (96). Thus far Janie's relationships with men have been about subservience; Tea Cake imagines that she is smart and worth the effort of teaching something, even if that means one day she might beat him. Janie has been told that any suggestion of equanimity in love is unlikely to last: "Humph! don't 'spect all dat tuh keep up. He ain't kissin' yo' mouf when he carry on over yuh lak dat. He's kissin' yo' foot and 'tain't in uh man tuh kiss foot long" (22). Tea Cake was certainly not the kind of man Nanny wanted her to have, and when Janie had picked for herself the first time she had not even known that someone like Tea Cake was an option. She had thought she lost herself in the "thousand sister-calyxes" with one man and, perhaps misguidedly, thought she could only find what she had lost with another. It seems as though she is continuing the journey she set out on twenty years before when, while sucking on a sugar baby, she jumped over the fence into Joe's arms. A relationship with Tea Cake is unacceptable and Janie revels in the spectacle of it. She has slowly been transforming into something closer to the woman she imagines she wants to be. While that course is not always forward moving, and is, in fact, messy, like the Diva she is trying to become, she wants to determine what the outside sees when it looks at her. Patti LaBelle's entreaties, discussed earlier, to "look at me; don't look at me" are at play here.

> It was after the picnic that the town began to notice things and got mad. Tea Cake and Mrs. Mayor Starks!...Joe Starks hadn't been dead but nine months and here she goes sashaying off to a picnic in pink linen. Done quit attending church. Gone off to Sanford in a car wit Tea Cake and her all dressed in blue! It was a shame. (110)

As a woman constantly forced to participate in confining cultural discourse—because of Joe, because of Nanny, because of the town—she is fearless when she finally sees something she thinks she wants. While Janie may have some questions about the direction of her next steps, she knows that whatever she was looking for, the Sanford undertaker Pheoby wanted her to set her things next to (93) is not it. In the past other's feelings and opinions have too often come before her own, and now that she has the opportunity to experience something new, she takes it. This is the act of a Diva.

Janie's third lover, Tea Cake, seems to broaden her horizons but, ironically, he is probably the most destructive force in the novel, as his presence undermines much of Janie's growing sense of Diva empowerment. Janie stops living for herself and begins to live for Tea Cake, and "was glad she took things the

way he wanted her to" (128). She goes on to describe her love for Tea Cake as "a self-crushing love" (128). The self that has just become free from Joe's dominance is being crushed and bent to fit another's desires. Tea Cake encourages her to break even farther away from the expected, to disrupt the life that Eatonville thinks that she should have, but in doing so he usurps her power to make her own decisions. While there are moments of independent thought, like the significant choice to date Tea Cake at all, most of the behavior the community considers reprehensible is done for Tea Cake and not for herself. This suggests ultimately that Janie is less likely to operate as an independent thinker with Tea Cake because his presence draws her attention away from her own desires. Again, Janie puts herself in the position where she must be understood in terms of the male company she keeps. She tries to think like him; that is, he is independent and so when behaving like him, she feels herself to be more independent. He suggests fishing in the middle of the night and she willingly participates, feeling "like a child breaking rules" (102). Tea Cake incites in her a desire to break rules.

This behavior suggests a faltering in this late Harlem Renaissance early Diva—not a typical moral faltering, as this disinterests Janie, but rather a faltering as self-actualization is stunted with the introduction of Tea Cake into her life. Janie stops soul-searching, stops critiquing the world around her, and, most importantly, forgets the details of her pear tree visions. She submits. Janie gives Tea Cake the power to temporarily make her decisions and with it she gives up her freedom of choice. Her desire for independence fades and soon Janie and Tea Cake cannot be separated from one another in thought or action. After being told a litany of the town's complaints by her good friend Pheoby, Janie participates in some rather roundabout thinking. "Tea Cake love me in blue, so Ah wears it. Jody ain't never in his life picked out no color for me. De world picked out black and white for mournin,' Joe didn't" (113). Here she complains that no one, not even Joe, cared enough about her to pick anything for her to wear. This claim does not take into account Joe's earlier gifts, which classed her off from the other town women. Her store-bought dresses—in particular, the "wine-colored red" (41) she wore on the night the store opened—did make Joe happy. As stated previously, "he didn't mean for nobody else's wife to rank with her" (41). Joe enjoys seeing his wife look fine. Tea Cake and Joe mirror a patriarchal presence onto the family structure; they are of the community and represent its interests in their relationships with Janie. The discussion between Janie and Pheoby suggests that Janie is taking a stand against the community but, in fact, she is articulating her desire to do as she likes. The

insistence of her desire marks her as an early Diva, what she is fighting for in her conversation with Pheoby, however, throws her Diva stance into question. She claims that she "done lived Grandma's way, now Ah means tuh live mine" (114), but the "self-crushing love" she is so excited to find sounds a lot like her grandmother's idea of love as a form of protection.

A number of authors attempt to make Janie's relationship with Tea Cake fit the vision of pear tree bliss from the novel's opening, but they ultimately forget what it means that she is able to shoot to kill and save her own life toward the end of the novel. Shawn Miller suggests that the reason Janie's marriage to Tea Cake is ideal is because Janie has ameliorated her expectations of marriage. "She must overcome her own impulse to demand that her marriages conform to her immature understanding of what marriage is" (Miller 83). He goes on to write that "as marriage is somewhat of a contractual agreement...submission becomes a way for a wife like Janie to demand that the other terms of the contract be satisfied as well, and a source of power in controlling her husband" (86). This argument, while inventive, is troubling. Inherently it suggests that Janie submits to standard definitions of marriage and, in so doing, she finds happiness. There is nothing particularly revolutionary about a woman giving up her dream, and thus this runs counter to the underlying goal of *Their Eyes Were Watching God*. Hurston writes at the novel's start: "women forget all those things they don't want to remember, and remember everything they don't want to forget. The dream is the truth. Then they act and do things accordingly" (1). While one must be mindful of always following the author's instruction on how to read a text, Miller's suggestion in no way engages Hurston's claim that for women "the dream is the truth." It is therefore unlikely that Janie's relationship with Tea Cake, as problematic as it is, reveals a new understanding that domestic bliss comes as the result of submission. Further, if this point could be conceded, then Janie should have been able to make similar demands of Joe. She conformed in every way for many years and saw nothing as a result of that conformity. Having been mistreated and ostracized, once out from under Joe's control she makes obvious her disregard for middle-class life—first, by divulging Joe's sexual inadequacies publicly and second, after his death, by taking on a suitor without financial or social status. Tea Cake's subsequent death even further derails Miller's argument. Where does murder, self-defense or otherwise, fit into standard definitions of marital contractual obligations? "Janie's act of killing is an act of physical self-defense" but it is not, as Clarke argues, "to protect the body that Tea Cake has restored to her" (Clarke 610). Janie is on a quest toward self-actu-

alization and her willingness to kill Tea Cake to protect herself reveals that she is self-centered in the best possible way. In the end, despite being "the meanest moment in eternity" (Hurston 184), Tea Cake's murder is the only way for Janie to continue her journey and so "she threw up the barrel of the rifle in frenzied hope and fear" (184). She does not want to kill him but she is not willing to sacrifice herself to let him stay alive.

Janie expresses strong Diva desire the moment she pulls the trigger to kill Tea Cake, revealing that "Hurston's narrations depict experiences of coming to know as dynamic, participatory passionate processes" (McMillan 80). It is easy to question the text, Janie and Hurston's motives for the choices Janie makes, and the abuses she accepts at the hands her lovers. We are frustrated readers who wonder why the road to self-actualization seems to take so long. This frustration may have led to "romantic readings" and a bevy of excuses. Instead of trying to make simple the complicated motives that are located in gender politics, communal expectations, New Negro ideology and Uplift, let's look at what is there.

> The pistol and the rifle rang out almost together. The pistol just enough after the rifle to seem its echo.... They came down heavily like that. Janie struggled to a sitting position and pried the dead Tea Cake's teeth from her arm. It was the meanest moment of eternity. (Hurston 184)

It was the meanest moment because Janie had to make a hard decision to let her rabies-infected, until that moment ideal, lover (to her) live, or kill him to save herself. The "fortyish thrice married, financially secure, and confidently independent" (McKnight 88) Janie makes an appearance here. As an older and more mature woman, Janie maintains her youthful hope of pear tree love and, with great respect for her own desires, she protects herself from certain death because for Janie "the dream is the truth" (Hurston 1). Logan was not her dream, neither was Joe, and, as she reveals in this scene, nor was a rabid Tea Cake. Her learning curve is getting shorter as her desire becomes stronger. Janie's ambivalent future notwithstanding, there is no more revolutionary moment in *Their Eyes Were Watching God* than this one.

Janie Crawford Killicks Starks Woods has awakenings, sexual and social, and because of the constraints of the era in which she is written, she is punished for wanting more than society dictates she should have. Jennifer Jordan places blame for Janie's actions solely at her own feet, arguing that "Janie's struggle for identity and self-direction remains stymied. She never defines herself outside the scope of her marital or romantic involvements" (Jordan 108). In

complete opposition and in celebration of the text, Margaret Marquis argues that Janie does become independent once she is free from her romantic entanglements, and that the end of the novel shows her coming into her own: "Janie is heroic; she endured, and the means by which she demonstrates this survival is through her physical being" (Marquis 85). I would like to trouble the line between these two points. While I resist the idea of Janie's ultimate survival, she does survive the controlling people in her life: Nanny, Logan, Joe, and Tea Cake. She manages to escape them, to come back to her home in a town that resents her and sit on her porch, relaying the story of her life to the only friend she's got. But survival of Janie's spirit is not assured. When Tea Cake dies, "she pulled in her horizon like a great fish-net" (Hurston 193) and seems to prepare for an unexamined life without him. She tells Pheoby, "Ah'm back home agin and Ah'm satisfied tuh be heah. Ah done been tuh de horizon and back, now ah kin set heah in mah house and live by comparisons" (191). But is living one's life by comparisons any kind of life at all? It is as though Janie plans to sit on the porch and reminisce about the past, stagnant, dying a slow death.

Their Eyes Were Watching God relays the story of a woman who is as tired of waiting to find the promised 'something else' as the protagonist in Marita Bonner's essay, "On Being Young—a Woman—and Colored." Janie Crawford returns to Eatonville after the death of Tea Cake and the subsequent trial to live her life by comparisons, which is a death in itself. The successes Janie is able to achieve occur not simply because Hurston wills them to, but also because Hurston is able to create a world where one woman could realistically want and expect more. The freedoms Janie enjoys are as wild as Hurston could imagine, but the reality of the Harlem Renaissance world means that it is difficult for early Divas living in liminal spaces to perform desired identities. The end of Janie's tale is like a lighthouse beckoning to future writers to revise her story and provide new insights into the Diva figure. Janie has moments where she escapes communal expectation and lives for herself, with varying degrees of success. "Hurston's Janie is a subject of circumstances, as much in motion as [the Black bourgeois], but bears with her a brooding power of inevitable development. The more she is threatened, the more resourceful she becomes. The more deprived, the more self-sufficient she becomes. That inner stability and outer indomitability mark her off from anything that has gone before" (Cooke 72). Her willingness to find out about living for herself attracts future writers to continue Janie's journey, to take her off the porch—a nexus of true womanhood, Uplift and New Negro ideology,—and push her forward. When Spike Lee begins his film, She's Gotta Have It, with the first two paragraphs of Zora Neale

Hurston's *Their Eyes Were Watching God*, we see the impact of this proto-Diva figure. "In short, with Zora Neale Hurston a window is pried open, a breeze blows through, and by the time of Toni Morrison's *Beloved*, an opening has become a prospect, a landscape of vistas of possibility" (Spillers 94). Janie Crawford becomes a literary archetype for twentieth-century African America. The Diva has arrived.

· 3 ·

THE BOTTOM'S
UNREPENTANT DIVA

Toni Morrison's *Sula* was written during a significant period in the development of the Diva figure. It was published in 1973 near the end of the Black Power Movement. This sociopolitical movement, which encouraged Black pride, caused great dissidence in gender relationships between Black women and men. While women were present in the artistic arm of the Black Power Movement, the Black Arts Movement, the ideologies of the political movement seemed to insist that women write solely about the revolution because there was "an effort to mark feminist concerns as antagonistic to black solidaritiy and the promotion of a conception of community that seems to require the exclusion of women's voices and concerns" (Iton 15[1]). Black women were essentially asked to subsume their womanhood in the name of the revolution. They were to be Black first and women if there was time. Therefore, when Brown suggests that the Diva is revolutionary "because her desire for uplift extends beyond herself to making a positive difference in the world" (19), she fails to recognize the personal, powerful, and self-interested nature of the Diva. The Diva longs for self-actualization, and if a byproduct of that is change for the larger community, so be it, but this is not her primary goal. Take Nikki Giovanni, for example. Her poems written during the Black Arts Movement were extremely militant. In "The True Import of Present Dialogue: Black vs.

Negro (For Peppe, Who Will Ultimately Judge Our Efforts)," she consistently asks "Nigger/ Can you kill" (*Black Feeling, Black Talk*, lines 1–2). When her poems speak of love, as in "Seduction," it is always heterosexual and points to the counterrevolutionary nature of love during political upheaval. Once her poetry is no longer restricted by the revolutionary aims of the Black Arts Movement, the preponderance of heterosexual themed poetry vanishes from her work, she has "Thug Life" tattooed on her arm in homage to Tupac Shakur and writes poetry that ranges from portraits of Black women artists to ideas around the persistence of love. The turning point for her poetry comes with the realization that the Black Aesthetic, as an ideal, is useless when attempting to articulate aspects of Black womanhood.

The Black Arts Movement is best described by Larry Neal's treatise of the same name, which argues "that your ethics and your aesthetics are one. That the contradiction between ethics and aesthetics in Western society is symptomatic of a dying culture" (275). Neal's powerful suggestion is reminiscent of Du Bois' insistence that all art should be propagandist in nature. These propagandist aims of the Black Arts Movement curtailed the voices of Black women writers in much the same way that Uplift ideology did several decades earlier. The ideals of the Black Arts Movement were different, but they mirrored the failed artistic movements that came before them. Henry Louis Gates has said of the period that it has been the most controversial and least successful literary movement in the African American literary tradition (Gates, "Black Creativity" 74–75).

From the late 1970s through the 1980s there was a rise in the publication of African American women's texts, often referred to as the Black Women's Renaissance. Poised between the Black Arts Movement and the Black Women's Renaissance, Morrison signals a rejection of some of the ideals lauded by the former, namely the Black Aesthetic, and alludes to the values visible in the latter, namely woman-centered communities. Cheryl Wall writes that "on the cusp of a new century, Black women's writing has been preoccupied with the recuperation and representation of the past three hundred years of Black peoples' lives in the United States and throughout the African Diaspora" (*Worrying the Line* 5). Black women writers begin to redress this preoccupation by telling stories closer to home.

In *Sula*, Morrison writes away from the idea of the traditional nuclear family. Seven Carpenter Road, the home of the Peace family, is very different from familial homes that came before it in the African American literary tradition. The home is devoid of a significant patriarchal influence. Morrison makes the

revolutionary suggestion, through the Peace household, that it is possible to have a community of women, devoid of men, that thrives. Within this frame-work, she deploys the Diva figure as a way to critique the acceptance of the mul-tivalent cultural expectations of Black womanhood. She simultaneously provides alternate examples of Black women surviving and thriving within a Black community. Sula, the protagonist of Morrison's novel of the same name, does this by actively refusing to subscribe to traditional ideologies of Black fem-ininity by refusing to value Black masculinity as it exists in her community of Medallion. She is immune to the apparent "manlove" Eva, her grandmother, bequeathed to the other Peace women. Her personhood, her womanness, is most important to her and, as a result, she is determined to define herself on her own terms.

In *Sula* Toni Morrison initially lulls the reader into a quiet calm—a vision of women with money enough to live and with rooms of their own. They seem happy, independent, and free. Yet, upon closer examination, the careless-ness they portray belies the happiness of their existence. They each strive to find a place for themselves in their world, the small Black community of Medallion, a place formed on the back of a "nigger joke" (Morrison 4). Despite the breathing room their material wealth provides, each is suffering because the liminal space in which they must operate does not permit difference. They are each looking for a place to experience what they all seem to want most: moth-erlove. Mary Helen Washington, however, reminds us that "motherhood, com-plicated and threatened by racism, is a special kind of motherhood" ("The Darkened Eye Restored" 6–7). The desire to be mothered is what unites these women, but their refusal to perform it is what ultimately keeps them apart. They are restless because they are not satisfied and peacefulness eludes them. Just as the town of Medallion is built upon a lie, so too is the strength of the Peace fam-ily of women. In order to understand how Sula emerges as a Diva, given her par-ticular family history, we must examine not only the household from which she comes and the women who live there, but also the other women who create the community around her. Living outside some cultural dictates, both Eva, Sula's grandmother, and Hannah, Sula's mother, model an extraordinary life for Sula. Coming from women who lived out loud, how could she be anything else besides Other?

The foundation of the Peace family begins with Eva Peace, whom Janice Sokoloff in "Intimations of Matriarchal Age: Notes on the Mythic Eva in Toni Morrison" names the matriarch of the family (432). The persona of Eva suggests the epitome of the stoic, Black woman—one abandoned by her hus-

band, with little money, and with young, needy children to feed—but instead of scraping to survive, as the stereotype of the strong Black woman demands, she revises this script and creates another life for herself. After sticking the last bit of food she had in the world into her son's anus to loosen his bowels, she decides that this life is not for her, that scraping to survive will not do. She disappears from Medallion with two legs; several months later, she returns with one and a monthly insurance check. She turns her home into a boarding house and takes in people for pay. Eva's life before her accident reveals the inaccuracy of giving her the title of Peace family matriarch. She spends what time she can trying to maintain her relationship with Boyboy, her then-husband and father of her three children, and thus allows him to mistreat her: "He did whatever he could that he liked, and he liked womanizing best, drinking second, and abusing Eva third" (Morrison 32). After an abusive five-year marriage, it is he who decides to leave. It is only in utter desperation that she reverses her fate and comes to find an identity outside of the role of supportive, tolerant, and loyal wife. Arguably, had he not left her, this story would not exist. You have to question a matriarch whose power is drawn primarily from her abandonment. While she does manage to survive, she is not a Diva because her desire to survive is forced upon her and is merely a reaction to hunger and desperation.

This misapplied title indicates a larger problem in the way of thinking about Black women—in particular, Black women characters as they exist in literature. To suggest that a woman is a matriarch is to suggest that she has power; this is not the case for Eva. Her choices are the result of the actions of others. Ultimately, she is completely powerless—so much so that she is unable to determine where her final days are spent. That Black women, from post-Reconstruction onward, have sometimes been in better economic positions than Black men and in this way have seemed to head the Black family in no way suggests that their status has changed in the larger society in which they live. A community of women exists in the Peace household, of which Eva could be perceived as the head; perhaps she may even suffer from a superwoman complex, but she is no matriarch. While she maintains a certain omnipotent presence for a good part of her life, in the end she is unable to control anything: her children's deviant behavior, her daughter's death, or her granddaughter's socially unacceptable behavior. She is not even able to keep herself out of the nursing home hell into which Sula consigns her, despite the lack of any real illness. "Her empire is built not on love, but upon a base of 'liquid hatred'" (Burrows 137). Ultimately, Eva never achieves Diva status because she never learns to want anything more than a room of her own.

Eva's daughter, Hannah, however, has not had the same bad experiences with men as her mother and, while some of her choices seem to mimic her mother's, she reveals a disdain for motherhood, something Eva seems more capable of hiding. Her husband died and thus her abandonment is not a result of choice. Unlike Eva, Hannah is not purposely left to fend for herself, penniless and hungry with many children to feed and no way to do it. Eva's wariness of men has meant that there is always a place for Hannah in her mother's home, because Eva would never remarry. Hannah never has to be a provider; her mother's financial stability means that, after her brief stint as a poor, briefly motherless child, she has never known material need. However, her psychological needs are left wholly unmet, and that, in combination with an absence of want, fuels a desire to fill the emotional vacancy; that space gets filled with detached sexual encounters.

Hannah seems to enjoy sex and, despite the death of her husband, she does not allow her desire to diminish. The lack of a sanctioned place in which to engage in sexual activity in no way deters her from her first priority: "what she succeeded in having more often than not, was a little touching everyday" (Morrison 44). She has sex with, but does not sleep with, all men with whom she comes into contact, with a seeming preference for the married kind; their familial connections mean affairs are never permanent. Hannah never attempts to re-create the marital relationship she had with her husband. She, like her mother, is not interested in remarrying. In this way, she is like her mother and unlike every other woman in Medallion. "Hannah seemed too unlike them, having no passion attached to her relationships and being wholly incapable of jealousy" (44). She is not interested in taking anyone's husband anywhere but into the pantry for a little male attention, only to send him home afterward to his wife. "She would make love to the new groom and wash his wife's dishes all in an afternoon" (44). Her libidinous behavior nearly runs the local prostitutes out of town, but, most importantly, she is not branded a whore or loose woman because of it: "the men, surprisingly, never gossiped about her. She was unquestionably a kind and generous woman and that, coupled with her extraordinary beauty and funky elegance of manner, made them defend her and protect her from any vitriol that new comers or their wives might spill" (45). For the most part, her personal reputation goes unscathed. While Hannah's rampant sexuality remains outside codes of social decorum, the town makes exceptions for her behavior because it does not lead to the more typical outcome, the destruction of nuclear families. Hannah is another exceptional woman in the Peace household, providing Sula with another

portrait of complicated Black womanhood. What other choice does Sula have but to be exceptional herself?

Hannah's sexuality seems pervasive, but, upon closer inspection, her uninhibited sexuality has little to do with real sexual desire as she has "no passion attached to her relationships" (44). Rather, her interest in men and in "some touching" (44), has more to do with attempting to repair the fractured mother-daughter relationship she has with her own mother. Hannah is searching for the motherlove Eva could not and did not provide. In a brief moment of introspection, she puts to her mother a question that has long weighed on her mind: "Mamma, did you ever love us?"(67). Upon receiving her mother's unsatisfactory answer, she tries to articulate the kind of love she felt deprived of as a child and now as an adult. She continues her questioning: "Did you ever, like play with us" (68)? The only description of Hannah's husband is of him as a "laughing man" (41) and this description, along with the questions put to Eva, suggest that she was looking for the play missing in her relationship with her mother. She attempts to recreate that play with men, not just because her mother did not provide it but also because the only real thing her mother taught her was manlove. "It was manlove Eva bequeathed to her daughters" (41). But that manlove is not enough to sustain Hannah, and ultimately she is left unsatisfied. Her concentration on the sex act, on the good feeling, suggests her need for love. The sexual pleasure—arousal and orgasm—is too short-lived, and thus she continues her mission daily. Her relationship with her mother is unfulfilling and the relationship she comes to have with Sula is unfulfilled as well. Supporting her habit comes to take precedence over nurturing herself or a relationship with her daughter, Sula. Her role as mother becomes just another reminder of her failed relationship with her own mother, Eva.

Trying to find her own mother voice, Hannah questions Eva about her brother Plum's death. This is a conversation Eva does not want to have. Burrows argues that she is "unable verbally to express the protective tenderness she feels, [so] Eva hides her fierce maternal love under her disparaging language and angry, ambivalent tone" (129). However, there is more to Eva's reaction. She never refers to how her son might have felt or how he needed saving; instead, she speaks primarily of herself and her unwillingness to mother him again. "Godhavemercy, I couldn't birth him twice" (Morrison 71). It seems Sokoloff misreads Plum's murder as well, arguing that Eva is ready to harm her children when she feels powerless to protect them (432). But Eva's mention of Plum's need comes only at the end of a diatribe, as an after-

thought. Eva will not allow Plum to be a child again because she does not want to be his mother again. Perhaps her memories of putting her last bit of food into his behind in the cold, stinking, outhouse are too vivid. Plum cannot continue to exist if he serves as a constant reminder of her past. Those days of desperation are behind her; she is a success now and no one, not even her own son, has the right to take that from her. Eva explains that she cannot birth him again, that she has done all she can for him, and that his need for more will ultimately consume her. Eva has an intense need for self-protection (Hirsch 265) and, to this extent, she does have Diva tendencies, because fundamentally the Diva fears the mother, mothering, and being mothered. Consider earlier discussions of Divas in this book. Helga Crane, protagonist of *Quicksand*, is trapped by her children; though she has visions of abandoning them, her numerous successive pregnancies and births have made her physically incapable of escape. Janie Crawford from *Their Eyes Were Watching God* suffers from a sort of magical infertility and, thus, what is implied but unspoken in those texts is given voice in *Sula*.

Hannah sees motherhood as confining, and says so. In a hen session with her friends she expresses her love but not like of her daughter (Morrison 57). While her disinterest and unease with motherhood do not lead her to physically leave her daughter, she does depart from Sula emotionally by spending most of her days in pursuit of sexual conquests. The idea that perhaps motherhood is something in which she did not have to participate is not a part of her experience. You get married; you have children. Like the other Black women in her circle of friends, Hannah is ultimately displeased with the experience of motherhood, but clearly not one of them ever considers that motherhood is not part of a natural progression of life.

"Yeh. Wish I'd listened to mamma. She told me not to have 'em too soon....Well, Hester grown now and I can't say love is exactly what I feel."

"Sure you do. You love her, like I love Sula. I just don't like her. That's the difference."

"Guess so. Likin' them is another thing" (56–57).

Hannah stands apart from the women in the town for more than just her sexual behavior. She feels a reluctance to mother and she not only willingly expresses this to other women, but she also goads them to speak about their own maternal dissatisfaction. Unfortunately, she never gets beyond this reluctance; she is never able to admit that motherhood for her was a mistake. It takes almost twenty-five more years before the Diva speaks this in Ntozake Shange's *Liliane: Resurrection of the Daughter* (1994).

Sula's life irrevocably changes the moment she overhears her mother pro-
nounce that she does not love her, though few literary critics acknowledge this.
Robert Grant argues in "Absence into Presence: The Thematics of Toni
Morrison's *Sula*" against the idea that Sula's life changes dramatically at this
point. The essay suggests this moment helped solidify a lax world that was
already taking shape for her. He insists that the far more interesting question
is why Hannah doesn't love her (57). While his first suggestion seems grounded,
I think the line of questioning he pursues is unproductive, especially if we
develop it along the same continuum. If we ask his question then we must ask
more: Why doesn't Eva love Hannah? Why doesn't Helene love Nel? Andrea
O'Reilly, in *Toni Morrison and Motherhood: A Politics of the Heart*, asserts some-
thing similar to Grant. She suggests that critics are misreading the lines (58)
and asserts instead, "What Hannah says is that a child is a separate person with
her own unique personality" (59). She goes on to suggest that what happens
is "motherblame" (59) because of the "daughter-centricity" (59) of the novel.
I disagree. It is nearly impossible for the novel *not* to be "daughter-centric";
despite her late appearance in the novel, Sula, herself a daughter, lends the work
its title. Furthermore, overhearing her mother's pronouncement reveals itself
to be a profound moment in Sula's life as evidenced not only by the tragic death
that immediately follows, but also by the life Sula chooses to lead as an adult.
The moment she learns her mother's true feelings, she understands that there
is no one to count on. "The first experience taught her there was no other that
you could count on; the second that there was no self to count on either" (119).
Years later, as Sula remembers her mother dying, she says, "I didn't mean any-
thing. I never meant anything" (147). In the drug-induced haze of her death
throes, she reconsiders moments in her life and states for the first time that she
watched her mother burn. Consider the positioning and structure of the state-
ments: "I didn't mean anything. I never meant anything. I stood there watch-
ing her burn and was thrilled" (147). The two parts of the statement are
dependent upon each other and so it could read, "I watched my mother burn
because I meant nothing." While she seems to quickly accept the fact that she
will have to exist without motherlove, it is clearly something that haunts her
until her death. She is unforgiving and, while she does not kill her mother, it
is easy to assert that it is more than just shock that leads to her inaction. Sula
relishes seeing Hannah burn not merely as punishment, but also perhaps
because this burning dance is the most active moment she has witnessed her
mother make in her entire life, with the exception, of course, of her daily dal-
liances in the pantry. Her mother is doing something and Sula will finally get

to join her mother in death. They can die together like great redwoods in the forest (143). Unfortunately before any of this can be potentially resolved, Chicken Little, a little local boy, has to die in order for Sula to begin to understand her mother.

Immediately following Hannah's declaration, Chicken Little is killed easily refuting any claim of Sula's ambivalence. Sula, floating off into dark thoughts, is summoned by her good girlfriend, Nel (57). They are restless all day, Nel, perhaps because she feels free from her mother's daily constraints, and Sula, because she is looking for some way to hold what she has heard and to find a way to deal with that pain. Playing with Chicken Little allows Sula to engage a mothering moment, which permits her to experience and then disconnect from it in order to survive. Chicken Little has to die in order for Sula to come to grips with her mother's lack of love, and thus his death allows her to give up on mothering as a source of meaning. O'Reilly asserts, "disconnected from the motherline and the values of the ancient properties it conveys, [Sula] rejects motherhood and embraces a dominant standard of female success and well-being" (61). It seems that just the opposite happens. It is because she is in tune with her mother's lack of maternal feelings that she learns an inadvertent lesson: One does not have to be a mother. That she learns this from her mother suggests that Sula is still in some way connected to Hannah. The naming here serves an important role. Chicken Little is so named because, in Sula's acts of mothering him, he is the realization that the sky is falling. Like the fairy-tale figure, he makes it evident that the world as she understood it is falling apart; her sky is falling down.[2] Killing Chicken Little is her attempt to physically accept her present state as a child without motherlove. She needs to experience what it is like to give away a child, to let one go. The moment in the hall overhearing her mother is better understood down by the lake when she lets Chicken Little "slip from her hands" (Morrison 61). Sula lets go of all the mothering duties thrust upon the women in the community. "Chicken Little's death…ends any aspirations that Sula holds towards maternity—they drown 'in the closed place in the water' along with the little boy" (Burrows 140). In that instant, she realizes that she never has to be a mother. It becomes perhaps the most freeing moment of her life. Hannah teaches her daughter more than she can ever hope to learn from Helene, Sula's temporary childhood idol. Hannah's casual comment amongst her friends articulates the idea that love for one's child is not necessary. As a Diva figure, Sula takes that message and applies it to her own life. She later articulates this to Eva, saying, "I don't want to make somebody else. I want to make myself" (Morrison 92). In her revi-

sion of her mother's dissatisfaction with motherhood, she makes the decision Hannah did not: She does not have children. Sitting in Chicken Little's funeral with an unshaken Nel, Sula mourns her lack of motherlove. "Sula simply cried. Soundlessly and with no heaving and gasping for breath, she let the tears roll into her mouth and slide down her chin to dot the front of her dress" (65). In this moment, with Chicken Little's bloated, unrecognizable body in a coffin before her, she buries her desire to mother and to be mothered. Devoid of familial figures to use as role models, Sula's idolization of Helene becomes more understandable. Sula's seeming reluctance to be a Diva leads her to admire the novel's strongest example of what a Diva is not.

The beautifully coifed Helene Wright is easily mistaken as the real Diva in *Sula*. "Helene Wright was an impressive woman....A woman who won all social battles with presence and a conviction of the legitimacy of her authority" (18). Sula is drawn in by her house and the woman who runs it. "Sula, who loved it...would sit...for ten to twenty minutes at a time—still as dawn" (29). Unlike Hannah, Helene cares that others consider her to be a model citizen, and to this end her house is a place of organization and moral virtue because "she devotes herself to creating a façade of ritualistic order" (Burrows 132). Of course, as a child, Sula does not recognize that what Helene creates is a brittle veneer, easily laid bare by a racist train conductor, as the novel reveals. As the epitome of middle-class pretensions, initially Helene is running from a prostitute mother, and her fear of her too-near-past leads her to discourage Nel from interacting with the likes of Sula. Hannah's reputation colors her daughter's, because Helene recognizes her own past in Sula's present. Helene moves to rural Ohio from New Orleans, marries a respectable man she is not very interested in, and has one daughter, who she tries to make even more sterile than herself by actively driving "her daughter's imagination underground" (Morrison18). Helene's grandmother, Cecile Sabat, tells Helene to be on the lookout for any signs of her mother's blood (17). She is ever vigilant with her own child but, as the text reveals, not always so careful with herself.

This fear of the mother and the self sounds all too familiar in a Diva's life. It is a fear echoed in the literature written during the period in which the novel is set. Nanny, Janie Crawford's grandmother, from *Their Eyes Were Watching God*, fears for her granddaughter's chastity because of her own experience of rape and its ever present threat. Helga Crane from *Quicksand* fears her mother's fate will be her own and as a result makes decisions that lead to her demise. More contemporarily, there is Jamaica Kincaid's novel *Lucy* (1990), in which the protagonist fears she cannot escape the specter of her mother. The mother reasserts

her position by telling her daughter that she will always be her mother. Mothers cannot be escaped and, in this way, Helene and Sula are the same—they both desire, in vain, to escape their mothers. "While Helene has attempted to dissociate herself from her mother's contaminating public sexuality and heritage of prostitution, in her performance with the white conductor she unconsciously turns to 'acting out' her despised maternal inheritance....Morrison draws attention to the inescapability of each woman's matrilineal heritage" (Burrows 134). Morrison, through Helene, reanimates and subsequently revises the Victorian trope of the fallen woman and echoes this in a funhouse mirroring, a distorted reflection, when Sula has her own self-defined fall from grace with the text's messenger god, Ajax/A. Jacks.

Helene falls from her delicate perch and destroys the false Diva image she has fashioned in her northern home on a single trip back to the South; by the time she reaches Lake Pontchartrain, she is proudly and shamelessly urinating in the bushes (Morrison 24). She tries to protect herself from her mother's blood but, in spite of the armor of her dull brown wool and velvet dress, she fails. So busy is she in her attempt to arm herself with grace (19) that she misses seeing her grandmother alive—the one person who, in her estimation, saved her life by taking her from "behind those shutters...of a Creole whore" (17). Nothing, however, can take precedence over the illusion of the middle-class virtue she creates; she works hard to avoid the trope of the fallen woman, the only legacy her mother provides. And yet her failure to escape this is visceral; public and miserable, in part, because she is so completely oblivious to her own fall. When faced with a rude, gross, racist white conductor, instead of standing the ground she so easily does in Medallion, she caves completely. Even in her own daughter's eyes she falls from grace, turning into weak, yellow-bellied custard.

> For no earthly reason, at least no reason that anybody could understand, certainly no reason that Nel understood then or later, she smiled. Like a street pup that wags its tail at the very doorjamb of the butcher shop he has been kicked away from only moments before, Helene smiled. Smiled dazzlingly and coquettishly at the salmon-colored face of the conductor. (21)

In this moment, Helene disrupts her own imagined ideal of Victorian womanhood; she resorts to an overt expression of unbridled sexuality, the one thing she has been on guard against, warned her child against, and moved across the country to deny. When faced with conflict, she lets the legacy of her birth protect her from personal discomfort without a thought to what it would mean to

all the onlookers, including Nel. "She had been frightened of the...custard pudding she believed lurked under her mother's heavy dress" (28). Sula, of course, does not see this, but it, nevertheless, serves as the catalyst for the beginning of her most meaningful relationship with Nel. Through her friendship with Nel she is able to correct her childlike worship of Helene.

Sula, as a child, is not equipped as the adult Sula is to recognize that Helene's position is hardly enviable. While Helene commands a certain amount of respect in Medallion, Sula misconstrues Helene's persona as being mature, confident, and respectable. As a result, she cannot see that it is her own mother, Hannah, who experiences some real sense of self-satisfaction. For Helene to retain her dignity, she must divorce herself from the world, from her roots, and instead inject herself with white, middle-class pretensions. The double jeopardy of being both a woman and Black is resolved by remaining behind a physical and emotional veil (Bjork 61). Everything is for show, even the futile insistence on the correct pronunciation of her name: "She lost only one battle....The people in the Bottom refused to say Helene. They called her Helen Wright and left it at that" (Morrison 18). Cecile Sabat provides a path to illusionary escape for Helene; Sula has to make her own. She has no one to instruct her on how to make her life what she wants it to be and so she sets out to search for her own truth. Sula refuses to allow her mother's life to dictate her own future. That conviction, and the symbiotic relationship she shares with Nel, allows for a transference of knowledge. Sula can feel the custard of Helene's countenance because Nel witnesses it. Through Nel's insight, Sula is able to see Helene's middle-class pretensions not as a marker of confidence, but as a complete absence of it.

Not only the adult women in *Sula*, but also the actual structures they inhabit, create the fodder that will turn Sula into the Diva they can never truly be. The Peace home is evidently very different from the home Helene creates for Nel and her ship-bound husband. Helene's home is built on the destruction of her past history, which threatens the person she has become. Eva's home is built on her past, as well, but it is built to be something she forever wants to remember.

> Knowing that she would hate him long and well filled her with pleasant anticipation, like when you know you are going to fall in love with someone and you wait for the happy signs. Hating BoyBoy, she would get on with it, and have the safety, the thrill, the consistency of that hatred as long as she wanted or needed it to define and strengthen her or protect her from routine vulnerabilities. (36)

Eva flourishes and she and her family never want for anything material again. The hole created by the absence of love is filled with food and money, which is

meant to serve much like the protective barrier of Helene's brown velvet dress on her long trip south. This is the house into which Sula is born, a house of extraordinary women. She thrives on their sense of independence and is extraordinary herself; she has no choice but to be. It is interesting, though, that through her acceptance of Nel's friendship she seems to insist on a level of normalcy, some aspect of the everyday. Sula could not have picked a more ordinary friend to love than Nel Wright. This choice makes one wonder: Was this an attempt to foist off the extraordinariness thrust upon her? Very little is written about Sula as a child. She is allowed to run wild and free without any meaningful adult interaction or supervision. Every memorable act commemorates morally and judgmentally questionable exploits. She cuts off part of her finger in order to protect her friend: "Her aim was determined but inaccurate. She slashed off only the tip of her finger....'If I can do that to myself, what you suppose I'll do to you'" (55)? She allows Chicken Little to die without intervening. She watches her mother burn without action or reaction. It is as if she is not participating in the world, but rather allowing it to move around her. The most important decision in her young life is a passive one: She allows Nel to select her for a friend. This relationship comes to define the rest of her childhood and much of her adult life.

There is a displaced love between Nel and Sula because they each have "distant mothers and incomprehensible fathers" (52). Nel's manipulative mother is only interested in mothering as far as it helps define her, and Sula's mother is not interested in motherhood at all. Nel and Sula come together as much from desire as from need; they know little of love, and what they know they find in each other. It is "important to say at the outset, however, that Sula and Nel, for all their apparent bonding, do not share a single perspective" (Baker, *Working the Spirit* 246). Rather, they are two girls who commiserate over their lack of motherlove. This is what brings them together and ultimately what pulls them apart. When Nel gets the opportunity to mother, to be in the position of providing motherlove, she embraces this, while Sula rejects it firmly. Nel mistakenly thinks that what her husband wants or requires of her is a self-sacrificing love and so she gives up her own personhood to support him in an attempt, perhaps, to attract her own mother's love. Nel unconsciously embraces the lifestyle choices her mother has seemingly made: marriage and children. Nel thereby welcomes the opportunity to love as she imagines love must be.

When Jude selects Nel as a wife, she realizes that there are other types of love, perhaps types more desirable than what she has experienced with Sula. Initially, she is not particularly interested in marrying Jude, and she only agrees to do so when it becomes clear that he wants someone to help him

define himself. Although Sula needs her more generally, Nel does not con-
sider that Sula also needs her for the sake of definition. Nel arranges each of
their needs—Sula's and Jude's—hierarchically: romantic love first, platonic
love second; Sula is displaced yet again. Sula lacks the impulse toward jeal-
ousy but recognizes that there is no longer a place for her in Medallion. Her
love for Nel, however, does not diminish, and so together with, Helene,
Sula puts together the largest wedding anyone has ever witnessed in the
town. Helene, so different from Hannah, relishes this moment as the culmi-
nation of all of her motherly efforts. Both Sula and Helene give Nel away,
only Sula is doing so reluctantly. Sula is primarily able to assist in the wed-
ding preparations because everyone sympathizes with her as a motherless
child. She exploits this knowingly. Unlike everyone else Sula knew that she
was motherless well before Hannah died. After she gives Nel away, like
another parent at the wedding, she leaves Medallion—just as Janie Crawford
left Eatonville—to find out about living for herself. Nel no longer provides
Sula with the sustenance she needs and so she puts on a hat and struts out of
town to look for it elsewhere. Her return ten years later suggests that she did
not find it out in the world.

Amidst the robins and the shit, Sula returns to Medallion in 1937 and tries
to save both Nel's life and her own. Sula recognizes that the bloom has come
off of her friend; the daily mothering Nel offers not just to her children but to
Jude as well has made her dull. Sula attempts to interrupt Nel's uncomplicated
motherlove for her husband by providing a different point of view of Jude's dif-
ficult life. "I mean I don't know what the fuss is about. I mean, everything in
the world loves you....White men love you...white women...colored
women...little children [and] you love yourselves" (Morrison 103). As if to
ensure the rupture of Nel from her life of mediocrity, Sula complicates her
friend's choices by having an affair with Jude. Sula, with that act, tries to
encourage her friend to recognize that the dual roles of wife and mother do not
equal total fulfillment; Sula "made her see old things with new eyes" (95).
While Nel's childhood dreams conjured images of a "fiery prince" (51), Sula
wanted to remind her friend of a stronger girlhood recollection: "each had dis-
covered years before...that all freedom and triumph was forbidden to them, [and
so] they had set about creating something else to be" (52). It seems that Sula
left town to avoid the trap of expected biological destiny and is saddened by
the Nel she finds—who is playing the role of her unenlightened mother,
Helene—when she returns from her wandering. As a Diva, Sula is able to see
from a better vantage point and she uses this perspective unselfishly in this one

instance. Her one act of motherlove serves as a reminder to her of the traps of motherhood. It takes Nel 28 years before she is able to see Sula's true intentions; she has so embraced the mother-wife role that she is angry when she is reduced to having a "sticky love" (138) for her children that she does not much enjoy. She cannot bear to face the woman who she feels "twisted her love for her own children into something so thick and monstrous she was afraid to show it lest it break loose and smother them with its heavy paw" (138). Nel has become so focused on mothering that she does not see herself, does not take note of her shallow marriage, of her unfulfilled life. It takes seeing Shadrack near the cemetery saying "always" to illuminate what Sula's affair with Jude years ago could not; Sula's was an act of motherlove, but Nel was not equipped to recognize it. Despite this, even on her deathbed, Sula challenges her to see her act as one of kindness.

> "How you know?" Sula asked.
>
> "Know what?" Nel still wouldn't look at her.
>
> "About who was good. How you know it was you?"
>
> "What you mean?"
>
> "I mean maybe it wasn't you. Maybe it was me." (146)

Sula wants Nel to realize that her having sex with Jude had nothing to do with loving him. Sula, in fact, only manages to love one man, Ajax. She has sex with Jude in an attempt to experience what Nel has. Although Sula seems to have some disdain for Nel's life, it is possible that Sula sees Nel as the new version of Helene and, perhaps, it is the order of that life that she longs for. She has sex with Jude to disrupt Nel's limited existence, but also to experience the uncomplicated domestic order that is Nel's life. It seems likely, though, that Sula slept with Jude in order to reclaim her friend. Sula holds no malice toward Nel, and on her deathbed she argues with Nel, challenging her to rethink her life. She sees in Nel the woman-love—the love of sister-women—that did not exist in her own household. Reinforcing her fear and misunderstanding of motherhood, her only semi-maternal act as an adult—to rescue Nel from a dull life and a loveless marriage—is categorized as a betrayal; Nel's refusal to accept Sula's help does not diminish the fact that help was offered. Sula learned from an early age not to trust the women in her household and not to look for love at home, but that does not mean that she does not want to know the love of a woman. She looks for it and for a time finds it in Nel, and so she is startled to

find that within a mere ten years "now Nel belonged to the town and all its ways" (120). Suffering from natal alienation, she is disappointed again by another mother.

Sula fears motherhood because of what it has meant in her life and in the life of her friend. Her own mother admits to not loving her and, in general, allows Sula to raise herself. Her grandmother, despite killing her own son, has a particular fondness for men; Sula is not a priority until later, when she is someone else upon whom Eva can pass judgment. She thinks Sula is evil and that she is responsible for Hannah's death insisting that Sula watches her mother burn with interest. While there are lingering questions as to why Hannah's death seems to have no perceptible effect on Sula, Eva seems quick to judge. Sula is not outwardly traumatized or concerned, but does that mean that she killed her? Sula just goes on living life and, while there is no textual evidence that she killed her mother as Eva suggests, maybe she let her die because she could not live without her love. She realizes that being mothered is just as dangerous as mothering, and so she lets her mother die and puts Eva in a nursing home because, as a Diva, she knows intuitively that mothers are dangerous people.

Sula seems to be a reluctant Diva in many ways; she lives her life as she does partly because no one else ever suggested another way to live. She has tried to find out about living for herself to no avail. "I have sung all the songs all the songs I have sung all the songs there are" (137). Despite her seemingly expansive travels, Sula comes to find out that the Bottom is a microcosm of everywhere else. In response to Nel's questions about the world outside Medallion, Sula simply replies, "Big is all it is. A big Medallion" (99). As Helga Crane discovers in *Quicksand*, there is nowhere to escape the expectations of Black womanhood. Herein is an indictment of Black communities. Because Sula chooses to live "an experimental life" (118), she is seen as Other and marked as evil living in Medallion's midst; she is something they must overcome. The expectations of Black womanhood in this community are strongly identified with obligatory motherhood, but there is a thick reluctance to actually fulfill an emotional mothering role: "likin' [your children] is another thing" (57). Many of the text's mothers experience their children like "exposed wounds" (122). That Sula is able to identify this and reject it in her own life keeps her forever distant from the lives of these Black women. "Sula knew that one clear young eye was all that kept the knife away from the throat's curve" (122). She clearly recognizes the self-sacrifice expected of mothers and therefore rejects their way of life. "She saw how the years had dusted their bronze with ash, the eyes that had once opened wide to the moon bent into grimy sickles

of concern." (121) In this community of women, acceptance is dependent on motherhood and personhood must be subsumed in order to be a community member. Sula refuses to participate. She recognizes the women's dissatisfaction with their lives and, by example, strongly suggests that womanhood is not dependent on motherhood. The power of children to thwart a woman's personal and intellectual growth is illustrated as clearly in this book as it was in *Quicksand*. Sula rejects her community as much as it rejects her.

The Diva figure views motherhood as the death of the self. Marianne Hirsch asserts that "Sula is haunted by the fears of the destruction domesticity brings and for Sula motherhood constitutes a threat of disintegration" (268). She does not want to become like the half-dead women in Medallion or like Eva, the self-sacrificing superwoman; rather, she wants to find and connect with herself on a deeply emotional and intimate level, and she believes that mothering or being mothered will prevent that from happening. Sula's membership into the community of Black women is finally completely revoked by the rumor that she may have slept with white men. But it is not just the seeming racial betrayal, it is the larger idea that she does not behave as other women in the community do. Gurleen Grewal clearly articulates the limits of that small Black world: "Any assertion of independence from the communal codes of conduct—especially by its women—is viewed with hostility. Such autonomy is considered an unwelcome departure by a beleaguered group whose energies are geared toward self-preservation" (44). Sula does not marry. She does not have children. And although the affair with Jude was condemned, the fact that she puts Eva into a nursing home is what marks her as un-Black, as not a part of the Black community in Medallion. The consensus is that no real Black person would do such a thing; that's what white folks do. Sula's behavior not only ostracizes her from the community, it also calls into question her admittance in the first place. While she looks like them, she does not behave like them, so she must not be Black. This line of thinking is similar to that which kept Black women from being real women according to the cult of true womanhood: Her lack of connection to mothering marks her as Other. "As a social pariah branded as different, she is the freedom against which others define themselves" (Willis 101). Essentially, her community deems her to be inauthentically Black. Despite their collective opinion, despite their refusal to admit her, living her life thusly suggests a new figuration of Black womanhood: Black woman as woman but not mother.

Sula is never accepted as a part of Medallion because she never conforms, and yet this is not true of her mother and grandmother after whom much of her behavior is often patterned. Sula is considered, by far, to be the worst member

of her family, even as her mother's and grandmother's behaviors are accepted with little interrogation. The townspeople do talk about Eva's missing leg and the ensuing influx of cash, but there is a certain amount of reverence for her. Hannah garners less respect, but her good treatment of Medallion's men through not only the ready availability of her body, but also her ability to not cling or want more, is easily tolerated. The difference here then is that Hannah and Eva followed cultural expectations at different periods—they each marry and procreate. It seems then that a rebellious woman can attain a measure of acceptance if she practices conformity for a time. As a widow and a divorcée they have no control over their new inability to conform. After a double over-ture—marriage and children—is made once in life, a woman is free to do as she likes; yet because of those earlier capitulations her choices become limited. However, Sula remains completely uninterested in marriage or children. Her refusal frightens even Eva because she cannot comprehend such independence of thought. Eva's own life has been entirely shaped by her children's needs. Her survival comes as a direct result of her need to provide for them. Therefore Sula's disinterest in creating a family is a too vivid rejection of Eva's choices. If her behavior frightened her own grandmother, a woman bold by most definitions, then there was little chance that the town would ever accept her. This refusal is in many ways freeing and connects Sula to Janie Crawford's sense of peace immediately after Joe's death. Neither the town's expectations nor her family's choices influence her to reconsider her own desires. This is a third zone from which Sula can suggest something altogether new.

Medallion refuses to recognize Sula as the Diva she is. Her life is a model of how to live as an unencumbered Black woman. Sula is very much like both her grandmother and mother; she takes what she wants and needs and leaves the rest. Like her mother, Sula enjoys sex, but clearly her reasons for it are not the same. Hannah celebrated other women's husbands and through her acts made women proud of their own choices. Sula used those same husbands for reasons she chooses not to explain to anyone. During sex she feels "particles of strength gathered in her like steel shavings drawn to a spacious magnetic cen-ter, forming a tight cluster that nothing, it seemed, could break" (Morrison 123). The center the novel claims she lacks is found in sex when her power becomes actualized. Sula "went to bed with men as frequently as she could [because] it was the only place where she could find what she was looking for: misery and the ability to feel deep sorrow" (122). Sula relives her sorrows in order to find herself. "She waited impatiently for him to turn away and leaving her to the postcoital privateness in which she met herself, welcomed herself, and joined

herself in matchless harmony" (123). Despite her mother's many trips into the pantry, Sula understands that Hannah's life was ultimately unfulfilling and she wants more for herself. Eva's life, in the end, was unfulfilling as well. After BoyBoy visits her for the last time, she retreats to the third floor of her home away from the throng, "leaving the bottom of the house more and more to those that lived there…and after 1910 she didn't willingly set foot on the stairs" (37). She spent her life hating one man and providing for their children as a result of that hate. Sokoloff argues, "matriarchal lines of temperamental inheritance shape [Morrison's] major female characters" (430), but Sula far outpaces Eva's strong disposition. As a Diva figure, Sula lives a far more examined life. She then takes that knowledge and applies it to her available choices. Sula does not love men without reason; she allows them a limited, pre-scripted role in her life for purposes that are purely for her benefit. They are not permitted free reign and her trajectory is not determined by their desires. This way of being is completely unlike every woman in her community. For them, she simply defies interpretation and is therefore marked as evil. Toward the end of the novel, even a distant Nel argues against Sula's position on men. She says,

> "I always understood how you could take a man. Now I understand why you can't keep none."
>
> "Is that what I'm supposed to do? Spend my life keeping a man."
>
> "They worth keeping Sula."
>
> "They ain't worth more than me. And besides, I never loved no man because he was worth it. Worth didn't have nothing to do with it."
>
> "What did?"
>
> "My mind did. That's all." (Morrison 143–144)

No one seems able to convince Sula that a man is worth any kind of personal sacrifice. Full self-actualization remains this Diva's primary goal.

Sula has found a way to tap into herself, unlike the women in her personal life and wider community. She demands the right to feel and refuses to accept the expectation that Black women should remain stoic and deny their complex emotions; this is part of what makes her a Diva. Nel demonstrates stoicism after Jude leaves—she just carries on. Similarly, when BoyBoy leaves, Eva just carries on as well. The act of mourning seems a luxury life does not afford Black women, but Sula does not accept this. Consequently, she allows herself the opportunity to mourn her lack of motherlove in her "postcoital privateness"

(123). Her life changes forever the moment her mother says that she does not like her: "She only heard Hannah's words, and the pronouncement sent her fly-ing up the stairs. In bewilderment, she stood at the window fingering the cur-tain edge, aware of a sting in her eye" (57); she spends a good deal of her adult life contemplating what that moment means. Her mother's lack of love haunts her and she unsuccessfully attempts to heal herself of this open wound. As she struggles to bring meaning to her life, she also destroys it.

Sula is a Diva because she has to be, even while there is some reluctance to accept this role. We see this reluctance reemerge when Sula enters into a rela-tionship with Ajax. When she first returns to the Bottom, Eva warns her that "pride goeth before a fall" (93). Cavalierly she dismisses her grandmother, but Eva's words come back to haunt her. Like one of her doubles, Helene, Sula's fall suggests a reinterpretation of the trope of the fallen woman. Loss of respect here does not happen as a result of the deflowering of some unsuspecting virginal half-woman, but because of her willingness to give up that which is most important to her—Sula loses her mind for a man. All that she has stood for, the right to be what and who she wants, when she wants to, is jeopardized with Ajax. It seems that she experiments with relationship-making because she has established her right to do as she wants, but what she so quickly gives up, and without notice, is startling. Their relationship lasts for eight pages of the novel, and in that short time Sula becomes like the dolls she played with as a child. When love, the pursuit of which made the other women in town so desperate, arrives, Sula loses her head: "I did not hold my head stiff enough when I met him and so I lost it just like the dolls" (136). Once confronted with a man whom she imagines to be her intellectual and emotional equal, she begins to realize how easy it is to lose oneself: "Sula began to discover what possession was" (131). This throws into disequilibrium all the values she has thus far expressed. As his name implies, Ajax appears to deliver a message. Has her strong claim to independence all been the musings of a slighted, unfulfilled woman who unconsciously enjoys monogamous longings, or is she "craving for the other half of her equation [as] the consequence of an idle imagination" (121)? It seems that Sula, out of both a spirit of adventure and perhaps some boredom, decides to understand and dismantle the coupling convention that has left her with-out her best and only friend.

The relationship Sula has with Ajax is unlike any she has ever known and she is thus hopelessly unprepared for it. Spurred by curiosity, Ajax makes a trip to see this woman he thinks might be interesting, like his mother. Ajax has enjoyed motherlove—"this woman Ajax loved" (126)—and he is hoping the

woman he will meet in Eva's house will therefore warrant his respect. She does at first. He appreciates that she does not seem to abide by local mores: "Her elusiveness and indifference to established habits of behavior reminded him of his mother" (127). After only a moment, she lets him in her house and takes him into the pantry, reliving the easy memory of her own mother. What seems about to develop is a healthy relationship in which neither initially wants more than the other can offer or accept. "His refusal to baby or protect her, his assumption that she was both tough and wise...sustained Sula's interest and enthusiasm" (128). Soon, however, Sula wants more. Obsessed, she wants to know what makes him different and better than anyone she has ever encountered. She decides that under his skin there is gold leaf, alabaster, and fresh, fertile loam (130). Ajax is an enigma for Sula, in part because he exudes the confidence of a person who has experienced motherlove. As a Diva this confounds her. Despite her travels she still has never met a man like Ajax, and the relationships she has had with men and women thus far have led her to more questions than answers. "*How much water to keep the loam moist? And how much loam will I need to keep my water still? And when do the two make mud?*" (131, emphasis Morrison). She is so entranced by the absence Ajax seems to fill that she reverts to the expressions of manlove she saw in her household as a child. Sula has made questionable choices throughout her life, and yet this one does not seem designed merely to shock; she wants Ajax but has no relationship skills to make manifest her desires. Cleaning the house and putting silly ribbons in her hair reveal the lack of exposure to demonstrative love she has experienced in her life. She becomes unsure of herself outside his attention and begins to crave his expressed valuation of her. The death knell of the relationship occurs when she is more interested in preserving their relationship rather than allowing it to exist without the type of expectations she has avoided all her life. Upon Ajax recognizing the signs of possessiveness "his eyes dimmed with a mild and momentary regret" (133) and soon thereafter he departs. With his absence, it becomes clear that Ajax serves as a test of Sula's own value system. Is her neck stiff enough to remain true to herself while exploring the possibilities of monogamous love? To her dismay she finds that, at least in one way, she is not so unlike the dying stumps of women around her. When confronted with a legitimate potential partner, she loses her head. She tries to comfort herself with the knowledge that her curiosity would have killed him, saying "It's just as well he left. Soon I would have torn the flesh from his face just to see if I was right about the gold and nobody would have understood that kind of curiosity" (136). Sula's untimely death acts then as the manifestation of both her disappointment in

the failure to meet the challenge of love and a thorough understanding that there is no place for her in this world. It is at the same time self-flagellation and celebration. She recognizes that "there aren't any more new songs....I have sung them all. I have sung all the songs there are" (137). She has no mother to love, no friend to love, and, when she encounters romantic love, she discovers there might be no self to love either. Only a Diva can recognize the real choices for what they are and make the hardest ones.

Medallion's Black community, surmising that Sula dies of some dirty woman's disease (139), is unable to understand that the joyfulness they find in her death reinforces their dissatisfaction with their own lives; ultimately that misplaced joy leads to their own deaths in the final Suicide Day in the novel. They misread her death as punishment for a refusal to live life according to their exacting standards, but Sula's death has nothing to do with acquiescence to communal pressure. Rather, it marks an active choice to test other boundaries. Faced with the monotony of a life lived in futility, this Diva decides she would rather not. As all of her sexual encounters suggest she is prone to do, Sula reconsiders her life in its final moments as if to be sure this is the choice she wants. She recalls her mother's death as a beautiful dance, alluding to her aesthetic approach to life: "I wanted her to keep on jerking like that, to keep on dancing" (147). When Sula dies, she even wants to tell Nel about death, how painless it is, as if she wants another to celebrate the choice she is making. "Well, I'll be damned....It didn't even hurt....Wait'll I tell Nel" (149). Death, for Sula, is not just a passive event that happens to her, but is an active experiment of which she is not afraid. It is an act of survival, a realization that there is nothing for her on Earth and a willingness to transcend the present to expand her explorations of the self. Grewal mistakenly argues that "Sula's refusal to assimilate costs her dearly: she lived and dies in isolation" (47). What she fails to consider here is the articulation of a choice that means her loneliness is of her own making—"my lonely is mine" (Morrison 143)—and that she is not afraid to pursue self-actualization to death. She wants to tell Nel that it is not painful and that women allowing themselves to be tied to marriage and motherhood, immobile, thinking that they are cheating death, are denying themselves and dying slowly and painfully without risk or joy; they are, in fact, living a "death-in-life conventionality" (Burrows 131). Medallion's women are afraid to embrace a destiny anything like Sula's; they are afraid to live because it might mean making hard choices between a half-life and a true death. "But the freefall, oh no, that required—demanded—invention: a thing to do with wings, a way of holding legs and most of all a full surrender to the

downward flight if they wished to taste their tongues or stay alive" (Morrison 120). What they are unwilling and perhaps unable to see is that she has the enviable life because she lives and dies without the fear that defines their existence. Sula, like a true Diva, is willing to step out, and though she never cares if she is emulated she knows that she will be loved—in time. "Oh, they'll love me all right. It will take time, but they'll love me....And I know just what it will feel like" (146). As a Diva she can value herself way before others recognize her greatness. Sula dies of the cancer of having no place to be. The smallness of the life she is expected to live eats away her insides to the point of death; she cannot live as an "artist with no art form" (121). The liminal space in which she is expected to operate is thoroughly unforgiving. Marie Nigro points out that it is the larger society that fails Sula, and, while this is true, the failure by the Black community is more readily apparent (734). Her cultural community fails to embrace her alternative way of living, to see anything valuable in the options her life potentially presents to others. Because they fear her, they ostracize her. Throughout "In Search of Self" Nigro argues that Sula depicts a community of characters whose concepts of self have been thwarted by the absence of opportunities for respectable gainful employment. For many characters this is true, but Sula longs for more than gainful employment; Sula is looking for her art. It seems that Sula, like Janie Crawford, who also lacks motherlove, is searching for more than employment or motherhood. Instead what they offer is more meaningful: It is a portrait of choice—difficult choice. In the end the indictment in Sula is ultimately of a Black community's inability and subsequent unwillingness to accept and learn from the valuable differences that a Diva reveals to them.

Their Eyes Were Watching God is published in the same year Sula returns to the Bottom—1937—and the communities in both, despite the 36 years that separate them, are too much the same. Janie Crawford longs to find things "petal open," not "leaf dead," as Sula continues to find them. Morrison, here, seems to be revising Janie's return to town, hoping for a different reception. Sula, in some ways, found out about living for herself. She attempts to impart this wisdom to her friend. Unlike Janie, though, who seems to fade away sitting on her porch, Sula makes decisions on that porch that give her measures of freedom. It is not, in the end, an external lover that makes Sula long for death; rather, it is because she is not able to love herself the way she wants, where she is or anywhere else. Ajax serves merely as a catalyst. The cancer of a tiny life, despite an unrestricted way of thinking about it, kills her. "At the end, [she is] fatally consumed by the battle [she wages] in the face of traditional morality and

authority. Death, [her] last act of defiance, becomes the final rupture with and escape from society" (Ghaly 22). Nel sums up the futility of the life expected of Sula: "You a woman and a colored woman at that. You can't act like a man. You can't be walking around all independent-like, doing whatever you like, taking what you want, leaving what you don't" (Morrison 142). Sula, unwilling to accept this as her truth, prefers to die; death here is an active and welcomed choice. "Sula felt her face smiling...it didn't even hurt" (149). In the end it was better to die than to live with the unimaginative sameness of everyday living.

Sula in many ways is Janie more fully realized. She is a woman before her time, wrestling with a lack of motherlove in a small, tight, unforgiving Black community. The porch reappears in *Sula* as a potent symbol; there Sula is watched and judged. On Eva's porch, the Bottom legitimizes its fear of her and reveals the inability to accept Sula's choices. Marked as evil from her actions on the porch, Sula is therefore "alone in [her] attempt to unmask social and political hypocrisies" (Ghaly 22). She comes from a clan of agitated and agitating women, and while they choose to live life unexamined, with time and introspection Sula rejects their life. There is no reason to suffocate in life or die like a stump. She willingly takes the next step without so much as a question. Her desire for more allows her to transcend life. As a Diva figure she steps into the unknown, searching for what she has promised herself.

· 4 ·

REVISING JANIE CRAWFORD

Divas under the Male Gaze

In 1986, Spike Lee attempts to revise Janie Crawford, to take her off the porch nexus of true womanhood, Uplift, and New Negro ideology; "presumably Janie's course of cultural narration is what Spike Lee alludes—no aspires—to for Nola Darling" (Baker, "Spike Lee" 246). Zora Neale Hurston's novel, *Their Eyes Were Watching God* (1937), serves as a frame for Spike Lee's film, *She's Gotta Have It*. Lee calls our attention to this revision by utilizing the first two paragraphs of her novel as the epigraph of his film. What unfolds, however, is a masculinized revision of the Diva figure because "Hurston's [text] is restaged in a manner that reasserts patriarchal privilege" (Iton 151). Thus Nola, from the outset is a faux Diva because she, by direction, does not explore life outside the limitations placed on Black womanhood. Instead, she is trying to achieve what amounts to a very male vision of what life off the porch means. We therefore have to answer the question: What happens to the Diva figure when she enters the male gaze? Lee draws what might initially seem to be a portrait of a strong, Black woman living outside cultural dictates. Upon closer inspection, however, it becomes evident that Lee's attempt at revision makes the world even smaller. Nola Darling, the protagonist of the film, is in no way more free—and in many ways is more limited—than Janie Crawford, the 1937 protagonist of Zora Neale Hurston's *Their Eyes Were Watching God*.

Lee's attempt to depict a Diva goes off the rails from the film's opening cred-
its. Nola Darling, the protagonist, is presented as an independent woman liv-
ing in urban New York City, circa the mid-1980s. She has three lovers: Greer
Childs, an elitist, self-absorbed fashion model; Jamie Overstreet, a middle class
Black man with a seemingly middle of the road value system who is hopelessly
in love with her; and Mars Blackmon, a crude bike messenger with a name
chain and expensive sneakers despite his underemployment. The body of the
film begins with a pictorial montage of mostly children and men, with two
exceptions: two of the images are of women. The first is of a portly, matronly
woman in a headless shot, which begins at her breast and continues down to
her feet, and the other is of a woman in a leopard-spotted catsuit hanging off
the side of a bus. This imagery immediately calls into question what Spike Lee
thinks a Diva is. The idea of the Diva is to move away from staid stereotypes
and yet the film opens with a mammy figure and a jezebel portrait; this is a
dichotomy the Diva figure seeks to undo.

Lee's revisionist intentions of Hurston's *Their Eyes Were Watching God* are
evident. However, it is unclear whether his revision will live up to his inspi-
ration, outlined in the film's epigraph. In both works, we have women
attempting to achieve self-actualization, interacting with three different
lovers, and insisting on telling her own story. When Lee's protagonist, Nola
Darling, appears, she is sitting under the covers in what Lee describes in his
journals as the "loving bed," attempting to legitimize her reason for revealing
her story. "I want you to know the only reason I am consenting to this is
because I wish to clear my name. Not that I care what people think, but
enough is enough" (*She's Gotta Have It*). Nola wants to make herself under-
stood, but both her location and claim seem to undermine what it attempts
to mirror in Hurston's text; the scene represents at best, a superficial under-
standing of *Their Eyes Were Watching God*. The pear tree under which Janie
sits is rife with more meaning than sexual freedom; she imagines equality in
love while lying there, something that Nola never seems interested in inves-
tigating. Janie relays her story of personal growth and tragedy from an empow-
ered position on the front porch of her own home. She tells her story to
enlighten her friend, to provide Pheoby with hope of a better life and a more
meaningful relationship. In Lee's revision, Nola's most prized possession is her
bed and her reason for speaking is to explain her sexual proclivities to a dis-
approving public. Evidently Lee's articulation of a Diva is less provocative and
more singular. The contrast between the two is stark and is more than gen-
erational.

There seems little to connect the choice of speech between Janie Crawford and Nola Darling: one is attempting to define Diva desire—Janie—and the other is capitulating to a disapproving audience—Nola. The reason for each woman's testimony and what their lovers reveal about them is vastly different. Janie, on the one hand, learns from her lovers and eventually loses the need to have one, which she makes evident by killing Tea Cake. The internal monologue throughout the book is hers; we hear her perspective and see more of her than anyone else. And although she allows her voice to be obscured at times, she more or less succeeds in having her own independent life. Nola's narrative, on the other hand, happens as the result of the voices of others. She begins the film saying she wants to clear her name; this is a very different articulation than in *Their Eyes Were Watching God*. Janie decides to speak, to tell her story, because she wants to encourage her friend to go to the horizon as she has, to truly experience life. We know she is successful because her listener claims, "Ah done growed ten feet higher jus' listenin' tuh you, Janie. Ah ain't satisfied wid mayself no mo" (Hurston 192). While Nola claims to want to clear her name, she is allowed very little space to do so. Jacquie Jones asserts that Nola "was only allowed to be viewed through the attitudes of three clearly deficient men—a narcissist, a dullard and a social retard" (254). Their deficits are further multiplied and their unreliability as narrators revealed because each has, as his final motive, possessing Nola. They go through many ministrations to try to convince her that her lack of reciprocal feelings of attachment, except perhaps in her sexual acts with them, suggests that she is mentally unstable and a freak. This becomes something she truly begins to fear. In typical fashion, Nola is unable to voice this herself and instead we hear of her fears from her new therapist: "Nola Darling came to my office a confused and frightened young lady. It seems as though one of her male friends told her she was sick" (*She's Gotta Have It*). When the film is over, we know more about her lovers than we do about her. Nola's refusal to tell her own story, and the inability of others to do a fair job of it, puts forth a discouraging and implicit suggestion that women defy understanding. Now Divas may defy interpretation, but fully realized they do have a plan—there is, in fact, a goal. Nola has none and thus is not a Diva. Her misunderstood "craziness" seems to be nothing more than sexual confusion; it is unlikely that she is having sex purely for pleasure.

Nola's "craziness," though, causes the men to label her a freak and she wilts under this accusation. The meaning of the word "freak" has shifted over time, according to Patricia Hill Collins in *Black Sexual Politics* (2005). She cites the

Rick James 1981 song "Superfreak," which suggests that a girl interested in satisfying a man's every pleasure is not a girl one takes "home to mother" ("Superfreak"). Nola, as written, is represented as this type of freak; her crude lover, Mars, recognizes this. Perhaps because of this recognition, this relationship seems more fulfilling for each party than any other portrayed in the film. Their relationship is based solely on their mutual interest in having sex with each other. In contrast, both Jamie and Greer are intent on changing her into the woman one can take home to mother. Unfortunately, the film never transcends this over-simplification of the notion of the freak. Unlike Missy Elliot's hip-hop anthem, "Get Ur Freak On," one is not sure that Nola has ever learned to do that except for in the most superficial of ways. Essentially she has not learned to truly live outside of any boundaries, or how to make choices that fit her own desires. While Helga Crane of *Quicksand* may not be able to name her desire, she is driven toward agency; Sula Peace, without an art form, is still living experimentally. These are examples of Diva desire and by comparison Nola seems merely immature. She surrounds herself with poorly matched partners and in this way curtains herself from the world.

Nola excommunicates herself from potentially helpful communities in her unexamined quest for sex. Nola lacks community, especially a community of women with whom to interact. While Janie lacks an active community of women, her isolation is not self-inflicted as Nola's is. Nola's world consists of her three lovers; a distrusting ex-roommate, Clorinda; and a lesbian friend, Opal, who is in hot pursuit of her. In his journals, Lee discusses a very different world for Nola—one in which she is featured, rather than the world of her paramours (Lee 150). He wants the relationship with Clorinda to figure more prominently, to represent a real friendship—despite the present hard feelings concerning Clorinda's exodus, which results from the sheer number of male guests Nola had in and out of the apartment. Lee wants to show Nola as being politically aware and working to register people to vote on the weekends. Lastly, he wants to show her as being active in her workplace. Unfortunately, as presented in the film, Nola lacks all of these dimensions. With the exception of perhaps three moments—working on a project in her loft, with Greer looking on; questioning Opal about lesbian sex; and bemoaning her loss of Jamie to a disinterested Clorinda—Nola does nothing except have sex with men. It seems in this instance Lee has mistaken isolation for independence. Houston Baker asserts that "neither men nor women in the black community are capable of fruitfully collaging with Nola. She escapes their comprehension, eludes their possessiveness, and provokes their wrath" (Baker, "Spike Lee"

249). Yet this isolation, upheld as a desirable subject position, provides her with no personal insight. Her solitary journey never achieves self-actualization, the goal of every Diva.

Unlike Nola, the "it" that Janie longs for is more substantial than sex—she longs for equality and self-actualization. While Janie's carnal desires do in some ways dictate how her life unfolds, she wants to do more than fulfill her sexual desires. The title of Lee's film suggests so much possibility: *She's Gotta Have It*. It is as laden with potential meaning as Hurston's portrait of the pear tree with bees sinking in every blossom. The "it" here suggests a multitude of things. Lee though, reduces that "it" to just sex, undermining his own idea of an independent Black woman. Nola seems clearly dependent on sex for survival—sex with a man, that is. While she seems to tease Opal in some ways, when Opal makes a serious advance, Nola rejects her thoroughly. Beyond being unwilling to explore what seems a bicuriosity, Nola cannot even do "it" to herself. The audience has the opportunity of witnessing her futile attempts at masturbation. This inability to physically satisfy herself speaks to her emotional dependence and her lack of knowledge about her own body. She reaches for others because she cannot find herself and she cannot find herself because she is not looking. While Janie Crawford has scant sexual experience by comparison, her first sexual encounter is by herself, arguably masturbating underneath the pear tree. How could Nola be a modern day revision of Janie with so little knowledge of self and pleasure? The "it" that Janie is looking for is far reaching—new concepts of womanhood, her place in the world, happiness, pleasure, and sex. It seems, however, that when the Diva figure enters the male gaze she loses agency. Her scope becomes small, limited—different from the liminal spaces of women writing during the Harlem Renaissance, but just as limited. Nola's ideas of independence are limited to her sexuality, and while Black sexuality has become a "site of contestation" (Manatu 126), the problem with a character like Nola Darling is whether or not she represents such a site. "The difficulty lies in telling the difference between representations of Black women who are sexually liberated and those who are sexual objects" (Collins, *Black Sexual Politics* 126). Rather, it seems that Nola becomes what Ed Guerrero names "the sign of the whore" (238). Positioned in her bed, she becomes a sexual object to be possessed by others. She lacks the ability to self-generate any power from her sexual encounters. Consider, for example, how Sula experiences a sense of powerfulness through her sex acts: "particles of strength gathered in her like steel shavings...forming a tight cluster that nothing, it seemed, could break" (Morrison 123). Nola never encounters any new part of herself through

the sexual politics she plays in the film. Instead it seems that the sex and the partners she has it with consume all of her time and effort. She manages them as a means to escape self-actualization. Sex becomes a way to avoid knowing herself.

She's Gotta Have It positions itself as creating a discussion about cutting-edge sexual politics, but moves very little from a traditional patriarchal understanding of it. Instead Lee just imbues his protagonist with a masculine playboy persona and pretends that this is what a real feminist looks like. Nola has a stable of men and her interactions with them are limited to shallow sexual encounters that leave her unfulfilled. She is presented as independent because she is essentially displaying masculinist tendencies at there worst but what makes participation in shallow sexual relations "sites of contestation" (Manatu 126) or acts of freedom? "*She's Gotta Have It* portrays black female sexuality as rooted in the body of Nola and in the speech acts and gestures of men" (Reid 97). The limitations in Lee's film suggest a lack of understanding about the complexity of Black feminist thought. He allows mainstream feminist ideals to inform his depiction of a liberated Black woman. Perhaps this is one of the reasons why, in response to Lee's requests for funding, the Black Pan-Hellenic group with the largest membership, Delta Sigma Theta, found themselves initially reluctant, and finally unwilling, to finance any portion of the film despite their interest in supporting Black filmmakers (Lee 253). According to Patricia Hill Collins, Black feminist thought has evolved and does not represent the "masculine" ideal as a marker of freedom. Black feminist thought is fluid in nature, and while "speaking out" and "speaking one's mind" (Collins 134) represent a large part of that ideal, the support of a community of women makes one's independence more meaningful. This is something made unavailable to Nola. Lee's supposition is that Nola is alone because she is strong, but this characterization of Nola is wishful thinking. At best she is kept in isolation by her overindulgence in the desires of men. That is, she is more concerned about disarming them than learning anything about herself. Nola is not experimenting with some new aspect her identity discovered through sex, as Sula does, but rather is preoccupied with the hopes and desires of the men in her life.

Nola is constantly defined by the company she keeps, and while Greer Childs is not the first male companion we encounter, his relationship with Nola is the most curious. After reading a draft of the screenplay, Tommy Hicks, the actor who plays Jamie, posed a simple question to Lee: "Why would Nola even see this guy" (Lee 188)? Lee says he is never able to answer that question, and

yet the relationship stands. "Now this is a question I have asked myself. What are his redeeming qualities? I was hard pressed to find one . . ." (188). As a fashion model, Greer's obsession with his physical appearance may be understandable to an extent, but there is the mark of the absurd about him. He is ever primping and preening. When accepting his award of sex from Nola for his recent appearance on the cover of GQ (the gift in and of itself is highly problematic), he takes the time to carefully fold his ratty workout clothing. It could be argued that he is trying to elevate Nola's anticipation, but he almost misses out when she nearly falls asleep waiting. Rather than creating anticipation, he seems to be attempting to assert dominance; he is not pressed or so he wants her to believe. Sex with Nola is good, but his actions suggest that he is no slave to it. His continued insistence on being a part of her life belies his intent—he means to possess Nola. He is obsessed with turning her seeming disinterest in him into an obsession of her own. To this end, he employs several tactics to undermine her confidence and sense of self. In general, he consistently attempts to belittle her worth, locating his interest in her as a purely physical one. Greer tells the camera that he "wouldn't bother with her if she weren't so fine" (She's Gotta Have it). Crassly, he makes it clear that he is most interested in her because of her physical appearance and that without it he would not put up with her insistence on polyamory, but who is he trying to convince? He has to create for both himself and others a reason for tolerating Nola's seeming indifference. His shallowness is revealed as the reason he falls prey to her bewitching beauty. Continuing to tolerate what he considers to be her abuse of him does not say much for his character and continues to confound attempts to explain Nola's interest in him. Initially, he is simply amusing to Nola, but eventually his tactics become more menacing. What Diva would put up with this type of behavior? Of course, one could argue that his impressions of her bear so little weight in her sense of self that she need not take him on, but with further examination this does not prove to be true.

Unable to come to any conclusions herself, Nola allows Greer to impress upon her his own idea of female sexuality. He calls her a freak—something the other men do not echo in her presence—and he suggests that she should see a psychologist. Now a Diva may choose to go to a psychologist, as Liliane in Notzake Shange's novel Liliane: Resurrection of the Daughter did, but the difference here is that Nola's decision to go is not her own. She is pushed into it by a manipulative boyfriend, allowing his self-serving calculation to unsettle her. Immediately, she seeks the help of a therapist because she lets Greer's limited notions of womanhood define her. When this definition is forced upon her, she almost accepts it.

S. Epatha Merkeson's characterization of a psychologist, perhaps the only strong portrait of Black womanhood in the film, prevents this by telling her that her sexual desires are normal, healthy even. She goes on to tell Nola, "Your sexual organ is between your ears, not your legs" (*She's Gotta Have It*). Nola, however, is unable to really hear this and continues using her body as her only means to express herself. For all her sexual independence, she needs another person to authenticate her sexual choices and freedoms. Notably, it is a woman who validates her sexuality. This again highlights her lack of a woman-oriented community. bell hooks, in "Whose Pussy Is This?" says a friend writes to her looking for a feminist response to her question: "Is Nola independent or is she just a WHORE?" (hooks 228, emphasis hers). It seems that this question was on the minds of many Black women who saw the film. Can we surmise from the positive interaction between the doctor and Nola, despite its inability to modify her behavior in any way, that had she had a community of women with whom to interact, her behavior might have been tempered? Had she a cadre of friends, would she have been able to talk to them and in this way been able to think more deeply about her relationships with these men and how they direct her life? In this way she is connected thematically to Toni Morrison's character Sula. Sula rejected her female community; Nola flounders within hers and is rejected by it. As a result there is no wisdom of experience to share or learn. Despite being an artist and because Lee rarely occupies her with her art, Nola, like Sula before her, is "like any artist with no art form...dangerous" (Morrison 121), becoming a danger not to the men around her but rather acting as a pariah to her own self-actualization. Nola has no friends, male or female, and thus her dependence on her male companions' definitions of her is so complete as to almost cause her to lose sight of herself. There is no mirror in potential girlfriends and she is incapable of holding up a mirror to herself. While she knows enough not to thoroughly trust the opinions of the men in her life, she is not comfortable enough in her choices to tell them all to go fly a kite. Nola is not a Diva because she does not exist outside of her relationships; her boyfriends attempt to define her for their own ends and she lets them.

Nola selects Greer because, despite her job, she seems to need some other outlet; she engages in a power struggle almost as if to pass the time. It's a game and, frankly, it is one Greer is losing. He constantly says that she is "rough around the edges" (*She's Gotta Have It*), someone who is beneath him, yet he longs to possess her, chiefly so he can mold her into someone else, someone acceptable. He never considers that there is someone who might already conform to his ideals; Nola presents a challenge he must conquer. Her relationship

with him satisfies Nola's ego, as she is able to manipulate him. Ultimately, however, the relationship is unsatisfying because it is a manipulation based purely on her physical appearance; she must turn to other men to satisfy other needs. Greer concedes in the end that Nola saw her paramours together as one complete man. I would argue that she does not see them as anything but space fillers. Dissatisfied with his inability to make Nola his, Greer attempts to destroy her sense of self. Nola almost becomes the troubled woman Greer sees. She puts aside her relationship with him and her other lover, bike messenger Mars, and attempts to live out romantic, monogamous longings with Jamie. This again reveals Lee's inability to write a Diva because longings of the sort she indulges in with Jamie Overstreet are what Divas, including Janie Crawford and Sula Peace, recognize as dangerous to their own freedoms.

An average man with no special knowledge or talents will not do for a Diva. Jamie Overstreet appears to be your average Black man. One day, he sees Nola walking down Nostrand Avenue in Brooklyn and for him it is love at first sight. That Nola is the only one for him supersedes whatever ideas Nola might have for herself. He never considers why he feels Nola is the only one in the world for him, or that he might not be *her* choice. Nola is clearly swayed by his attentions. Unlike Greer, he is initially not unkind; he lavishes her with compliments, time, and attention. Unlike Mars, he is able to spend money, to entertain her in ways that are pleasurable and not status-seeking acts, as is the case with Greer. Instead of dinners at posh restaurants, Jamie arranges for dancers to perform in the park in honor of her birthday. None of the other lovers even acknowledge her birthday. At first, he seems to be the most appealing of the suitors. In the end, he turns out to be the most aggressively possessive and dangerous.

Nola reciprocates Jamie's declarations of love. Lee shows this by making her only able to reach orgasm during sex with him (Lee 150). By doing this, Lee implies that Nola can only be truly sexually fulfilled within the confines of a traditional relationship, perhaps even a traditional marriage. This is not to be for these two; it seems unlikely that love plays any part in their relationship. With little exception, Jamie attempts to claim ownership over Nola. Consider their initial meeting; He stalks her down the street and presses her into a date with him, a complete stranger. When she is ill, his sickbed monitoring becomes another moment for him to express his possession. Instead of joining Opal, a friend and unrequited suitor, in taking care of Nola, he verbally pushes Opal around with menacing tone and behavior until she leaves. For Jamie, Nola is another thing to be possessed, and for a time Nola toys with

the idea of being possessed. As with her relationship with Greer, in the beginning Nola is just having a little fun, but the romance then turns into a play for power. What other purpose does Jamie serve but to play Romeo to Nola's Juliet? Nola eventually longs for this relationship to such a degree that she attempts to re-draw her world in order to keep him; this insinuates some longing to play the role of a more traditionally acceptable woman. For Nola, Jamie is a fantasy; he plays into her seemingly deep-seated desire to behave in a more culturally acceptable manner—he is a romantic fantasy. With him, she could stop being Nola the freak and become Nola "the Black Lady," in Collins's terminology (139). But she does not really want what life with him offers. She does not want to be his wife, just as Helga Crane in *Quicksand* has no interest in being James Vayle's wife. Jamie tries to force his mainstream ideal of monogamous, heterosexual, romantic love onto their relationship. He both wants her and wants her to see that he is the logical choice. By desiring her as a wife he tries to appeal to Nola's sensibilities, suggesting that she needs to reenter the world of the acceptable. To a certain extent, she begins to be taken in by his ideal of womanhood, but, to her credit, she eventually rejects him and, through that rejection, refuses acceptance of restrictive communal expectations. Although he is presented as the most understanding of the group, he is the only one who vigorously objects to her relationships with other men and the only one who has jealous suppositions about Opal, her lesbian friend. His acts of devotion merely mask his true desires for possession. Greer and Mars are not happy about her relationships with the other men, but besides questioning her taste, and perhaps for Greer her morality and sanity, their objections are muted. Dissatisfied with Nola's lack of allegiance to the relationship, Jamie begins seeing another woman. Nola, unable to satisfy herself sexually, calls upon him, the most caring of her lovers. When Nola calls he is in bed with another woman and, despite his anger, he comes when she calls. She tells him it is urgent, but the audience assumes that Jamie is well aware of what need Nola wants fulfilled. When he arrives at her apartment, Jamie is angry with himself for not being able to convince Nola to enter into a more permanent arrangement and at his willingness to forgo a more traditional relationship with someone else in order to take another chance at getting his prize—Nola. Here we see "women are so brutally relegated to the status of 'prize' as to suggest an over identification with white maleness and the systems of sexual oppression in the society at large" (J. Jones 254). His tactics this time are more visceral and more physical. He violates her sexually. If she will not bend to his will after all his romantic gestures, then he will use violence to win her over. It almost does.

The debate that has swirled around the rape scene in the film makes clear the dismantling of any Diva figure Lee is trying to establish. The following scene of sexual violence between Jamie and Nola has been much discussed:

NOLA: Make love to me.

Jamie lets her go, steps back and glares at Nola. He has not forgotten.

JAMIE: I'll fuck you but I won't make love to you.

Jamie grabs Nola and flings her onto the "loving bed"...Nola looks up at Jamie while he bends down and turns her around. Jamie pulls up her pajamas and takes down her panties....Jamie unzips his pants and enters Nola from behind. This is unlike the Jamie we've seen, the Jamie we have known up to this point. He's frustrated and treating her rough. While Jamie is doing this he's yelling all kinds of stuff at her. He's trying his best to hurt her feelings, he's demeaning her.

JAMIE: Is this the way you like it? Is this the way you like it? Does Greer do it like this?

What about Mars?

Who else? Who else?

Nola is crying.

JAMIE: Now you have something to cry about.

NOLA: You're hurting me.

JAMIE: Whose pussy is this?

NOLA: It's yours. (Lee 350)

The question lying at the heart of this scene is not whether Nola is raped, but rather, why Nola fails to recognize her rape as such. What educated, independent, maybe-feminist woman character, as Spike Lee would have the audience believe, would not recognize Jamie's sexual violation as anything other than rape? But Nola is wholly incapable of it, going only as far as it label it a "near-rape." But as hooks stridently argues "those of us who understand rape to be an act of coercive sexual contact, wherein one person is forced by another to participate without consent, watched a rape scene in *She's Gotta Have It* (hooks, "Whose Pussy Is This" 232). Felly Nkweto Simmonds similarly argues, pushing the definition of rape even further by suggesting that Lee "subjects her not only to physical but psychological rape" (18). It is difficult to understand why this scene provokes a need to clarify the boundaries of rape; these clarifications leave too much room to excuse Lee's choice. In the over twenty-five years since

the film's release, he has expressed progressively greater regrets for including the scene, ultimately claiming it to be the mistake of a young director (Hoffman 111). His excuses notwithstanding, unlike any other scene in the film, Nola's rape, plainly reveals his total lack of understanding of either Hurston's heroine or the Diva figure he is trying to imagine. The scene's construction limits the potential of Nola to portray an independent woman. "Even when Jamie rapes her, the threat and danger are minimized by the way the scene is constructed" (Simmonds 18). The final devastation of whatever might remain of the Diva construct comes when Jamie asks Nola "Whose pussy is this ?" and she answers "It's yours" (*She's Gotta Have It*). Nola has attempted throughout the film to assert independence, to insist that no one has a right to her body. The rape scene itself and the manner in which she is debased—being both asked and answering affirmatively to give away ownership of her sex—undoes any progressive spirit the film purports to express. It seems as though the film gives up on Nola and Nola gives up on herself. Clearly there is no space where any version of Spike Lee's Nola can exist without being reined in, if not by cultural mores, than by physical threat. All hope for the emergence of a Diva figure in *She's Gotta Have It* vanish and the audience is left with a patriarchal fantasy of an independent woman crushed because of her unwillingness to behave in socially acceptable ways. And as if a final, coup de grâce Nola accepts this punishment without retaliation.

Nola's life changes radically after this incident. She ends her relationships with both Greer and Mars. She goes to Jamie to announce that he is her choice, but that she wants to be celibate until she recovers from what she continues to name a "near rape." The mask of the understanding Jamie is gone; he is dissatisfied with this new celibate arrangement, and she eventually relents. While it might appear that Nola has given in to monogamous, heterosexist longings, it seems more likely that she is trying to reestablish control in her relationship with Jamie. Misguidedly, she thinks that by controlling him she controls herself, but Jamie has revised the sexual politics of their relationship and gained the upper hand. Through his violent act he once again becomes interesting to Nola. He is no longer playing the role of a pleading man begging for love and a relationship; he is a man asserting his power over her through sexual domination. It is as if his attempt to renegotiate the playing field by taking control sexually proves he is a real man. Nola rids herself of all distractions, as the other men in her life provide no challenge; she leaves them to focus on controlling just one, Jamie. The ultimate message of the film is that violence is sexually interesting. Has Jamie now become a desirable man in Nola's eyes?

Does violence become equated with manliness? Again, all of this points to Nola's loss of voice; the only way she knows how to gain control is through her body. Even more disturbing is her seeming interest in violence. She is not brave enough to inflict self-harm, but rather expresses masochistic tendencies. Being unable to process pleasure, it seems, she longs for some other way to feel. Nola's impetus for change comes via sexual violence; she is not able to self-generate change and thus puts herself in ever more physically dangerous situations. Perhaps she wants a different life, but until she is raped she is unable to even begin to articulate that desire. For a true Diva the desire for change comes from within.

In Lee's source material, *Their Eyes Were Watching God*, Janie's survival may not be assured, but there is a window of opportunity. She does not have to live her life by comparisons, although she may choose to do so. Nola's survival in the end, however, is much less assured. Her final choice of the three, Jamie Overstreet, brutalizes her. While one cannot blame the victim for her perpetrator's crimes, one can worry that it may happen again. She is not truly in control of her destiny, despite her feelings to the contrary. When her life is at stake, Janie sacrifices her lover and the happiness their relationship brought her rather than die herself. Nola merely stops speaking to her lover; her act lacks the same finality that Janie's has. She does not call the police, ask for protection, or attempt to protect herself in any meaningful way.

Houston Baker makes evident that he is frustrated by the romantic readings of the *Their Eyes Were Watching God*—what he maintains is a refusal to see the book for what it is. And yet, he seems to give Nola what amounts to a romantic reading in his essay "Spike Lee and the Culture of Commerce." Baker suggests that only a woman like Nola can attempt to control her destiny because she has learned to make collages: "People know only parts of Nola. And unlike Nola herself, those who claim to know 'parts' have not mastered the art of collage" (Baker 248). He continues to argue that her ability as an artist makes her a new world woman and, as such, she is powerful. Unfortunately, he does not see that Nola is all but silenced throughout the film. She rarely speaks on her own behalf and the men in her life come to define her because she refuses to define herself, or, more specifically, she is never given that opportunity.

The silences of Janie Crawford and Nola Darling have different underlying motivations. When Janie is silent in the final court scene, she is making an active decision not to speak. She refuses to plead her case because she no longer seeks the approval of others; "she just sat there and told and when she was through she hushed. She had been through for some time before the

judge and the lawyer and the rest seemed to know it" (Hurston 187–8). Nola's silence is deafening but not active. She does not have the verbal vocabulary to express herself and almost everything we learn about her manifests itself through her physical actions and not through her words. When she does speak, she uses her voice in a manner completely contrary to Janie because her only attempts to articulate herself occur when she tries to defend her sexual choices while sitting in her bed at the beginning of the film; Nola speaks to defend her actions. Janie never speaks in the name of self-defense; she speaks to lay wide a bigger world. Nola never comes to any true understanding of herself, the world, or her place in it. Superficially, she may appear to fit the Diva persona: She flouts communal expectations of Black womanhood and seems at times to reach for the intangible. When she pulls her hand back and finds it empty, however, she stops any real personal growth and is content to live life unexamined. She suggests no new figurations of womanhood and provides no insight into how to live successfully in the world as Black and female. In fact, the film dismantles the idea of the Diva in almost every way while purporting to create a new paradigm for thinking about new Black woman characters as strong, independent, and original.

 She's Gotta Have It fails to present a promising image of a Diva. This, however, does not stop Spike Lee from making another attempt in his 1996 film *Girl 6*. He calls the audience's attention to his intent to revise his earlier failed attempt to portray a Diva by signifying on his first film. The protagonist here, Girl 6/Judy, uses for her working monologue as an actress the beginning of Nola Darling's first monologue from *She's Gotta Have It*: "I want you to know the only reason I am consenting to this is because I wish to clear my name. Not that I care what people think but enough is enough . . ." (*Girl 6*). While it is clear that he is signifying on his earlier film, "at these moments she seems to be doubling for Lee, who is also clearing his name with this film, wiping away the charges that he can only create sexist representations of black women" (hooks, "Good Girls" 21). Women were outraged by his portrayal of Black womanhood in *She's Gotta Have It* and, as if to acknowledge his failure at writing a Diva, he enlists Susan Lori-Parks of future MacArthur Grant and Pulitzer Prize fame to write the script of *Girl 6*. Bringing a woman in to write the script, though, turns out not to be enough. "The Spiked Lens is so pervasive that . . . the script cannot be flipped effectively or convincingly within a hegemonic patriarchal framework or the Spiked Lens" (Harris and Moffitt 318–9). Even Roger Ebert expresses in a film review that *Girl 6* "seems conceived from the point of view of a male caller, who would like to believe that the woman he's hiring by the minute is

enjoying their conversation just as much as he is" (Ebert). Lee serves only as this film's director and *Girl 6* is, to some extent, more successful, but it again fails in its attempts to portray a Diva largely because "the implication—that Lee is closing a circle and making a statement about the journey of black women— is forced and false" (Guthmann). Lee does this by showing his protagonist as an unnamed, confused, and struggling actress, and the film ends with Girl 6 newly renamed Judy, a centered, self-assured woman. At best this transition is forced and, at worst, implausible.

Phone sex is meant to be a way out for Girl 6; it proves to be the opposite. *Girl 6* is the story of a young African-American woman who becomes a phone sex worker in order to support herself and her fledgling dream of becoming an actress. Judy views her work as a phone sex operator as a means to pursue her art. Each new caller becomes another opportunity to express herself. She lends her voice to her callers and reserves her body for herself. She becomes very successful at her job and begins to connect with callers emotionally. When her boss realizes that she is burnt out, she is sent on forced leave to pull herself together. In order to maintain her revenue stream, she takes on home-girl[1] work, but when a home caller with snuff-film fantasies locates her address and threatens to kill her, the fantasy becomes too real. The caller moves beyond just the fantasy of killing Girl 6. He locates her real address and phone number and begins making real threats from a phone booth just outside her building. She immediately recognizes the danger, returns to a more direct path to stardom, ceases all phone sex work, and heads off to Hollywood. While this is an improvement over Nola's relative inaction in the face of rape, being victims of violence is the only way for these faux Divas to initiate change. There is no internal drive and, as a result, they merely react to the world around them rather than act on it.

The film starts with an audition, which quickly derails. The director constantly tells her "don't talk, just listen" (*Girl* 6). To entice her to really put on her best, he tells her that he is looking for the next big star who will have "the beauty of Halle Berry, the sexiness of Jada Pinkett, the soaring voice of Whitney...the range of Angela Bassett" (*Girl* 6). Girl 6, aka Judy, is trying to tell her story, but the director insists that she not talk. Her story is to be the one he is creating for her. The film for which she is auditioning is to be about a Black woman from a Black woman's perspective, but the only Black woman in the room, Judy, is being asked to be silent; she consents. Throughout the film she chooses to embody fictive Hollywood images of Black womanhood scattered about the film haphazardly, rather than be herself. She submits to this first

degradation when she is asked to expose her breasts in order to be taken seriously for the role. Girl 6 does as asked but immediately regrets it and leaves the audition in shame. Edward Guthman poses an interesting question about this moment: "So what's the point here: that actresses should be judged on talent alone? Or that Lee, because he's a serious film maker, should be judged by different standards when he pulls the same stunt as the Tarantino character?" (Guthmann) Girl 6's Diva desires are incomprehensible here, and better reflect Lee's desire to be taken seriously than her own desire to be a star. His protagonist wants to be seen, to be a movie star, but she does not accept the cost she is being asked to pay. When a similar scene to this one bookends the film, she outright refuses and does what she is not allowed to do in the first audition— she completes her monologue. These scenes suggest that unlike in *She's Gotta Have It*, the audience is meant to focus in on her voice, her art, and not her body. Judy's story is not written on her body; like Janie's, it is one she constructs with her mouth. Nola wants you to look at her mouth, but by talking from bed she undoes her spoken desires. Judy, however, does the reverse: Once her clothes come off, her mouth closes.

Girl 6 reveals storyline connections to both *She's Gotta Have it* and *Their Eyes Were Watching God*. Unlike Nola, Girl 6 works hard. She is a coat check girl, a film extra, a person who passes out flyers. Despite this, she is still unable to pay the bills until she becomes a phone sex worker. While sex centers part of her story, unlike both Janie and Nola it is not sexual desire that motivates her. Sex—fake sex—is just a means to an end for her. She has a dream of becoming an actress, and she is willing, like Janie, to do anything to accomplish that dream, her truth. But her acting coach tells her to "drop into the pain" (*Girl 6*) and belittles her inability to understand the business of acting. When complaining about her failed audition and her embarrassment at being asked to expose her breasts, the coach tells her to "make it art" (*Girl 6*). This becomes the focus of the life we see in the film. In an attempt to make every request art, she performs a number of fantasies. These performances allow her, at times, to lose herself in pursuit of her unexamined desires. This happens because Girl 6 never questions her choices or her goal of becoming a movie star. Each act is in dogged pursuit of an unexamined dream. Why she dreams what she does and what the achievement of the dream will mean to her personal development goes unanswered and, more significantly, unasked.

The viewing audience is given entry into Girl 6's vivid fantasy life through a series of narrative disruptions. While Janie's dream is provided through a single image, pear tree love, this film uses a number of different images in an

attempt to allow Girl 6 to find a place that fits. Her inability to find one that rings true throughout the film suggests that, despite the passage of over half a century between *Their Eyes Were Watching God* and the 1996 release of this film, that there is no place where the dreams of Black women can be realized. They must fantasize instead. Girl 6 daydreams that she is Foxy Brown; the fictional daughter of the title characters in the 1970s sitcom *The Jeffersons*, Jenny; and, most often, Dorothy Dandridge in *Carmen*. Her fantasies, combined with her constant wardrobe changes, suggest that she has no tangible way to be a Black woman. Instead, she must play roles that have already been established within the sexist, racist, and patriarchal systems of the Western world. As much as she seems to derive pleasure from this form of acting in both her fantasies and on phone sex calls, she is as much acting for herself as she is for each caller. It is obvious to the audience that she is losing herself in others' wants and desires. Her Diva desire is being sublimated. One of the recurring images in the film is of falling down an empty elevator shaft. Judy identifies with the news story played throughout the film of a little Black girl who is thus injured, which serves as an under-examined subplot of the film. While Judy may be subconsciously afraid that she is losing herself, she cannot shake the desire to be the center of attention. In particular she craves this attention from the male callers who populate her work world. At work, she attempts to regain the control she loses in the liminal spaces between the strong portrayal of Carmen and the bottom of the dark, empty elevator shaft.

The world of phone sex operators in the film is filled with women of every color, size, and shape. Some enjoy their work while others engage in a variety of activities to pass the time. Girl 6 proves to be very good at this job. She never brings in any other work to occupy her because she has convinced herself that she is making her work art, the dictum her acting coach told her at their final session. The film presents phone sex operators as savvy saleswomen, but, as Girl 6 displays, while their clothes remain on they *do* give some of themselves away with each call. Spike Lee says in an interview for *Filmmaker*, "Women are in control in this film because they're listening to these guys, but at the same time they're doing crossword puzzles, doing their nails" (Pierson 26). Eroticism here, though, is being completely manufactured and is only for the service of others; they keep their clothes on, but they are still getting (mind)fucked. As with Girl 6, some of these women lose themselves and become addicted to their work. Theirs is not a position of power just because they are protected by working in a clean, well-lit office. They are still working as prostitutes who must create fantasies for men in order to pay the bills. They suffer from some of the same dele-

terious effects as their better-known streetwalker complements. While Judy easily allows this slip in her work life, giving it away for a price, she is on constant guard against it at home.

There are only two men who have a physical presence in her life: Jimmy, her next-door neighbor and friend; and her shoplifting ex-husband. The limited number of male companions and the types of interactions she has with them suggest an independence of spirit. Jimmy has a mild sexual interest in Judy, while her ex-husband is on a wholesale campaign to get her back. She shows no interest in either of them, and when Jimmy questions her total immersion in "phone-bone," (*Girl* 6), she threatens to throw him out of her apartment and belittles his own dreams of baseball card collecting. She argues that by comparison her financial freedom is in the present. Her husband, at first sexually excited by her work and then concerned by what it seems to do to her, gives her a magazine cover of her idol, Dorothy Dandridge. He wants to give her a part of her dream, to make it tangible in whatever way he can. Her dream of Dandridge, though, brings some of the complexities of her desire to light. The actual men in her life are Black, and the fantasy ones from whom she craves attention are all white. This mirrors, as bell hooks points out, Dandridge's own relationships with men: "Subtextually she symbolically follows the path of Dorothy Dandridge, who late in her career was repulsed by the touch of black men...[and] who was often sexually involved with the white men who helped advance her career" (hooks, "Good Girls" 17). The real, present Black men are not worth the time it takes to work up a fantasy about, but Bob Regular, a caller she falls for and is later stood up by, is. Like Janie, it is the threat of real physical violence that pushes her to look for the dream with which she starts the film. Unlike her, the act is not transformative. It realigns her with her first dream, but it never leads her to question why that first dream is her only dream.

Judy seems to be a Diva character. She flouts communal expectations through her type of employment; she wants more than low-grade film work, and she loses her agent and potential career advancement by refusing to have her breasts gawked at by a powerful director. She survives her stalker and her own destructive tendencies. Yet, she is no Diva. Finding herself is a key element of the Diva figure. Judy is unable to examine her willingness to give away so much of herself in order to access her dream. Ultimately, being a Diva is not about loss. Spike Lee attempts to portray Diva figures by reenvisioning Janie Crawford as first Nola Darling, and later as Girl 6/Judy. Unfortunately, he never quite succeeds. The voice he is trying to free becomes entangled in misappropriated feminist ideals: "Where women are concerned, he delivers the same old stuff,

served up in a provocative, beautifully photographed package" (Malveaux 80). He does not understand what makes a woman a Diva, despite staring longingly from the outside. He may be intrigued by women's stories, but to date he has yet to get one right. Like many other artists, he is drawn to Janie because he wants to revise her for the latter part of the twentieth century; he wants to take her off the porch at the end of *Their Eyes Were Watching God* and create a less uncertain future for her but, his aspirations speak only to the enduring power of Janie Crawford as an iconic character and highlight his inability to frame the Diva.

· 5 ·

A CANVAS OF HER OWN

The Diva in *Liliane: Resurrection of the Daughter*

daughters choosin to be women
lick their wounds with their own spit
til they heal

—Ntozake Shange

Born Paulette Williams to a Black upper middle class family, Ntozake Shange is one of the privileged few of whom Du Bois spoke when he referred to the Talented Tenth. Her father was an Air Force surgeon and her mother an educator and social worker. Her family also maintained a life-long commitment to the African American literary arts, and in this regard Du Bois was a regular guest at the family's dinner table. A life lived in Uplift prosperity as a member of the elite Talented Tenth was to be the dictate of her life. However, at the age of 23, rejecting all that she came from, she changed her name to the one we know now, Ntozake Shange, reflecting the Black Arts/Black Power sentiment of the 1960s. She gives birth to herself in Xhosa: Ntozake, meaning "one who comes with her own things," and Shange, meaning "walking among the lions." Without even necessarily considering the breadth and body of her work, Shange's life has been lived in protest of Uplift ideals, Talented Tenth ideology, and the remnant misogyny present in the Black Power Movement. These rejections are reflected in her life, and this trajectory

can also be observed in her work beginning with the "half notes, scattered with no tune" she speaks of in *For Colored Girls Who Considered Suicide When the Rainbow Is Enuf* (1975), to the prime subject of this chapter, her 1994 novel, *Liliane: Resurrection of the Daughter* a widely under-read text that provides key insight into Diva studies.

Tipping on a Tightrope has traced what at times seems a difficult trajectory in order to define and explore the slipperiness of the Diva figure in African American literature. Many of the proposed Diva characters fall short of full self-actualization in varied ways. What we have been observing along the way, then, are glimpses of the attitude and the expression of Diva desire. In this chapter, through Ntozake Shange's title character in *Liliane: Resurrection of the Daughter*, we witness a self-actualized, fully realized, and articulated Diva. Liliane Lincoln is Sula Peace more realized; she is Janie Crawford more fully realized. She is faced in many ways with some of the same challenges as the women characters who came before her faced, but her challenges are the generations-old remnants of those ideas, twisted and even less palatable. Janie had to contend with Uplift and Sula with Authentic Blackness. Liliane's era is fraught with the outgrowths of those ideals. As a result, Liliane is a product of a generation and an era that placed value in success that could be ascribed to Talented Tenth ideology that was built on a foundation of Uplift ideology. Her father's acceptance to Princeton, and subsequent rejection because of his race, underscored the life she is meant to live; her family intends for access to elitism to be more easily granted to her. But Liliane goes beyond her family's desire for access to higher social status and is able to know how to want more. Actively, she defines what it is she wants and shapes the world around her in order that it may fulfill *her* expectations. In the process she also manages to throw off the yoke of parental authority. Through her actions, she meaningfully rebels against the cult of true womanhood, New Negro ideology, Uplift ideology, and the limitations placed on women during the Black Arts Movement. Liliane knows how and when to access all available resources necessary to assist her in living the life she desires, but she also demands entry into a wider world. While her life is not without struggle, in the end she attains the goals she sets for herself because she is able to define the shape she wants her life to take, what work she does, who she allows in her life, and under what circumstances. As a Diva, she informs the world around her.

Liliane exists in contrast and response to the women characters in Shange's most famous work, *For Colored Girls Who Considered Suicide When the Rainbow Is Enuf*. While Diva desire skirts around some of the characters in *For Colored*

Girls, they are in turns hopeful, angry, dejected, and confused; ultimately, there are no Divas there. In it we see the legacy of the Black Arts/Black Power Movements on Black relationships, and in particular on the effects of those relationships on Black women. *For Colored Girls* also works as another portrait of caught women, serving as a potential update to Jean Toomer's *Cane* (1923), which Alice Walker cites as part of the inspiration for her definition of Womanism. Each of the characters, identified solely by the color they wear, hail from major urban centers across the United States. The color identification serves as a marker of the then prevalent ideas ensconced in a monolithic portrait of Black womanhood. The Lady in Red is the last narrative poem in the text and it is in that moment that we see a primary counterpoint to Liliane. In order to survive, the Lady in Red loses her voice and then her children.

Survival is directly connected to loss for the Lady in Red. This motif is echoed in the unstated background story of her longtime boyfriend and the father of her children. Seeing him now as a drug-addicted and violent Vietnam veteran, the reader is left to wonder what it was he had to lose in order to come back from the war. The Lady in Red's relationship with him has been onerous, and at the start of the poem she puts him out of the family's apartment and is working hard to better the condition of her life and those of her children. Willie, irate about the relationship's end, demands that Crystal, the Lady in Red, consent to marry him. She refuses mockingly: "she burst out laughin / hollerin watchu wanna marry me for now / so I can support yr ass /...o no I wdnt marry yr pitiful Black ass for nothing" (*For Colored Girls* 56–57). Lulling her, he seeks out the children, and then while hanging them out of the fifth-floor window, he demands her compliant obedience. Unwilling to see her life tied back to his, she cannot force herself to speak above a strained whisper and Willie drops their children. "i stood by beau in the window / with Naomi reachin for me / & kwame screamin mommy mommy from the fifth story / but i cd only whisper / & he dropped em" (60). This character is presented with what looks like an easy predicament, but it is anything but. We see a woman asked to lie in order to save her children or to speak honestly and save herself. She chooses to save herself. As the Diva figure evolves, she is no longer forced to make such decisions. At the end of *For Colored Girls*, there is a signal that the dire situations in which these characters find themselves, and the havoc these situations make of their emotional well-being, are coming to an end. Shange writes first: "i found god in myself & I loved her / I loved her fiercely" (63), and finally, on the last page

of the play, "& this is for colored girls who have considered suicide / but are movin to the ends of their own rainbows" (64). Liliane does both of these things: She centers her universe around herself by finding God in herself, and she finds a way back to the place she feels she belongs by moving to the ends of her own rainbow. Ultimately, Liliane loses nothing but that which she lets go of freely.

Continuing the trajectory of the Diva, Ntozake Shange offers in *Liliane* a stinging social critique of middle class Black values—specifically of, but not limited to, Uplift ideology and the concept of the Talented Tenth. Shange argues, through the protagonist, that acceptance of and into upper middle class Black life comes at a steep price, and this fact alone has the power to undermine her ability to be a fully realized, self-actualized Diva. Liliane's father, a pioneering Black judge, and her mother, a beautiful, trapped spirit, live in a world of Uplift expectations. Those expectations dictate every aspect of their lives: with whom they may and may not publicly associate, the kinds of schools they can and should attend, even where they should and should not live. Liliane is expected to surpass the substantial achievements of her family and serve as an example for other Blacks who may hope to follow the successful path her parents' generation has scratched out. A generation removed from Du Bois' Talented Tenth ideals, we encounter a generation of upper middle class Blacks unable to get out from underneath the weight of those expectations. Of the cadre of privileged playmates, including her female complement Roxie, Liliane is the only one to survive the assault. Identifying the failure of Du Bois' ideals through her mother's flight she decides that none of the principles she is expected to live by suit the life she wants to lead. So, instead, she "crafted a delicate social structure, penetrable only by her, and contrived for her desires and her protection" (Shange, *Liliane* 92). Liliane's articulation of her life's path and subsequent successful navigation through it suggest that there are alternate ways to be Black, privileged, and female that do not subscribe to Uplift expectations.

Liliane: Resurrection of the Daughter is a novel designed to provoke and to reveal how a fully realized Diva comes into existence. The Uplift world of Talented Tenthers, Du Bois suggests, is an altruistic one. It is a world where the elite few use their power and influence to make gains socially for other Blacks not in a position to do so, and simultaneously reach out a helping hand to their economically and academically disadvantaged brothers and sisters. The text reveals such a moment at the Legal Defense Fund gala that the Golightlys— an equally well-to-do Black family—throw, and which Liliane and her family

attend, as family friends. The party is a fundraiser to ensure that, as Mr. Golightly, a civil rights attorney, says in reference to Blacks, "our place is any place we choose" (42). And when the party is interrupted by shots fired and a police suggestion to disperse, the hosts hand out guns, turn up the Ruth Brown records, and dance the night away in support of Black people everywhere. Even the music is the right sort, a little on the popular side, a little on the blues side, sung by a woman whose success built Atlantic Records and who went on to fight for Black musicians' rights. This party is thus, on its face, the epitome of the ways in which Uplift should work. But it is here, too, that the reader begins to observe the tenuousness of this world. This is made evident in the foreshadowing of events in the life of the protagonist, Liliane, her mother, Sunday Bliss, and her best friend, Roxie Golightly.

Roxie, unlike her friend Liliane, is unable to escape the Uplift expectations inherent in her upper middle class Black family. Her desire to so closely emulate her own uncomplicated view of her mother suggests that she will never be a Diva. Her father is considered "less the rebel rouser and more the old school" type who had a penchant for knowing, "when to push and when to be still" (38). Her mother, R.C. Golightly, named for the reverence her parents assumed of the Catholic Church, "was every inch a lady of the house" (41). She married both late and well, deftly establishing herself as the quintessential Uplift wife and mother and thus setting an example that her daughter was to follow. Roxie's grand home and parents are a measure of pride for her, as well as a source of tension. She articulates a desire to live well and to marry well—to have a life like her parents—but she is intrigued by Liliane's mother, Sunday Bliss, a woman who urges the girls to recognize that their "minds are the first battlefields for freedom" (44). Roxie struggles to reconcile the privileges her social status grants her with the seemingly unreasonable expectations her social milieu dictates and, on occasion, she attempts to articulate this to a less than understanding Liliane.

> I wanted to be, plain as that, just be, without all the planning, preening, fixing, and carrying on....All the polishing of Negro girls about to be grown is as clear as I can get....How to serve bouillon as opposed to gumbo. What fork goes where and why. When to take gloves off and when to put them on. I was weary, weary. (35)

The world Roxie describes is the one in which Liliane is expected to take her place. Immediately, though, the significance of that world is put into question by Sunday Bliss, a mother "who didn't receive visitors...gave mambo lessons, looked like Ruth Brown and grew orchids" (37). Liliane is thus being given

entry into a world that was, if not flush with new possibilities, at least with alternate ways of being. Roxie, however, is left awed and tired. The next time the reader encounters Roxie, she is a murdered single mother, victim of an abusive boyfriend who is new to the American social landscape as a consequence of Castro's program of Mariel boatlifts. Hadara Bar-Nadav, in one of the very few critical discussions of this novel, argues for quite a different reading of Roxie. She suggests that Roxie "conveys the revisionary hope of the black woman artist budding in childhood" (45) and mirrors Liliane's success as a freed artist. While Roxie is written about as an artist, her work is never described and in the end, she is silenced by her misunderstanding of a political ideal. Even when she decides to emulate Diva desire, she fails.

Roxie's unfortunate outcome is disturbing, as her attempt at living in protest as a single mother artist, moving away from the Uplift ideologies that have thus far shaped her life, ends in her death. It suggests that for many, there is no escape. Without training to be much more than a good Uplift wife and mother, as an adult she remembers her fondness and awe of Sunday Bliss, and her final choice of partner causes her childhood question, "Is your mother a communist, Liliane?" (33) to reverberate. With no examples and little life experience beyond extravagant charity dinners, Roxie misinterprets the way she imagines that Sunday Bliss is free. Bliss's interests in Cuba and Castro are literally converted by Roxie into an interest in a person who is tied to Castro's aims, but not an understanding of Castro's political agenda. She does not understand the complex ideas inherent in Bliss's interests in communism, particularly as it relates to African American communities as another avenue of escape from the 1960s racist American landscape surrounding them. Roxie's inability to understand this, despite what we can assume is a superior private education, is a direct critique of the ideology of Uplift and a clear attack on the Talented Tenth. Quite simply, what have her parents been teaching her? How can she be expected to lead given the choices with which she is presented and the ones she ultimately makes?

Liliane internalizes her mother's choice to leave and is thus able to recognize it as an opportunity to escape the world in which and by which Roxie is trapped; unlike her friend she is a Diva because she learns from the mistakes of others and shapes her life to reflect her own desires. Ultimately, Liliane's understanding of her mother's choices is quite different from Roxie's. Both Liliane and her mother attempt to make an escape, each with varying degrees of success. The relative success of these escape attempts led to complete social excommunication and the breakdown of family ties for Sunday Bliss, and for

Liliane the ability to choose for herself which aspects of privilege and family suit her and which do not. Liliane's privilege grants her the opportunity to see the world and to be well educated, and this worldliness is expressed in her relationships with men. We see that she makes unconventional choices, particularly in her Latin American lover, Victor Jesus, who attempts to control her in ways she will not allow, and yet she does not banish him completely. Those choices can also be seen when she meets Zoom in France and forays into the interracial politics that led her mother to be excommunicated from the world of the Black elite. Unlike Roxie, Liliane does not, literally and without question, mimic what she imagines her mother's political freedoms and liberal attitude to be. Instead, she brings them in for a closer view in order to make sense of them for herself. She does one better than her mother by finding a way to keep what works, let go of what does not, and she forces the world around her to shift to fit her desires.

Liliane turns out not to be the *gringa negra* her one-time lover, Victor Jesus, imagines her to be; not even a man who speaks to authentic life and art has the smallest chance of changing Liliane to fit his desires, because she is a Diva. The nickname he gives her, *la gringa negra*, immediately suggests that Liliane is different from the other women he has dated, and perhaps different from the other Black women he knows. *Gringo/a* is derogatorily used by some Latinos to suggest the ignorance and arrogance of Americans, particularly when acting as tourists. The term also generally indicates white Americans, hence his choice to use negra to indicate that Liliane is not white. The *gringa* here could be many things. Bost argues that "in this description, she belongs to the *negra* race because of her chosen identification, but her wealth, her education, and her social advantages class her with the *gringa* race" (81). It may imply that she is "white-acting," a derision that is often thrown at well-spoken and educated African Americans. It could suggest her light complexion, as the Creole blood in her mother's family might reveal. It suggests most strongly though, the power of her opinions and her unwillingness to be dominated by this man who is clearly used to women falling at his feet. "*Mi luchadora*"[1] he calls her, and fight she does—to stay with him, to be bilingual, and to be understood. He cooks for her and yet sends her down to the bodega daily to buy an avocado. This is a continuous ordeal because the owners refuse to speak to her in English and her Spanish is suspect because of the Black body which speaks it, so they pretend not to understand her. She never gives in to either the humiliation that her lover knows will be hers or the resistance of the proprietors: "The Medina wouldn't speak English to her cause it was beyond their version of the world

that *mi negra linda* wasn't a *morena* at all, but a regular niggah" (Shange 68). Each time, she returns with the avocado, undaunted and without complaint. She marches her way through these peccadilloes in an attempt to connect with her lover, linking them to a larger African Diaspora. She speaks of a connectedness of all people of color and while Victor humors her, he spends the majority of his time trying to dominate her: "Gotta keep her on her toes, ya know, a bit off balance, outta focus" (68). He has sex with her in an attempt to will her to him, and yet she comes and goes as she pleases and insists on a relationship that has meaning beyond sex. She continues to take her pictures and make her art. Realizing that it is the art that makes her run, Victor tries another tactic. He tells her a long story about a musician and a dancer. Initially he cites the story as one of Liliane's favorites, and at first it seems like a story suggestive of a symbiotic relationship between two artists; the music only exists when there is a dancer. But then the story shifts. Liliane feels it coming and pleads with her lover not to continue. Slowly and insistently, he reveals a story that puts him as the arbiter of her art; that is, he moves her and thus she can create art. "Our young girl, Liliane, who was so much like you, saw what he felt and she knew as he did not know that you do not own the beauty you create. Right, hear me. You don't own the beauty" (73). This Liliane refuses to accept, and in what is a usual scene at his apartment, curses him and leaves. However, this time is not like all the others. "I'll be damned if it ain't some sick-assed voyeuristic photographer thinks his arts is nurtured by a woman's tears....My art is not dependent on fuckin' you or hurtin' you" (74). This time she does not return. Unlike Roxie, she is unwilling to negotiate her life, and in this case, her art is her life. While she wants to see people of color connected in every way, she is able to see that this, in some ways, is an imagined community. No idea or lover is worth more than she is to herself. This is one of the lessons she learns from her mother. The next one she learns on her own in France with Zoom.

Even though seemingly disastrous, Liliane's relationship with Zoom represents the furthest she travels from a sense of Black community in order to find herself. In this relationship she is a Diva experimenting in spite of all of the lessons that tell her not to do so. Zoom's name here operates as an onomatopoeia. She zooms away from every teaching she has been taught about race and class and into the arms of whiteness, the sin that gets her mother excommunicated: "If I knew not to bring home a white boy, surely Mama knew it" (181). This aspect of her journey to self-discovery suggests her desire both to be closer to her mother and to understand that which she feels was given up

for a white male lover. It also reveals her Diva intuition. She is not willing to take as her own her father's view of interracial relationships. This part of the story is narrated by Victor Jesus and the tone of his storytelling jealousies mimic Liliane's jealousy of her mother's new and elusive husband. There is, at this point, still a refusal to accept that her mother's absence is more complicated than she wants it to be. Yes, her mother left her, but primarily as a part of the gilded cage she decided no longer fit the woman she felt she could be. Sunday tells her sister just this: "I have never been what anybody expected, or wanted for that matter: I'm not even what I wanted" (191). In this instant, her mother's escape is revealed to be tied to the overly confining structure of lived Talented Tenth experience. However, this is not a conversation to which Liliane is privy and, thus, it is now in her relationship with Zoom that she feels abraded by the walls of Black patriarchal expectation.

Liliane experiences a sense of confinement similar to her mother's when she fears telling her father about her relationship with Zoom. She does not merely imagine her mother's sense of trapped urgency—she attempts to re-create it in order to understand and shape it to fit her own desires. It is this time of fear-less risk-taking that marks her as a Diva. Not wanting to offend or endanger what little relationship she has with her father, she tints a black and white picture of Zoom and sends it to her father. She does this hoping to spare herself her father's rage and to lead him to think Zoom could possibly be a light-skinned Creole man and not the white man he is. So intent on avoiding her father's rage, she never considers how Zoom might feel, being Blackened. Bost argues that "by pretending that the white man is black, by claiming that it would be better for him to be black, Liliane erases the authority, the superiority, and the centrality of Anglo-American men" (Bost 83). Her reading needs to be com-plicated. To Liliane, being Black has been an experience of privilege. This also might be a way to challenge the way the reader sees Zoom irritate and annoy Liliane, and others, with the easy way he fits in with her multicultural and mul-tiethnic group of friends. "Zoom mingled well, like he'd been waiting all his life to not be so white, to be comfortable when he was the only one around them in a way that Lili could not....The whole world was at risk with his gangly out-of-control I-am-a-white-boy contortions" (Shange 138–39). It is as though she is painting him as an unwitting minstrel character, but is in fact coercively imposing involuntary racial passing onto his body. This act also suggests Diva tendencies. It is her desire and will that forces him to conform to her needs. She is no Janie Crawford, forced to marry an old man she did not love to assuage her Nanny; or Helga Crane, outfitted like a "veritable savage" (Larsen 69) to

earn her relatives greater social status. This can even be seen in the contrast with what happens in her earlier relationship with Victor Jesus. Victor tried to push her to become the woman he wanted, to take the fight out of his "*luchadora.*" She seemed at first somewhat oblivious to this, but in her relationship with Zoom, she takes action quickly before discussion can happen, and colors him in in her photograph. She wants so much to be in the world that she pushes hard against the boundaries it attempts to impose upon her. And like Janie at the end of her life with Tea Cake, when Zoom threatens the narrative she is actively constructing, she immediately puts him out of her life.

Zoom seems intent on smoothing out her edges and pushes her into a box she does not readily see. "'Listen to yourself Liliane,' Zoom firmly but softly utters the first words of his pattern of seduction that keeps my Lili constantly reevaluating the immediate effect of racism on her and her loved ones" (Shange 137). He urges her to rethink each point of contention until it fits more cohesively with his ideal woman, and slid up against him on the back of his motorcycle she allows him to feel as though they have become soul mates. There is, though, a problem for her: he is not Black, and so she darkens him so he can fit into her concept of what she imagines her soul mate to be: Black. She is able to experience his whiteness, but in her imaginary life he needs to be tinted as well. This is done for both herself and him; to her being Black is a good thing and so she upgrades him to the racial category that has always been one of privilege for her. Liliane presents Zoom with her gift of Black breeding as both a boon and a challenge. He is pushing and she is pushing back—hard. Liliane improves upon Sula's one encounter with desire turned love turned possession with Ajax, and through this reveals the maturation of the Diva. Momentarily Liliane engages the rationalizations of her lover but throughout she prickles at his desire to change her and thus challenges him to change as well; Zoom will meet Liliane where she is or be pushed aside. In the end, the only person in danger of losing a head is Zoom.

The push-pull here ends in necessary Diva destruction. Zoom "changed...he screamed at me. 'Nobody has the right to be ashamed of me. You have no right to make me dark or light or less white'" (140). Zoom does not take kindly to being Blackened, [2] and she refuses to make room for his objections. What she imagines will be a serious conversation—debate even—like all of the other ones they have when he wants her to change, devolves into racial epithets and violence. Zoom quickly calls her a bitch and she in return, with knife in hand, threatens to kill him. Distraught not just by her slip to violence, she is comforted that in the end the battle is for her mind. But more signifi-

cantly, her interaction with Zoom leads her no closer to answers about her mother's disappearance. Liliane had hopes of understanding her mother's choice by duplicating it in some small way. Victor pushes her to realize "that sad revelation of the hour…was Zoom's ease with his whiteness, his presumptuous colonization of my Lili's spirit, body" (143). This is one of the many incidents that lead her into therapy—not the failed romantic relationship, but rather the relationship's inability to lead her to a better understanding of herself. While willing to allow life to teach her, she wants more than to be beat about by it. She wants answers, and when sought-out life experience does not give her those, she keeps looking. It is her continued willingness to obtain what she seeks—enlightenment, understanding, self-fulfillment—that makes her a successful Diva. Unlike Janie, she keeps pushing past this incident. A death or failed relationship comes to be another opportunity to explore her own feelings and to develop new plans for her future. And to accomplish this state of being, she uses everything at her disposal: experience, therapy, and art.

Mimicry without change is not part of a Diva's arsenal. At the novel's start, Liliane is not in the country demonstrating an attempt to reenact her mother's freedom by moving as far away from the elite Black American social hierarchies as is geographically possible; she is a fawn in the diaspora court, as the title of the chapter suggests. But, as her artwork reveals, she initially finds difficulty in fully comprehending her mother's choices. Most of Liliane's described images are tied to ideas of maternity and motherhood and it is possible to see the evolution of her acceptance of her mother's choice as her work progresses throughout the text. The first piece of art that Liliane discusses in the text is of "superimposed AK-47s over fetal transparencies under Frelimo banners" (16). While these images have Frelimo banners over the top, which offer a sense of hope embodied in the Liberation Front of Mozambique, there is a sense of death here, or of life with death lingering comfortably nearby. It also suggests a futility in childhood, represented through the undeveloped fetus and the lack of care about life or death with the AK-47 layered on top of it. In particular, using an AK-47 also lends itself to suggestions of war between staunch enemies. Designed by the then–Soviet Union in 1947, and still widely used, the weapon is arguably a fitting symbol of the Cold War. Liliane's war in her life and art is the one between her mother's choices and her own. She says of herself that her signature is an image (17) and this specific image suggests the imprint of her mother's misunderstood abandonment. It seems to express the sense that she, Liliane, without a mother, never had a chance, despite her father's feelings to the contrary, which are made evident by the performed funeral. Her next art piece in

the text is colored with her own menstrual blood. Here, her blood signals a failed pregnancy; there is no implantation and all of the preparation for a baby is washed away. In the text, this suggests two things: The first is that she is giving up the dream that is the relationship she once had with her mother in their beautiful garden, and the second is that she is beginning her life without her mother anew. She is currently moving between Paris and Morocco, having been seduced by her current lover, Jean René, and though she enjoys his attention, it is in the early morning, while bleeding, that she begins to paint herself back into her world. She soon thereafter returns to the United States from her self-imposed exile.

Once back in the United States, she continues to assert a Diva stance by beginning work with a therapist. As a result, her art shifts as she attempts to sort out her early childhood trauma. She makes little books of handmade paper that are constructed from pieces of letters she claims her mother sent to her after her father's imposed death of her mother. They do not sell, and she then tries to sell one to her therapist. The introduction of this art into her sessions ends up being successful, as it forces her to unravel the conflicted relationship with her mother. In discussing this art, she focuses her anger on white America. Liliane faults the racial tensions in the United States for creating a world apart; "white folks got us so tangled up and wound round ourselves we can't live without them or the idea of them where we can touch it" (178). Her therapist, however, pushes her to think about that hate more concretely and, as a result, she shifts her attention to her mother. After all, it is not the white Jewish man who forced her mother to leave—it was her mother's decision. Forced to contend with her father's choice to make her mother dead and with her mother's choice to stay dead, Liliane details her father's inept response when she finally confronts him about the subject. He tells her that "once she told me she'd always love him, I had no choice, I told her Liliane, I told her, she'd lose you and everything we'd worked for. I couldn't let you go with her, don't you see?" (179). Parnell Lincoln is not merely angered by his wife's abandonment, he is also worried about what it may mean for his social status and that of his daughter. Liliane would have no chance to make good matches, to make Uplift babies, if her mother's acts were not obscured by a fake death. It is in this therapy session and subsequent ones that she begins to take apart the Talented Tenth world of her parents, which she later calls an "incestuous milieu"(112). Her choice to describe her world in this way reveals at least some momentary understanding of the forced claustrophobia imposed on her mother as part of this small, Black, upper middle class community. Liliane begins to complicate

her understanding of both her mother and her father: "The white people made my father kill off my mother…he couldn't allow my mother to live in the house with a white man in her heart" (180).

It is this "polishing of negro girls" that Roxie is so tired of and against which Liliane rebels with greater success. Liliane refuses to accept the psychologically damaged state of many second-generation Talented Tenthers; as a Diva she rec-ognizes that the only way to overcome that type of damage is to break down the insularity of the elite Black world, and she does this through both her choice of sexual partners and her reflections on those relationships with her therapist. She is, in those sessions and in other aspects of her life, the *luchadora* Victor Jesus derides. It is this fighting for more than survival that is another marker of her Diva stance. Trying to understand her mother's example but coming to realize that undertaking the defeat of Uplift ideology on her own is impossible, she enlists the help of an outsider. This decision suggests that Liliane was, in fact, listening to her mother, when Bliss told her that the battleground was for her mind. Inside the therapy sessions, Liliane is also able to deconstruct the underpinning of the nuclear family, a key component in the novel's presenta-tion of Talented Tenth ideology. She wants to find her way back into her world on her own terms. While in therapy, she identifies her problems, which lie in Talented Tenth doctrine and her own generations-old Uplift upbringing. Abandoned by her mother and misunderstood by her father, she demystifies the parental relationship and makes peace with her parents' choices, noting that their choices do not have to be her own.

Sunday Bliss's decision to finally leave her family has been a long time in the making and is key to Liliane's ability to effect a Diva stance. Carol Osbourne mistakenly attributes Bliss's decision to leave to her husband's unwillingness to accept her promiscuity, and in particular her relationship with a white man. She argues that "Parnell is largely to blame for Liliane's separa-tion from her mother" (Osbourne 1138). This reading obscures the subtleties of the relationship Bliss has with both herself and her husband. Early in the novel we hear Roxie narrate what seems like a loveless marriage: "Liliane's mother never touched her father as far as I could tell" (Shange 42). At the gala near the novel's beginning, her mask of holding it all together begins to slip publicly. "I heard Liliane's father…shout up for [her] mother. She rushed so, leaving, that her dress got caught on the knob of [the] door. Then, instead of working the cloth off, she just ripped it. Ripped that gorgeous peach organza" (45). The peach organza here is symbolic of her Uplift life: pale, shiny, draw-ing attention to itself as it moves, but ultimately not substantive and easily

destroyed. Everyone in that room at that moment realizes how the tearing of the dress reflects back to them the image of their world, though they refuse to see it for what it is. Roxie explains "Liliane blushed and when I looked at my mama, she lowered her eyes, I…kep[t] my mouth shut" (45). This is the only response available to the four women in that room, because any other verbal or non-verbal response would have undermined the Uplift ideology each was bound to support, particularly in the presence of others, whose silence marks their assent. The incident of the torn organza, years later, produces a more verbal response from Sunday, which she shares with her sister. "I'm sick of it. I'm sick of all of it. The posturin,' and the frontin,' the fuckin' grandeur of it. I'm sick. I'm sick and tired of it all. Do you understand me?" (191–92). Her marriage is little more than a politically correct shell. When Bliss greets her husband enthusiastically one morning, his response is chilly: "That's enough of that now, Bliss. All you sit down and eat" (187). Sunday does not want to be cloaked within an insular community, quite literally behind a veil that is easily rent. In an attempt to ameliorate her sister's outrage, Sunday offers, "I have never been what anybody expected, or wanted for that matter: I'm not even what I wanted" (191). For example, Liliane's mother was pleased with Castro's ascent to power in Cuba and the ensuing communist ideology that followed it. This marks her mother as different, and eventually this will be a path that Liliane follows. Finally, Sunday decides that she is willing to accept the social ostracism that accompanies her decision to flee, and thus she removes herself physically from what would be considered her appropriate society by leaving her husband and thoroughly severing her ties to that community by marrying outside of her race. As a result, she is excommunicated by her family, with her husband going so far as to hold an actual funeral for her death—a death attributed to a boating accident. Sunday is metaphorically lost at sea. In preparation for what she knows will be her final departure, she tries to create something to leave her Liliane—a garden: "This is all designed for Liliane. I've a purpose here, Aurelia. Lili can come here for the rest of her life and know herself to be one of the most ravishing creatures on earth" (190). But she leaves behind much, much more. She leaves behind the example of her escape, something Liliane will use as a guide to make her own peace with the limitations of Uplift expectations. Liliane uses this example and improves upon it. This is something her mother either does not know or is incapable of doing. In the end, Liliane is a part of her world, on her own terms, signified by the picture at the novel's end, which includes all of her friends, alive and dead, her parents, her family, and her sometime lovers.

Liliane is only able to become a Diva because her mother, by leaving, has demonstrated Diva desire. Sunday wants more for herself and her daughter and departs from their home in part, to make the path a little easier for when Liliane is able to come to similar realizations. Liliane's childlike fascination with her mother provokes Sunday to action; this admiration turned emulation of Sunday as she is with Parnell saddens her and becomes yet another motivating factor in her decision to leave. Her greatest hope is that Liliane will be able to escape: "She won't have to be anything at all like you or me…she'll have the whole real world" (191). Her daughter thinks she is being like her mother, but because Liliane is unable to realize that the portrait of her mother as wife and mother in upper middle class Black society is one into which Sunday has been uncomfortably wedged. Aurelia, her sister, recognizes this, and in a heated argument about Sunday's imminent departure says, "That girl thinks the world of you, bitch. She lives and breathes for you to simply spend your time with her.…I been watchin' you all her life, makin' the world pretty…so maybe she wouldn't notice whatever in the hell you think is so 'ugly' bout her" (193). The ugliness to which Aurelia refers seems to be Sunday's dissatisfaction with who her daughter is becoming in the world of privilege in which they live. She wants to leave her daughter something greater than the Talented Tenth legacy with which her community has provided her. By leaving, she gives her daughter the greatest gift. Through Sunday's actions, Liliane can surmise that the world is not as small as it might appear to be, that the world her family is a part of is but a small fish bowl. Sunday's exit suggests that it may be acceptable to live there if it is of one's own choosing, but that forcing oneself to be a square peg in a round hole is not the only choice open to women who take risks. The reward is not fancy cars or stately homes, but rather, the gift of oneself unencumbered.

Sunday's attempts at mothering allows Liliane to make the ultimate Diva decision: Liliane will not procreate. The relationship Sunday chose for Liliane and herself opens the door for Liliane to recognize the fraught nature of motherhood. When Liliane realizes she is pregnant, she is not unwilling to mother, as Sula declares, or magically unable to, as seems to be the case with Janie, but rather, she wants the choice of where and when the desire strikes her. "I just couldn't stand it, the idea that some child, somebody, would love me like nobody else on the earth and all I'd be able to say is I don't know how to do this" (80–81). Childbearing has historically been a biological burden, particularly for Black women, in American society; consider Harriet Jacobs's predicament in *Incidents of a Slave Girl*. The ability to exercise the choice of abortion

has also been viewed as an unsound choice and, when contemplated or carried out, an outright act of shame. This is particularly overwrought in African American communities [3] because of the tensions between stereotypes of hyper-sexuality, the juxtaposition of the ideal mother figure—embodied in The Black Lady (Claire Huxtable)—and the Bad Mother (Precious's mother),[4] and an insistence on piety. We see, too, the amalgamation of these ideas in Shange's earlier work. The Lady in Blue in *For Colored Girls* is ashamed of herself for having an abortion and expects her community to be ashamed of her as well. She is therefore alone and silenced, her experience hidden. While Liliane mourns the choice she makes, she knows that, given her issues with her missing mother and the importance of her ability to travel the world and immerse herself in the art that renews her, a child will hinder her life. When she is presented with another opportunity to mother, this time with Roxie's daughter, she again understands that she is in no position to do so and, while there is a bond with the child, she is under no delusion that as a Black woman it is a burden, not a privilege, to mother at all costs: "I can't keep Sierra anymore than I can keep a wish or a dream" (223). She discusses these decisions with her therapist, and it is then that we see her as a character with more room to evolve than an earlier counterpart had—Sula. Sula refuses to mother and has sex with whomever because she is looking for an intimate space to be with herself. Liliane's decisions are as a result of a clear articulation of her desires. She thinks. She watches. She reasons. And she does all of these things even when she is suffering from the death of her best friend. She can learn from herself and from others. Expectations of her womanhood or her Blackness do not function to deprive her of living a fulfilling existence. She is not a victim of her gender or her race, as "Shange provides alternatives to the status quo of the male-female relationship where the woman is suppressed, objectified, and defined" (Bar-Nadav 63). Liliane sheds her chrysalis in order to satisfy her Diva desires.

Liliane as a fully realized Diva takes her mother's lesson and improves on it by steadfastly experimenting and pushing and creating the life she wants, and in the end forcing others to accept it. She is not some cast aside, broken-down reject; instead, she forces her community to change in order that she may be in and of it when she chooses. Alice Walker writes in her seminal essay, "In Search of Our Mother's Gardens: The Creativity of Black Women in the South" (1967), "our mothers and grandmothers have, more often than not anonymously, handed on the creative spark, the seed of the flower they themselves never hoped to see: or like a sealed letter they could not plainly read" (240). This is the case for Sunday and Liliane. Sunday leaves everything

behind, including what seems most important to her, her maternal family, and to ensure her complete departure from the world of Uplift, she marries a white Jewish man and becomes Sunday Bliss Rothenstein. Her choice to leave and to marry interracially and interculturally is a flat rejection of all that Uplift ideology cherishes. She steps over everything that the Black elite holds dear—things like the Black nuclear family and white friends (but not lovers)—and through her actions makes clear that she has never put much stock in those ideals, revealing again the flimsiness of the fabric that is the Uplift world. Bliss makes obvious through her actions that she isn't "goin' to die just so I can live my own life" (Shange 193). Liliane, however, opens her mother's sealed letter and, unlike her mother, finds a way to stay connected to her family while simultaneously remaining true to her world as she constructs it. She does not have to explore death as Sula does because she forces life to meet her where she is and where she wants to be.

Liliane rejects the expectation to surpass the triumphs of her family because she is a Diva. Divas do not follow—they lead—and her ability to come out of exile and live amongst her original friends and family without compromise is an expression of this. She comes to realize and understand that acceptance of this lifestyle comes at a price. "Taking hold of the ability to define and order perception, Liliane uses her aesthetic ability to redefine relationships that have been externally imposed by dominant culture . . ." (Bar-Nadav 58). A generation removed from Du Bois' Talented Tenth, we encounter a group of children unable to escape the weight of that expectation. Liliane is the child who survives and thrives, because during her adolescence she decided that none of the principles that are meant to define her life suit the life she wants to lead. And so "Liliane crafted a delicate social structure, penetrable only by her, and contrived for her desires and her protection" (Shange 92). This becomes the guiding principle of her life. Liliane performs survival; she critiques the mores that attempt to color her world and she creates an alternative way to live away from Uplift dictates but within her community. "Liliane believed you picked up what gleams and stands out lovely from the hardness and hushing up. You pull these startling elements onto a canvas of your own, and that's your life" (92). Liliane constantly defines and redefines that which "gleams" and "stands out;" while she is not able to choose the upbringing and society from which she came, she resolves that, despite this, she is the only one who will determine how her life will unfold.

All of the second-generation Talented Tenth children are compromised: Roxie is murdered because of a limited ability to intellectually engage other

ways of being; Sawyer Malveaux, Liliane's cousin, is also murdered, a casualty of the class tensions between Black elites and their economically disadvantaged counterparts; his sister, Lollie, is institutionalized, never able to recover from her brother's murder or her mother's displeasure with her dark complexion. Liliane is the only one to survive and she is only able to do this because she willingly relinquishes claim to the privileges her Uplift upbringing provide her. Ntozake Shange critiques the insularity and elitism Du Bois' ideologies suggest and which in turn shape the upper middle class values and ethics of which she is to be a part. Shange offers a different suggestion, one which reveals that success is not necessarily tied to economic wealth or social status, but rather, to a clear sense of one's ideas about the self.

Much of how the Diva comes to know herself has to do with loss, or at least the willingness to lose something in order to come to a better understanding of herself and the world. In *Liliane: Resurrection of the Daughter*, we meet for the first time a Diva who loses nothing. At the novel's beginning, Liliane Lincoln, the protagonist, is living outside cultural expectations of Black womanhood. In fact, she is even living outside the United States, far away from her home. But she comes back and tackles her demons with a therapist, on her own and through her art. These acts speak to her Diva stance. She wants to find her way back into her world, but on her own terms. While in therapy, she identifies her problems, which lie in both Talented Tenth doctrine and her own upbringing. Abandoned by her mother and deceived by her father, she demystifies the parental relationship and lives the life she chooses. As Bar-Nadav sums up nicely, Liliane "returns, she reveres herself, her heritage, prizes family, relationships, communities, and is highly aware of the need for liberated cultural models specifically for women" (64). Ntozake Shange creates a Diva character who paints over all that is not useful, making the canvas her very own.

CONCLUSION:
DIVAS BEYOND THE FIN DE SIÈCLE

African-American culture is Afrofuturist
at its heart....The street finds its own uses for things.
—MARK DERY

Diva desire, in its past history, is often marked by longing and eventual loss, and early twentieth-century Divas must be willing to lose something or someone in order to better understand themselves and the communities in which they live. Janie Crawford has to lose Tea Cake; Helga Crane, herself; Sula Peace loses an attachment to her community, her mother, and her best friend. But ultimately the Diva is not about loss; she is about finding herself and loving her. Divas do this in spite of the barrage of messages that tell them not to do so, which they receive from their families, surrounding communities, and the white patriarchal society that influences those around them. Consider the unexamined joy Sula's death brought to the Bottom; many community members came to her funeral just to make sure she was dead. Hannah, her mother, did not love her; her grandmother, Eva, became afraid of her; and the only real friend she had, Nel, forgets the value of their friendship until Sula has been dead for 28 years. Sula is disowned by her community even in death, but this is not the only wound she bears. She,

along with the other literary Divas discussed herein, struggles to survive in the absence of motherlove, and when the cultural community they are a part of continues that rejection, completely untethered to the expectations of womanhood or mores of communal living, Divas create new ways to be in the ashes of that love. Sula freefalls into an experimental life in order to find out about living and, because there are no supports in place for her, she attempts to create her own. In so doing, she turns A. Jacks/Ajax into a god. He holds sway because it is the first time anyone has met her where she is emotionally, physically, spiritually, and despite the value added to her life, her initial desire is to possess it and then finally to destroy it. This destruction is all in the service of loving herself because there is little evidence that any one else will do it. As Nikki Giovanni writes in "Poem for a Lady Whose Voice I Like": "Show me someone not full of herself and I'll show you a hungry person" (*The Selected Poems* 96). The Diva understands this and spends much of her time addressing this absence, sometimes quite productively. How that absence is shaped over time is directly tied to how the Diva of the future seeks out new and meaningful ways to express herself. In this regard, Afrofuturism seems an ideal space through which the Diva can persist.

Afrofuturism suggests that Blackness is akin to an alien or futuristic subject position. Consider, for example, Octavia Butler's work, which rarely discusses race specifically and yet is often read as a commentary on U.S. race relations.[1] This ideology is grounded in a sense of intentional absence and asks a big question: "Can a community whose past has been deliberately rubbed out, and whose energies have subsequently been consumed by the search for legible traces of its history, imagine possible futures" (Dery 8)? With that question in mind, another space becomes possible for the Diva's continued existence. In particular, Robin James writes about the idea of the Robo-Diva in "'Robo-Diva R & B': Aesthetics, Politics, and Black Female Robots in Contemporary Popular Music" (2009). She cites as examples Beyoncé's 2007 BET performance of "Get Me Bodied" which attempts to capture the essence of Fritz Lang's famous film *Metropolis* (1927), and the robo-theatrics of Rihanna's hit song and video, "Umbrella" (2007). James argues that "to adopt the aesthetic of the robo-diva is to throw in white patriarchy's face what it most fears—black women and black femininity not as some 'redeeming' path to 'wholeness'...but as competent, empowered agents of their own destiny, whose very existence challenges the political and aesthetic norms of white patriarchy" (417). This idea, though, seems more hopeful than real, particularly if we examine Beyoncé's song and video, "Diva."

The lyrics from Beyoncé's song, "Diva," reveal the elusive fixity of the term. The chorus, which predominates the song, merely repeats the declarative statement: "I am a Diva," suggesting that a definition is not necessary, that Beyoncé so inhabits Diva space that her literal body is all the evidence the audience needs of her Diva status. This also works in reverse—that is to say, if your Divaness is so evident, why is the claim so vociferously made? The repetitiveness of the declaration also points to the desire to lay claim to a subject position that exudes power. The word has a long, dense history with godlike narcissistic implications, and yet there is a shared respect for a common imagined portrait of what a Diva is. Naomi Campbell may throw her phone at support staff, and some may condemn her for it, but everyone ducks when she reaches in her Birkin to retrieve it. In the end, Divas negotiate a kind of threatened and threatening respect. Seeking to be identified as omnipotent, the Diva desire in Beyoncé's song locates her power strictly in a male sphere of influence. The barebones definition the lyrics provide state that "a diva is a female version of a hustla." In hip-hop vernacular, a hustla generally refers to a young man (or woman, though rarely)[2] who makes a living any way he or she can in order to attain and maintain material markers of success. The object for Beyoncé's Diva, then, is linked to phallocentric ideals of success; there is no Diva stance that is apart from ideals established within a Western capitalist patriarchal society. There is no imagining a world of feminine empowerment that is not built on patriarchal moorings. The mimicry in her performance is deeply troubling and ultimately obscures the freefalling, risk-taking desire evident in the experimental lives Divas set out to investigate. In this faux Afrofuturistic video, Beyoncé as a faux Diva situates herself intentionally within the male gaze and locks herself there of her own volition. In this song and video, the women become one articulation of what misogynists imagine women to be: jealous of male sexual hardware. Constrained by masculinist spaces where female empowerment is undermined, Beyoncé's performance exists firmly within a male vernacular and so, even if it is not exactly penis envy, the way she expresses herself is through a phallocentric script. The song suggests that all a woman really wants, and ultimately needs to do, is to become a man if she wants to attain power.

The video contains a preponderance of male imagery that further asserts her desire, not for power, but for power as defined through accepted masculinist proclivities. In this video, from the outset, the Diva is cast as a woman desperately wanting to be a man. Dressed in the classic rebel costume of jeans, white tank top, and black leather jacket as made famous by James Dean in *Rebel Without a Cause* (1955), she deviates only in the type of sunglasses—

sparkling, shingled, silver, in a style reminiscent of the seductive veil of a belly dancer. The addition of the glasses has potential as a signifier of difference (could she be hiding the Diva within her?), but this detail is left unexplored. As the video starts, she walks away from an abandoned car containing Caucasian mannequin parts. Inside a warehouse, her costume changes and in a tight, shiny, mini-dress, she dances with abrupt, stilted, lifeless, robotic movements, first with two other women and then alone with a collection of golden mannequins. A play between shadow and light makes these women look like a series of individual body parts, allowing the casual observer to decide that some parts are worth keeping for their erotic gyrations, and others, disrobed and broken, are not. She continues to support this reading by blowing up the mannequin filled car in male-coded action movie–hero style at the end of the video.

Beyoncé's Diva is a complete product of the male gaze; by her definition a Diva is merely a woman who inhabits a male subject position. She is constructed as a male fantasy of what a Diva should want to be: shallow and materialistic. The Diva revealed in this song and video is little more than an aggressive sex kitten. Consider the lyrics:

> When he pull up, wanna pop my hood up
> Bet he better have a six pack in the cooler
> Getting money, divas getting money
> If you ain't getting money then you ain't got nothing for me ("Diva")

This faux Diva cites her interest only in men who look good and have money, but, as we have witnessed in earlier discussions, the Diva is hardly interested in money or men for their own sakes. Instead, Divas are interested in living out ideals that make their lives open to possibility—consider Janie Crawford and her desire for pear tree love, Helga Crane and her desire for substantive agency, and Sula Peace's desire to make herself. In the spaces in which those characters embody a Diva stance, uncomplicated materialism is not present. Even Helga Crane in *Quicksand* says that her uncle's money is a means only of economic freedom. Free from the daily concerns of making her way she begins to look for meaningful access to agency. Marked by a simple desire for things, at best Beyoncé is a Studio- Diva, someone who has her Diva persona constructed for her and handed to her by her former father-manager, Matthew Knowles, and her present husband and champion, Jay-Z. Despite Beyoncé's poor emulation of a Diva, James's Robo-Diva idea still has useful applications, we just need to turn the lens a bit to a place where a Diva is actually present.

Lakhan, a young Black musician out of the United Kingdom, considers herself to be "the official Robo-Diva." Her song "Problem Child" (2009) makes an authentic claim to a Diva stance.

> They say I'm just acting up to be the center of attention
> I'm just being me, it's not my intention
> I don't need to explain everything I do
> Stop watching me and
> Start watching you ("Problem Child")

Here, we observe Diva desire outside the gaze, male or female. Lakhan employs an Afrofuturistic look and sound as a means of empowerment. "The Problem Child" video, originally only available for viewing on Lakhan's personal website, like its irregular availability, reveals unclear frames of the artist singing straight forwardly to the camera. Parts of the background are a brilliant purple and Lakhan is shot in black and white, with filmic distortions often obscuring a clear view of the singer. As the lyrics state, "stop watching me / start watching you," the video and the Diva in it are not concerned with whether you can see her or what you may think if you can. Instead she directs the viewer to reverse the gaze in an interesting way. "The Problem Child" video is clearly made on a shoestring budget, which seems to further her point; she tells the viewer not only to stop looking and worrying about her motives and misunderstood behavior but directs them to "watch you," thereby encouraging the viewer to turn inward for self-reflection and understanding. Simultaneously, the singer maintains her right to preserve the armor of her countenance; she determines when, where, and how often she is seen. Tricia Rose's suggestion that Afrofuturism is best exemplified through the Black body's intentional self-othering is modeled through Lakhan's video. Embodying Afrofuturism is "like wearing body armor that identifies you as an alien; if it's always on anyway, in some symbolic sense, perhaps you could master the wearing of this guise in order to use it against your interpolation" (Rose qtd. in Dery 11). Lakhan, as a self-designated Robo-Diva, masters the armor as a way to redirect the gaze. As a counterexample, Beyoncé puts her own armor on as a tinny display; there is little substance there and should one scrape at the shiny getup it would all flake away. Given the popularity of faux Divas like Beyoncé, the Diva's continued existence absolutely depends on the further development of complex figurations of womanhood—like those demonstrated in "The Problem Child"—that are firmly planted outside the male gaze and in her own voice. That being said, in a white patriarchal society a Diva's potential can be stunted and the rise of faux

Divas threatens the existence of the real thing. This drive to destroy the Diva is a part of her trajectory and thus this is not a reason to lose hope. Consider the OED's first cited usage in *Harper's Magazine*. The editor, George William Curtis, attempts to knock down an operatic singer by derogatorily calling her Diva, suggesting that she is both overpaid and without talent. This type of attack occurs most often because those who habitually hold the power to direct the gaze have come to understand the potential in the Diva's ability to self-generate power and influence. Thus the future of the Diva is far from assured. Consider that of the two musicians under observation here, Beyoncé and Lakhan, one is famous, respected, and rich and the other is a relative unknown. Since beginning this project Lakhan has both debuted and fizzled in relative obscurity. She was discovered, made a few videos with hopes of securing a record contract, and subsequently vanished; her website domain is now little more than a placeholder. That Lakhan never got a chance to enter mainstream popular culture and Beyoncé is a major celebrity is more than just the result of the trials you go through when you gamble in the music business. There is a particular agenda afoot to silence some and replace them with poor approximations of the real thing. Often the success of a musician's career is attributed to the oft-cited vagaries of fickle consumer tastes, but that argument once unpacked reveals that consumer choice is often an illusion. Consider the public's continuous fascination with Naomi Campbell, which exists in stark opposition to most clothing designers' preference for pale-skinned models. Campbell's long career has occurred in spite of white preference and patriarchal support of white womanhood. The Diva is not afraid of the spectacle and instead of fearing it, manipulates it to her own ends. Of course, for a Diva like Lakhan, this is not an option—one has to be among the choices in order to be chosen. "Within the marketplace of mass-produced and corporate-sponsored production of difference, the productive possibilities...bump up against the dominant workings of power with differing effects" (Fleetwood 126). Thus we should not assume that the consumer has necessarily expressed a preference for Beyoncé over artists like Lakhan; rather, Beyoncé has been manufactured, pre-packaged, and, most importantly, pre-selected.

The Diva's future is difficult, but despite the problems revealed in the Lakhan/Beyoncé dichotomy, Diva replaced with faux Diva, there is reason to be hopeful. Janelle Monáe is a young, Black, female artist who also employs an Afrofuturistic look and sound, which she combines with androgyny in order to affect a Diva stance. Despite being discovered by Big Boi of OutKast, she formed her own artist collective/label, Wondaland, and self-financed and

released her first album, *Metropolis: Suite I (The Chase)*, in 2007, at just 22 years old. Her resourcefulness and talent caught the eye of Bad Boy impresario Sean Combs, and under Bad Boy and Wondaland she released *The ArchAndroid*, which, like "Get Me Bodied" and her previous album, uses Fritz Lang's *Metropolis* as source material. Here though, Monáe is more sanguine and uses the framework he establishes in the film to critique the misperceptions of outsiders about the daily existence of Black women. *The ArchAndroid* continues the storyline from her first album, that of narrator Cindi Mayweather, "a state-of-the-art organic android [with] a rock-star proficiency package and a working soul" (liner notes, *Metropolis*), a tool through which she conveys the seemingly alien subject position experienced by many Black women. The first song and video realized from the album displays Monáe in her self-imposed uniform, an ever-changing array of strictly black and white androgynous clothing. Tucked away in an asylum, the video "Tightrope" attempts to capture the challenges of living as a Black woman in the twenty-first century. She is marked as mentally challenged and is walking a tightrope between sanity and lucidity, or at least this is the only way a white patriarchal society can understand her existence. The lyrics of the song, however, reveal something deeper:

> And I'm still tippin' on it
> See I'm not walkin' on it
> Or tryin' to run around it
> This ain't no acrobatics
> You either follow or you lead
> Yeah, I'm talkin' 'bout you
> I'll keep on blaming the machine
> Yeah, I'm talkin' bout it
> T-t-t-talkin' bout it
> I can't complain about it
> I gotta keep my balance
> And just keep dancin' on it
> We gettin' funky on the scene
> And you know about it
> Like a star on the screen
> Watch me tip all on it ("Tightope")

The subject of the song is the tightrope on which the protagonist is expected to perform her identity as a Black woman. She is not walking but rather tipping on the tenuous fragility of the rope, but makes it clear that she is not attempting to skirt difficulties, although her survival does depend on deft negotiation of the tightrope. Taking fate into her own hands, she decides to

"lead" and in so doing she places the blame for her predicament where it rightly belongs—on "the machine" ("Tightrope"). And yet this is of minimal concern because she, as the song reveals, successfully navigates it. Dancing in this liminal space, she manages to be a star and, assured of the strength of her position, invites the gazer to "watch [her] tip all on it." Monáe's successful, star-like navigation is more than just song-ready.

Monáe's particular rise is marked by desire and difference, but not for their own sakes; she knew there was something more to want and to give. "I always wanted to create my own world, to produce my own material and write my own characters....I knew that I had a unique way of seeing the world" (McNulty). The ability to recognize her own vision as inherently valuable suggests that Divas are still among us. Monáe is a darling of *Vogue* and its famous senior editor-at-large, Leon Talley, and despite her small stature and untraditional beauty she has appeared three times (November 2009, April 2010, and November 2010) in the magazine over the span of a single year. Perhaps this is why she has been called "a different kind of diva" (McNulty). At present she also has the support and financial backing of influential music label Bad Boy; the company has given her the space to have her own vision and style. "For this album, Sean Combs provided clout and contacts and left everything else to Wondaland" (Lynskey 7). The important point in the note above is the simple, easily overlooked prepositional phrase "for this album." Monáe has support for her work, for now, and maybe this means the idea of the Diva has support, for now, as well.

Tracing the trajectory of the Diva figure from the Italian castrati to Ntozake Shange's *Liliane: Resurrection of the Daughter* suggests a way around staid and fixed stereotypes about Black womanhood that often dictate the analysis of Black female literary figures. In defense of the complaint that cosmopolitanism leads to useless universalism, Bruce Robbins calls for difficult generalizations, "the more difficult though less pious procedure of *not* assuming agency to be everywhere present, but trying to explain why it is where it is and why it isn't where it isn't" (Robbins 175). This may be a useful way to think about seemingly wide generalizations about Black women and Black women characters. Houston Baker in *Blues, Ideology, and Afro-American Literature* says, "There is a constant need for original and suggestive tropes to capture an ever changing American scene" (112). The Diva figure is just that. It provides a new lens through which to survey portraits of women characters in African American literature. The performative aspect of the survival act inherent in the Diva allows for fluidity in its application. Black women characters are given another space to perform identity, and as readers our understanding of Black literature is enriched.

NOTES

Introduction

1. At press time the last aired *Divas Live* program was in 2010 but there is another performance scheduled for December 19, 2011. Scheduled performers include: Mary J. Blige, Kelly Clarkson, Florence and the Machine, Jennifer Hudson, Jessie J and Jill Scott.
2. See Guy Trebay's *New York Times* article "Naomi Campbell: Model, Citizen" for an extended discussion of Naomi Campbell's legal troubles.
3. Premier Model Management managed Naomi Campbell's career for over twenty years. The relationship ended in 2006.
4. The "us" here refers to Christy Turlington and Linda Evangelista, two of the highest earning, most famous supermodels in the 1990s. Because of their immense popularity at the time, the ultimatum that Turlington gave Dolce & Gabbana had significant implications.
5. On November 8, 2005, Tyra Banks invites Naomi Campbell onto her show, *The Tyra Banks Show*, and confronts Campbell about her alleged personal attacks. For the most part Campbell denies all of the allegations but later gives a half-hearted apology, which Banks scoops up with delight.
6. In *Bullet Proof Diva* by Lisa Jones she usefully offers the definition of a Diva as "whoever you make her...as long as she has the lip and nerve, and as long as she uses that lip and nerve to raise up herself and the world"(3).

7. For example, Nanny from *Their Eyes Were Watching God*, and Eva and Hannah from *Sula*.

8. See Claudia Tate's *Domestic Allegories of Political Desire: The Black Heroine's Text at the Turn of the Century* for further discussion.

9. Naomi André's idea of the "third zone" utilizes Marjorie Garber's idea for a third gender.

10. Collins locates the modern mammy as no longer working in the house of the master, per se, but as a character who still finds satisfaction in his ultimate survival. She is often educated, professional, and well groomed, but her devotion to work—and primarily to her boss, often male—defies understanding.

11. This new image of the jezebel is reimagined as the "sexualized black bitch" and merges ideas of Black matriarchy with sexual power and control. There is a site of difference in the representation of Black womanhood in images of the "sexualized black bitch" in rap music. While some rappers, like Lil' Kim, who calls herself "Queen B(itch)," and Trina, who calls herself "The Baddest Bitch," are seen as modern jezebels or "sexualized black bitches," there are others who express more liberated forms of Black womanhood. Take, for example, artists like Queen Latifah, who suggests calling a woman a bitch or a ho only makes her feel low ("U.N.I.T.Y"), and Missy Elliot, who suggests that one get their "freak on" as a suggestion to do well ("Get Ur Freak On").

12. Cheryl Wall in *Women in the Harlem Renaissance* dates the Harlem Renaissance as 1922 to 1941 in order to allow women's literary work to fit in more neatly. As this project relates to women during this period as well as others it seems logical to employ those dates also.

Chapter 1

1. Consider the works of Jessie Fauset in comparison to Bonner's fiction.

2. Nella Larsen's *Passing* does this as well, but whereas *Quicksand* speaks about the small, the intimate, and the particularly feminine, *Passing* makes more of the nation and the political, only through the lens of the small.

3. *Passing* is dedicated to Carl Van Vechten and Fania Marinoff, famous white patrons during the Harlem Renaissance. Larsen's relationship with these two at the time of publication was much more in line with an acquaintanceship. Her dedication can therefore be seen as pandering.

4. "Di'ba" is swardspeak for "isn't it? Swardspeak is a rapidly changing Tagalong-English insider dialect spoken primarily by Filipino gay men. See Martin F. Manalansan IV's *Global Divas: Filipino Gay Men in the Diaspora*. Duke University Press: Durham, 2003 for further discussion.

5. See W.E.B. Du Bois' "Two Novels." *Crisis* June 1928: 202.

6. Kimberly Monda discusses this at length in "Self-Delusion and Self-Sacrifice in Nella Larsen's *Quicksand*."

7. Helga Crane felt "bright colours *were* fitting and that dark-complexioned people *should* wear yellow, green, and red. Black, brown and gray were ruinous to them, actually destroyed the luminous tones lurking in their dusky skins....Why, she wondered, didn't someone write *A Plea for Color?*" (18, Larsen's emphasis).

8. See Marita Bonner's "Drab Rambles" as an example of the type of protection young, Black women living in urban areas needed.

9. See the Lunde and Stenport essay "Helga Crane's Copenhagen: Denmark, Colonialism, and Transnational Identity in Nella Larsen's *Quicksand*" for further discussion.

10. Anne Grey is the cultured and well-to-do woman with whom Helga lives in Harlem. Initially Anne represents to Helga the epitome of Black style and sophistication.

11. Audrey Henny is a fair-complexioned Black beauty, who without comment or excuse, displays her attractiveness and mixes in interracial company in stark contrast to the expectations of the period.

Chapter 2

1. See Du Bois' "Criteria for Negro Art" for his lengthy discussion on the necessary function of Black art.

2. Annie Tyler, a widow from Eatonville, leaves town with her young lover, named Who Flung. He steals her money and her automobile and she must return to town penniless and disgraced (Hurston 120).

Chapter 3

1. While Richard Iton in *In Search of the Black Fantastic: Politics and Popular Culture in the Post-Civil Rights Era* reveals this to largely take place in the aftermath of Alice Walker's *The Color Purple*, I think the evidence of that discord is sown much earlier.

2. There are several versions of this story, which can be largely categorized into two groups: positive encouragement in which all of the characters live and cautionary tale in which they all die. Morrison seems to be playing with the latter, an example of which is the 1865 Degen, Estes, & Co. version entitled *Remarkable Story of Chicken Little*.

Chapter 4

1. *Home-girls* are phone sex operators who work from home for clients who are into more risqué sexual requests, including BDSM and the like. *Office girls*, what she is initially, do not do this kind of work and their clients are of a more vanilla variety.

Chapter 5

1. *Mi luchadora* translates as "my fighter."
2. Before mailing a picture off to her father of her and Zoom together, Liliane tints the black and white photograph such that Zoom looks like a light-complexioned Black man rather than the white man he is.
3. See Faith Pennick's film *Silent Choices* for compelling arguments about African American women's fraught relationship to abortion.
4. *Push*, written by Sapphire, was published in 1996, with a film based on the novel, *Precious*, released to acclaim in 2009. Actress Mo'Nique plays the role of the title character's sexually and physically abusive mother. Her monstrous characterization of a mother who allows her boyfriend to sexually abuse her daughter in order to temporarily retain his affections while actively blaming and punishing her daughter through sexual and physical violence can be viewed as a quintessential portrait of a bad Black mother.

Conclusion

1. Consider Octavia's short story "Bloodchild" (1985), in which human beings are colonized by aliens who save them from their own destruction and as payment use human bodies as hosts for their often deadly offspring.
2. For an example of a female hustla, consider the character Snoop from the television series *The Wire*, a young woman who eschews classic ideas of femininity and works as a hired gun and part of security detail for the top drug dealer in her local Baltimore neighborhood. Working as a hustla includes but is not limited to any aspect of the street drug business, but does not generally include hustling in the more traditional sense involving male prostitution.

WORKS CITED

André, Naomi. *Voicing Gender: Castrati, Travesti, and the Second Woman in Early-Nineteenth-Century Italian Opera*. Bloomington: Indiana University Press, 2006.

Babuscio, Jack. "The Cinema of Camp: (AKA Camp and The Gay Sensibility)." *Camp: Queer Aesthetics and the Performing Subject—A Reader*. Ed. Fabio Cleto. Michigan: University of Michigan Press, 1999.

Baker, Houston. *Blues, Ideology, and Afro-American Literature: A Vernacular Theory*. Chicago: University of Chicago Press, 1984.

———. "Spike Lee and the Culture of Commerce." *Black American Literature Forum* 25.2 Black Film Issue (Summer, 1991): 237–52.

———. *Workings of the Spirit: The Poetics of Afro-American Women's Writing*. Chicago: University of Chicago Press, 1993.

Bar-Nadav, Hadara. *Weaving the Woman Artist: Ntozake Shange's Sassafrass, Cypress & Indigo and Liliane: Resurrection of the Daughter*. Thesis, Montclair State University. Ann Arbor: ProQuest/UMI, 1994. (Publication No. 39144664)

Berlant, Lauren. *The Queen of America Goes to Washington City: Essays on Sex and Citizenship*. Durham, NC: Duke University Press, 1997.

Beyoncé. *I Am . . . Sasha Fierce*. Sony, 2008. Album.

"Beyoncé—'Diva.'" YouTube. Web. Retrieved 3 Aug 2010.

"Beyonce & Kelly Rowland—'Get Me Bodied/Like This.'" YouTube. Web. Retrieved 3 Aug 2010.

Bjork, Patrick Bryce. "Sula: The Contradictions of Self and Place." *The Novels of Toni Morrison: The Search for Self and Place within the Community*. Ed. Patrick Bryce Bjork. New York: Peter Lang, 1992. 55–83.

Bobo, Jacqueline. *Black Women Film & Video Artists*. London: Routledge, 1998.

Bonner, Marita. "Drab Rambles." *The Crisis Reader*. Orig. 1927. Ed. Sondra Kathryn Wilson. New York: Random House, 1999. 172–180.

———. "On Being Young—a Woman and Colored." *The Norton Anthology of African American Literature*. Orig. 1925. Ed. Henry Louis Gates. New York: Norton, 1997. 206–09.

Bost, Suzanne. *Mulattas and Mestizas: Representing Mixed Identities in the Americas, 1850–2000*. Athens: University of Georgia Press, 2003.

Bradshaw, Melissa. "Devouring the Diva: Martyrdom as Feminist Backlash in The Rose." *Camera Obscura* 67.23 (2008): 69–87.

Brown, Kimberly. *Writing the Black Revolutionary Diva: Women's Subjectivity and the Decolonizing Text*. Bloomington: Indiana University Press, 2010.

Burrows, Victoria. *Whiteness and Trauma: The Mother-Daughter Knot in the Fiction of Jean Rhys, Jamaica Kincaid, and Toni Morrison*. New York: Palgrave Macmillan, 2004.

Carby, Hazel. *Reconstructing Womanhood: The Emergence of the Afro-American Woman Novelist*. Oxford: Oxford University Press, 1987.

Clarke, Deborah. "'The Porch Couldn't Talk for Looking': Voice and Vision in *Their Eyes Were Watching God*." *African American Review* 35.4 (2001): 599–613.

Collins, Patricia Hill. *Black Feminist Thought*. New York: Routledge, 1991.

———. *Black Sexual Politics: African Americans, Gender, and the New Racism*. New York: Routledge, 2005.

Cooke, Michael G. *Afro-American Literature in the Twentieth Century: The Achievement of Intimacy*. New Haven, CT: Yale University Press, 1984.

Cooper, Anna Julia. "Womanhood Vital Element in the Regeneration and Progress of the Race." *The Norton Anthology of African American Literature*. Ed. Henry Louis Gates. New York: Norton, 1997. 554–69.

Curtis, George William. "Christmas." *Harper's Magazine* Dec. 1883: 3–16.

Davis, Thadious. *Nella Larsen, Novelist of The Harlem Renaissance: A Woman's Life Unveiled*. Baton Rouge: Louisiana State University Press, 1996.

DeFalco, Ameilia. "Jungle Creatures and Dancing Apes: Modern Primitivism and Nella Larsen's *Quicksand*." *Mosaic* 38.2 (2005): 19–35.

Dery, Mark. "Black to the Future: Afro-Furturism 1.0." *Afro-Future Females: Black Writers Chart Science Fiction's Newest New-Wave Trajectory*. Ed. Marleen Barr. Columbus: The Ohio State University Press, 2008. 6–13.

Diva. Dir. Jean-Jacques Beineix. Perf. Wilhelmenia Wiggins Fernandez. Les Films Galaxie, 1981.

"diva." The Oxford English Dictionary. 2nd ed. 1989. OED Online. Oxford University Press. 4 Apr. 2000.

Douglass, Frederick. *Narrative of the Life of Frederick Douglass, an American Slave*. Boston: Anti-Slavery Office, 1845.

Doty, Alexander. "Introduction: The Good, the Bad, and the Fabulous; or, The Diva Issue Strikes Back." *Camera Obscura* 67.23.1 (2008): 1–9.

Doyle, Laura. "Transnational History at Our Backs: A Long View of Larsen, Woolf, and Queer Racial Subjectivity in Atlantic Modernism." *Modernism/Modernity* 13.3 (2006): 531–59.

Du Bois, W. E. B. "Criteria for Negro Art." *The Norton Anthology of African American Literature.* 1st ed. Orig. 1926. Ed. Henry Louis Gates. New York: Norton, 1997. 752–59.

———. "The Souls of Black Folk." *The Norton Anthology of African American Literature.* Orig. 1903. Ed. Henry Louis Gates. New York: Norton, 1997. 613–740.

Ebert, Roger. "Girl 6." *Chicago Sun Times.* 21 March 2006: Retrieved 11 Nov 2011. Web.

Elliot, Missy. "Get Ur Freak On." *So Addictive.* Electra, 2001.

Fauset, Jessie Redmon. *Plum Bun: A Novel without a Moral.* New York: F. A. Stokes, 1929.

Favor, J. Martin. *Authentic Blackness: The Folk in the New Negro Renaissance.* Durham, NC: Duke University Press, 1999.

Feldman, Martha. *Opera and Sovereignty: Transforming Myths in Eighteenth-Century Italy.* Chicago: University of Chicago Press, 2007.

Fleetwood, Nicole R. *Troubling Vision: Performance, Visuality, and Blackness.* Chicago: University of Chicago Press, 2011.

Francis, Terri. "Embodied Fictions, Melancholy Migrations: Josephine Baker's Cinematic Celebrity." *Modern Fiction Studies* 51.4 (2005): 824–54.

Frankel, Sushanna. "Naomi Campbell: A Model of Privacy." *The Independent* 16 Feb 2002.

Gates, Henry, Louis. "Black Creativity: On the Cutting Edge." *Time* 10 Oct 1994: 74–75.

———. *The Signifying Monkey.* Oxford: Oxford University Press, 1989.

Ghaly, Salwa. "Evil Encounters with 'Others' in Tayeb Salih and Toni Morrison: The Case of Mustafa Saeed and Sula Peace." *This Thing of Darkness; Perspectives on Evil and Human Wickedness.* Eds. Richard Paul Hamilton and Margaret Sönser Breen. Amsterdam: Rodopi, 2004. 21–36.

Giovanni, Nikki. *Black Feeling, Black Talk.* New York: Afro Arts, 1968.

———. *The Selected Poems of Nikki Giovanni.* New York: William Morrow, 1996.

Girl 6. Dir. Spike Lee. Prod. Jon Kilik and Cirri Nottage, Perf. Theresa Randle and Isaiah Washington. A 40 Acres and a Mule Filmworks, 1996.

Grant, Robert. "Absence into Presence: The Thematics of Toni Morrison's *Sula*." *Critical Essays on Toni Morrison.* Ed. Nellie Y. Mckay. Boston: G. K. Hall, 1998. 90–103.

Grewal, Gurleen. *Circles of Sorrow, Lines of Struggle.* Baton Rouge: Louisiana State University Press, 1998.

Grimke, Angelina. *Rachel, a Play in Three Acts.* Boston: The Comhill Company, 1920.

Guerrero, Ed. "The Black Image in Protective Custody: Hollywood's Biracial Buddy Films." *Black American Cinema.* Ed. Manthia Diawara. New York: Routledge, 1993. 247–57.

Guthmann, Edward. " Lee Takes Five on *Girl 6* / Glib Film About Phone-Sex Operator" San Francisco Chronicle. 22 March 1996: Retrieved 11 Dec 2011. Web.

Hampton, Greg. "Beauty and the Exotic: Writing Black Bodies in Nella Larsen's *Quicksand*." *CLA Journal* 50.2 (2006): 162–74.

Harris, Heather E. and Kimberly R. Moffitt. "A Critical Exploration of African American Women Through the 'Spiked Lens.'" Eds. Janice D. Hamlet and Robin R. Means. *Fight the Power: The Spike Lee Reader*. New York: Peter Lang, 2009. 302–320.

Hirsch, Marianne. "Maternal Narratives: Cruel Enough to Stop the Blood." *Toni Morrison: Critical Perspectives: Past and Present*. Eds. Henry Louis Gates and K. A. Appiah. New York: Amistad, 1993. 261–273.

Hite, Molly. "Romance, Marginality, Matrilineage: Alice Walker's *The Color Purple* and Zora Neale Hurston's *Their Eyes Were Watching God*." *Novel: A Forum on Fiction* 22.3 (1989): 257–73.

Hoffman, Katrina. "Feminists and Freaks: She's Gotta Have It and Girl 6." *The Philosophy of Spike Lee*. Ed. Mark T. Conrad. Lexington: University of Kentucky Press, 2011.

hooks, bell. *Ain't I a Woman: Black Women and Feminism*. Boston: South End Press, 1981.

———, ed."Good Girls Look the Other Way." *Reel to Real: Race, Sex and Class at the Movies*. New York: Routledge, 1996. 10–19.

———, ed. "Whose Pussy Is This?: A Feminist Comment." *Reel to Real; Race, Sex and Class at the Movies*. New York: Routledge, 1996. 227–35.

———. "Selling Hot Pussy: Representations of Black Female Sexuality in the Cultural Marketplace." Eds. Katie Conboy, Nadia Medina and Sarah Stanbury. *Writing on the Body: Female Embodiment and Feminist Theory*. New York: Columbia University Press, 1997. 113–28.

Horton, James Oliver. "The Ties that Bind: Networks of Communication and Support from Slavery to Freedom." The Legacies of Slavery and Sisterhood: The Life and Work of Harriet Jacobs. October 6–7, 2006, Pace University.

Hosteler, Ann E. "The Aesthetics of Race and Gender in Nella Larsen's *Quicksand*." *PMLA* 104.1. (1990): 35–46.

Hurston, Zora Neale. *Their Eyes Were Watching God*. Philadelphia: Lippincott, 1937.

Iton, Richard. *In Search of the Black Fantastic: Politics and Popular Culture in the Post-Civil Rights Era*. Oxford: Oxford University Press, 2008.

Jacobs, Harriet. *Incidents in the Life of a Slave Girl*. Boston: Published for the Author, 1861.

James, Rick. "Superfreak." *Reflections*. Motown, 1990.

James, Robin. "'Robo-Diva R&B': Aesthetics, Politics, and Black Female Robots in Contemporary Popular Music." *Journal of Popular Music Studies* 20.4 (2009): 402–23.

Jones, Jacquie. "The Construction of Black Sexuality." *Black American Cinema*. Ed. Manthia Diawara. New York: Routledge, 1993. 247–57.

Jones, Lisa. *Bulletproof Diva: Tales of Race, Sex, and Hair*. New York: Doubleday, 1994.

Jordan, Jennifer. "Feminist Fantasies: Zora Neale Hurston's *Their Eyes Were Watching God*." *Tulsa Studies in Women's Literature* 7.1 (1988): 105–117.

Kaplan, E. Ann, ed."Is the Gaze Male?" *Feminism and Film*. 1983. London: Oxford University Press, 2000. 119–38.

Keckley, Elizabeth. *Behind the Scenes, Formerly a Slave, but More Recently Modiste, and a Friend to Mrs. Lincoln, or, Thirty Years a Slave, and Four Years in the White House*. Urbana: University of Illinois Press, 2001. [Originally published: New York : G.W. Carleton, 1868. This edition originally published: Chicago : R.R. Donnelly, 1998.]

Kincaid, Jamaica. *Lucy: A Novel*. New York: Farrar, Straus and Giroux, 1990.

Koestenbaum, Wayne. *The Queens Throat: Opera, Homosexuality, and the Mystery of Desire*. Cambridge, MA: Da Capo, 2001.

Kozinn, Allan. "Review/Music; With Theatrics Stripped Away, a Diva Stakes All on Her Voice." *New York Times* 2 Mar 1994.

"Lakhan—'Problem Child' (promo video)." YouTube. Web. 3 Aug 2010.

Larsen, Nella. *Quicksand*. New York: Alfred A. Knopf, 1928.

Lee, Spike. *Spike Lee's Gotta Have It: Inside Guerrilla Filmmaking*. New York: Fireside, 1987.

Levecq, Christine. "'You Hear Her, You Ain't Blind': Subversive Shifts in Zora Neale Hurston's *Their Eyes Were Watching God*." *Tulsa Studies in Women's Literature* 13.1 (1994): 87–111.

Lewis, D. L. *When Harlem Was in Vogue*. New York: Penguin (Non-Classics), 1997.

Locke, Alain. "The New Negro." *The New Negro: Voices of the Harlem Renaissance*. New York: Albert and Charles Boni Inc., 1925.

Lunde, Arne, and Anna Stenport. "Helga Crane's Copenhagen: Denmark, Colonialism, and Transnational Identity in Nella Larsen's *Quicksand*."*Comparative Literature* 60.3 (2008): 228–43.

Lynskey, Dorian. "Janelle Monáe: Sister from Another Planet." *Guardian*. 27 Aug 2010: 7.

Malveaux, J. "Spike's Spite." *Ms*. September/October 1991: 80.

Manalansan IV, Martin F. *Global Divas: Filipino Gay Men in the Diaspora*. Durham, NC: Duke University Press, 2003.

Manatu, Norma. *African American Women and Sexuality in the Cinema*. Jefferson, NC: McFarland, 2003.

Marquis, Margaret. "'When De Notion Strikes Me': Body Image, Food, and Desire in *Their Eyes Were Watching God*." *Southern Literary Journal* 35.2 (2003): 79–88.

McDouglad, Elise Johnson. "The Double Task: The Struggle of Negro Women for Sex and Race Emancipation." *Harlem's Glory: Black Women Writing 1900–1950*. Orig. 1925. Ed. Lorraine Elena Roses. Cambridge, MA: Harvard University Press, 1986. 307–314.

McKnight, Maureen. "Discerning Nostalgia in Zora Neale Hurston's *Their Eyes Were Watching God*." *Southern Quarterly* 44 (2007): 83–115.

McMillan, Sally. "Janie's Journey: Zora Neale Hurston's Framework for an Alternative Quest." *Southern Studies* 12 (2005): 79–94.

McNulty, Bernadette. "Monáe Talks: Quiff Queen Janelle Monáe Is a Different Kind of Diva." *The Telegraph*. 14 Mar 2011. Retrieved 31 July 2011. Web.

Metropolis. Dir. Fritz Lang. Prod. Erich Pommer, Perf. Alfred Abel and Brigitte Helm. Universum Film (UFA), 1927.

Miller, Shawn. "'Some Other Ways to Try': From Defiance to Creative Submission in *Their Eyes Were Watching God*." *Southern Literary Journal* 37:1 (2004): 74–95.

Monae, Janelle. *Metropolis: Suite I (The Chase)*. Bad Boy Records, 2007.

Monae, Janelle. *The ArchAndroid (Suites II and III)*. Bad Boy Records, 2010.

Monda, Kimberly. "Self-Delusion and Self-Sacrifice in Nella Larsen's *Quicksand*." *African American Review* 31.1 (1997): 23–39.

Morrison, Toni. *Sula*. New York: Alfred A. Knopf, 1973.

Musser, Judith. "African American Women and Education: Marita Bonner's Response to the 'Talented Tenth.'" *Studies in Short Fiction* 34 (1997): 73–85.

Neal, Larry. "The Black Arts Movement." *Within the Circle: An Anthology of African American Literary Criticism from the Harlem Renaissance to the Present*. Orig. 1968. Ed. Angelyn Mitchell. Durham, NC: Duke University Press, 1994. 184–99.

Nelson, Jill. *Volunteer Slavery: My Authentic Negro Experience*. New York: Viking Penguin, 1994.

Nigro, Marie. "In Search of Self: Frustration and Denial in Toni Morrison's *Sula*." *Journal of Black Studies* 28.6 (1998): 724–37.

O'Reilly, Andrea. *Toni Morrison and Motherhood: A Politics of the Heart*. Albany: State University of New York Press, 2004.

Osbourne, Carol. "Family Matters: Fiction's Contribution to the Memory Wars." *Signs* 28.4 (2003) 1121–149. Web.

Pearse, Damien."Naomi Campbell Gives Evidence at 'Blood Diamonds' War Crimes Trial." *Herald Sun*. 08 August 2010. Retrieved 2 July 2011. Web.

Perez, Hiram. "Two or Three Spectacular." *Camera Obscura* 67.23.1 (2008): 113–42.

Pierson, John. "*Girl 6*, Boys 3." *Filmmaker: the Magazine of Independent Film* 4.2 (1996): 25–31.

Pool, Hannah. "Naomi Campbell Fights Racism in Fashion." *The Guardian* 22 August 2007: G2.

———. "'Fashion Is Probably a Bit Racist.'" *The Guardian* 22 February 2011: G2.

Prince, Mary. *The History of Mary Prince, a West Indian Slave*. London: F. Westley and A.H. Daviseckley, 1831.

Pringle, Peter. "Bloody Battle at the Met.; Prima Donna/ Chief Female Singer in Opera; Temperamentally Self-important Person." *Independent* 17 Feb 1994: 23.

Reid, Mark, A. *Redefining Black Film*. Berkeley: University of California Press, 1993.

Remarkable Story of Chicken Little. Boston: Degen, Estes & Co., 1865. Open Library. Web. Retrieved 21 July 2011.

Robbins, Bruce. "Comparative Cosmopolitanism." *Social Text*. 31/32 (1992): 169–86.

Roffman, Karin. "Nella Larsen, Librarian at 135th Street." *Modern Fiction Studies* 53.4 (2007): 752–87.

Rose, Tricia. *Black Noise: Rap Music and Black Culture in Contemporary America*. Hanover, NH: University Press of New England, 1994.

Sapphire. *Push*. New York: Vintage, 1996.

Schmidt, Michael S. "For a Supermodel with a Temper, No Charges." *New York Times* 03 Mar 2010: A28.

Shange, Ntozake. *For Colored Girls Who Have Considered Suicide When the Rainbow Is Enuf*. Oakland, CA: Shameless Hussy Press, 1975.

Shange, Ntozake. *Liliane: Resurrection of the Daughter*. New York: St. Martin's Press, 1994.

———. "Resurrection of the Daughter." *Nappy Edges*. New York: St. Martin's Press, 1972.

She's Gotta Have It. Dir. Spike Lee. Prod. Shelton J. Lee, Perf. Tracy Camila Johns, Redmond Hicks, John Canada Terrell, Spike Lee, and Raye Dowell. A 40 Acres and a Mule Filmworks, 1986.

Silent Choices. Dir. Faith Pennick. Organized Chaos Mediaworks, 2007.

Simmons, Ryan. "'The Hierarchy Itself'": Hurston's *Their Eyes Were Watching God* and the Sacrifice of Narrative Authority." *African American Review*. 36.2 (2002): 181–193.

Simmonds, Felly Nkweto. "*She's Gotta Have It*: The Representation of Black Female Sexuality on Film." *Feminist Review* 29 (1988): 10–22.

"Snickers Road Trip Commercial." *YouTube*. Web. 3 Aug 2010.

Smith, Valerie. "Introduction." *Incidents in the Life of a Slave Girl*. New York: Oxford University Press, 1988.

Sokoloff, Janice. "Intimations of Matriarchal Age: Notes on the Mythical Eva in Toni Morrison's *Sula*." *Journal of Black Studies* 16.4 (1986): 429–434.

Spillers, Hortense J. "A Tale of Three Zoras: Barbara Johnson and Black Women Writers." *Diacritics* 34.1 (2004): 94–97.

Tate, Claudia. *Domestic Allegories of Political Desire: The Black Heroine's Text at the Turn of the Century*. Oxford: Oxford University Press, 1992.

Toomer, Jean. *Cane*. New York: Boni and Liveright, 1923.

Trebay, Guy. "Naomi Campbell: Model, Citizen." *The New York Times* 08 September 2010: E1.

Tyra Banks Show. Perf. Tyra Banks. Dir. Brian K. Campbell. Warner Brothers, 2005. Web.

VH1 Divas Live. DVD. Sony, 1998.

Vogel, Shane. "Lena Horne's Impersona." *Camera Obscura* 67.23.1 (2008): 11–45.

"Voguepedia—Naomi Campbell." Vogue.com. Retrieved 11 July 2011. Web.

Walker, Alice. *In Search of Our Mothers' Gardens: Womanist Prose 1967*. San Diego: Harcourt Brace, 1983.

Wall, Cheryl A. "Passing for What? Aspects of Identity in Nella Larsen's Novels." *Black American Literature Forum* , 20.1/2 (1986): 97–111.

———. *Worrying the Line: Black Women Writers, Lineage, and Literary Tradition.* Chapel Hill: University of North Carolina Press, 2005.

———. *Women of the Harlem Renaissance: Women of Letters.* Bloomington: Indiana University Press, 1995.

Walsh, Michael. "Battle Fatigue." *Time Magazine* 21 February 1994.

Washington, Mary Helen. "I Love the Way Janie Crawford Left Her Husbands: Zora Neale Hurston's Emergent Female Hero." *Sweat.* Ed. Cheryl Wall. New Brunswick, NJ: Rutgers University Press, 1997. pp. 193–209.

———. "The Darkened Eye Restored: Notes toward a Literary History of Black Women." *Within the Circle: An Anthology of African American Literary Criticism from the Harlem Renaissance to the Present.* Orig. 1987. Ed. Angelyn Mitchell. Durham, NC: Duke University Press, 1994. 442–53.

———. *Invented Lives: Narrative of Black Women, 1860–1960.* Garden City, NY: Anchor Books, 1980.

Weathers, Glenda B. "Biblical Trees, Biblical Deliverance: Literary Landscapes of Zora Hurston and Toni Morrison." *African American Review* 39.1–2 (2005): 201–12.

Welter, Barbara. *Dimity Convictions: The American Woman in the Nineteenth Century.* Athens: Ohio University Press, 1976.

The Wendy Williams Experience. Perf. Wendy Williams and Diahann Carroll. Dir. Debbie Miller. BET, 2009. Web.

White, Deborah Gray. *Ar'n't I a Woman?: Female Slaves in the Plantation South.* New York: W.W. Norton, 1985.

Willis, Susan. *Specifying: Black Women Writing the American Experience.* Madison: University of Wisconsin Press, 1989.

INDEX

AFRICAN AMERICAN LITERATURE AND CULTURE

EXPANDING AND EXPLODING THE BOUNDARIES

General Editor
Carlyle V. Thompson

The purpose of this series is to present innovative, in-depth, and provocatively critical literary and cultural investigations of critical issues in African American literature and life. We welcome critiques of fiction, poetry, drama, film, sports, and popular culture. Of particular interest are literary and cultural analyses that involve contemporary psychoanalytical criticism, new historicism, deconstructionism, critical race theory, critical legal theory, and critical gender theory.

For additional information about this series or for the submission of manuscripts, please contact:

Peter Lang Publishing, Inc.
Acquisitions Department
29 Broadway, 18th floor
New York, New York 10006

To order other books in this series, please contact our Customer Service Department:

(800) 770-LANG (within the U.S.)
(212) 647-7706 (outside the U.S.)
(212) 647-7707 FAX

Or browse online by series:

www.peterlang.com